WHIZLIMITED

TOKYO

First published in the United States of America in 2022
by Rizzoli International Publications, Inc.
300 Park Avenue South
New York, NY 10010
www.rizzoliusa.com

WHIZLIMITED
Copyright ©2022 WHIZLIMITED and Hiroaki Shitano
Contributions by Shigeyuki Kunii and Nobukazu Kishi

For Rizzoli:
Publisher: Charles Miers
Editor: Ian Luna
Project Editors: Meaghan McGovern & Taichi Watanabe
Translator: Marie Iida
Design Coordination: Olivia Russin and Eugene Lee
Production Manager: Barbara Sadick
Copy Editor / Proofreader: Angela Taormina

For WHIZLIMITED:
Art Director: Motoki Mizoguchi (mo'design inc.)
Designer: Ryu Goda & Junya Kishimoto (mo'design inc.)
Assistant Designer: Genki Mizoguchi
Photographer: Atsushi Fuseya
Contributor: Nobukazu Kishi

Photography:
Photographers: Julian Loh, RK, Yozo Yoshino & Genki Nishikawa (mild inc.)
Stylist: Masahiro Hiramatsu & Ryota Yamada
Hair & Make-up: Ken Yoshimura, Shutaro, Ryo Matsuda & Taro Yoshida (W)
Make-up: Shino Ariizumi

Special Thanks: Shigeyuki Kunii (mita sneakers), HIDDY (SECRETBASE),
Taichi Iwasa (YUBI RENTAL) & The Tribe Of Whiz

Printed in China

2022 2023 2024 2025 / 10 9 8 7 6 5 4 3 2 1

ISBN: 978-0-8478-7134-6
Library of Congress Control Number: 2021951222

Visit us online:
Facebook.com/RizzoliNewYork
Twitter: @Rizzoli_Books
Instagram.com/RizzoliBooks
Pinterest.com/RizzoliBooks
Youtube.com/user/RizzoliNY
Issuu.com/Rizzoli

WHIZ LIMITED

RIZZOLI NEW YORK

WHIZLIMITED

TOKYO

A graphic that holds the brand's world view and pride as a designer,
or an icon that proves the connection between the brand and fans.

The Story of WHIZLIMITED

by Nobukazu Kishi

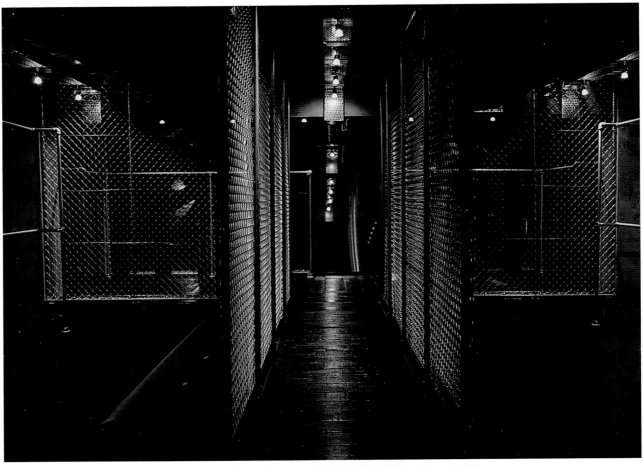

The interior of Lump Tokyo, the flagship store of WHIZLIMITED and Rebirth which opened in 2003.
Metal fencing was used as partitions to give the space an industrial feel in keeping with the brand's identity rooted in Tokyo's street culture.

*WHIZLIMITED strives to be an expression of Tokyo's street culture through apparel.
For its founder/designer Hiroaki Shitano, this book is "a corridor of memories,"
a document of over two decades of creative activity.*

Tokyo / Shinjuku. The metropolis is filled with shops, condominiums, and detached houses surrounding an urban core composed of skyscrapers. Of these, the most iconic are the twin towers of the Tokyo Metropolitan Government Building—the center of city politics—and clustered around them, Japan's premier entertainment district. Born in 1976, Hiroaki Shitano spent his boyhood in downtown Shinjuku. In the late 1980s, when Shitano entered junior high school as a teenager, Yankee or *yankii* culture (a subculture popular among delinquent youth) had a spontaneous influence on fashion nationwide. Shitano would go to the area around Ueno Station, the gateway into Tokyo from northern Japan, to visit a long-established shop in Ameyoko, which imported clothing from Europe and the United States. It was there that he learned the basics of streetwear. In high school, he started to frequent thrift stores in Harajuku, Shibuya, and the hip neighborhood of Daikanyama to the southwest. Shitano recalls visiting EM, a now defunct select shop in Namikibashi, Shibuya, where he would covetously eye the "Big Polo" (an oversized version of the Ralph Lauren polo shirt with the horse-and-rider logo embroidered on the hem) which was all the rage in those days. Not being able to afford the extravagant price tag, however, Shitano bought a Goodenough polo shirt instead, unaware of how deeply he would become influenced by the brand's designer, Hiroshi Fujiwara, in the years to come.

Although the surroundings of Shinjuku station, which Shitano passed through every day on his way to high school and back, was hardly the most fashion-oriented area in Tokyo, he made it a daily habit to see what was on offer at American Bluebird for *amekaji* ("American casual") looks, at Hawk Surfboards, and at Murasaki Sports for skate style items.

Shitano attended a high school without uniforms, a very rare thing in Japan, and this was undoubtedly one of the contributing factors that developed in him a commitment to fashion. In fact, he'd dreamed of becoming a stylist after graduation. But despite his enthusiasm, it seemed unrealistic for someone without a mentor to launch into a career as a stylist straight out of high school. "I had a vague admiration for the profession, of being a stylist who coordinates the clothes I borrowed from a shop, putting them on a model...but at that time I didn't know how to become a stylist, so I decided to go to a correspondence university for the time being. Then, at least in my spare time, during the day, I tried to get a part-time job in something related to clothes. That's how I got my start at World Sports Plaza on Fire Street in Shibuya, which handled NBA and MLB uniforms and other branded wear."

This experience with sportswear proved a good and consequential fit. Shitano had played sports throughout his education, with the soccer club in elementary school, the tennis club in junior high school, and the basketball club in high school, and appreciated the balance between style and performance of the best gear. In his late teens the '90s NBA boom arrived on the streets of Tokyo, on the heels of the b-boys and their attendant dance clubs. An exclusive 3x3 basketball court even appeared at a prime location in Harajuku, and the city reveled in this new energy. It was during this period that many breakers and dancers started sporting Nike

staples like Air Max Classic BW, Air Force 1 and Michael Jordan's signature series. This exposure was crucial to the NBA boom, and these brands gradually became difficult to obtain. With World Sports Plaza as a part-time job, Shitano found himself in the center of a fast-evolving scene.

Around the same time, Shitano had a classmate who made and sold original t-shirts, whose work he admired. "He was doing something interesting, and had given me access to the tools for printing t-shirts. I already had a Macintosh and a printer to design the graphics, so I took over the silkscreen kit and set up a system to produce original t-shirts." It is no exaggeration to say that this was the fateful first step in Shitano becoming a designer. "Macintosh was in the Performa series era, and I had to learn on the fly, using a manual called *Master Illustrator in a Week* or something like that. I took the same approach to silkscreen and, without really being taught, just blindly began making hand-printed shirts that I would sell on the street. Not long after, I met Tsutomu Takahashi, whom I worked alongside with in a Harajuku select shop while attending the same university. We attempted to start our own brand, and in 1995, Rebirth was born. We'd purchase blank t-shirts and sweatshirts, then silkscreen-print original graphics on them. Sew the original brand name on that and you have an independent brand. We secured a sales floor at a select shop where Takahashi worked and started wholesaling to local dealers. Rebirth quickly gained a reputation as a rising indie brand, with custom streetwear remade from off-the-shelf shirts."

However, the following year, Shitano left Rebirth to start making his own clothing under a new brand called Rookey for Household. Rebirth itself was evolving through collaborations with designer Atsushi Horiki, Takahashi's select shop co-worker. Rookey was Shitano's first solo activity: "I had the opportunity to develop my own designs as I wanted, but looking back again, I became anxious because I knew nothing about the clothing business. So while continuing with Rookey, I got a job on the shop staff at Harajuku Famouz in 1997."

At the time, Famouz had pattern designers and production control staff led by the designer Ryuji Kamiyama, and it was a perfect environment to learn how to make clothes by starting with the basics. In addition to receiving guidance from Kamiyama on how to use the Mac, which he had been using for design, Shitano was taught general behind-the-scenes tasks for running an apparel brand, which formed the basis of something that he could actually make a living from. In 2000, Shitano became independent, and the newly launched brand was named WHIZ.

[As an aside, one of the representative graphics of WHIZLIMITED, the stylized "76," was actually produced during the Rookey era. The logo symbolizes a generation born in 1976, which included Shitano, Tsutomu Takahashi

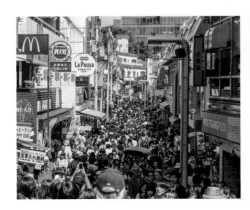
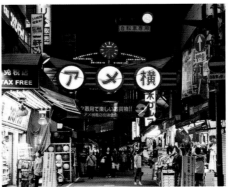

Left: Takeshita Street, the gateway into Harajuku, Tokyo. It is the undisputed capital of fashion in Japan, deeply ingrained in the imaginations of young people across the country. Ura-Harajuku where numerous street fashion brands including Lump Tokyo set up their stores, is situated beyond Takeshita Street, in an area across Meiji-Dori Avenue.

Right: The Ameyoko shopping street in Ueno, Tokyo, frequented by Shitano during his youth. All manner of establishments including long-standing import shops, military surplus vendors, bargain grocery stores and sport shops line the street. It remains one of Tokyo's most popular destinations, especially during the holiday season when Ameyoko's old-Tokyo charm attracts droves of shoppers from across the city.

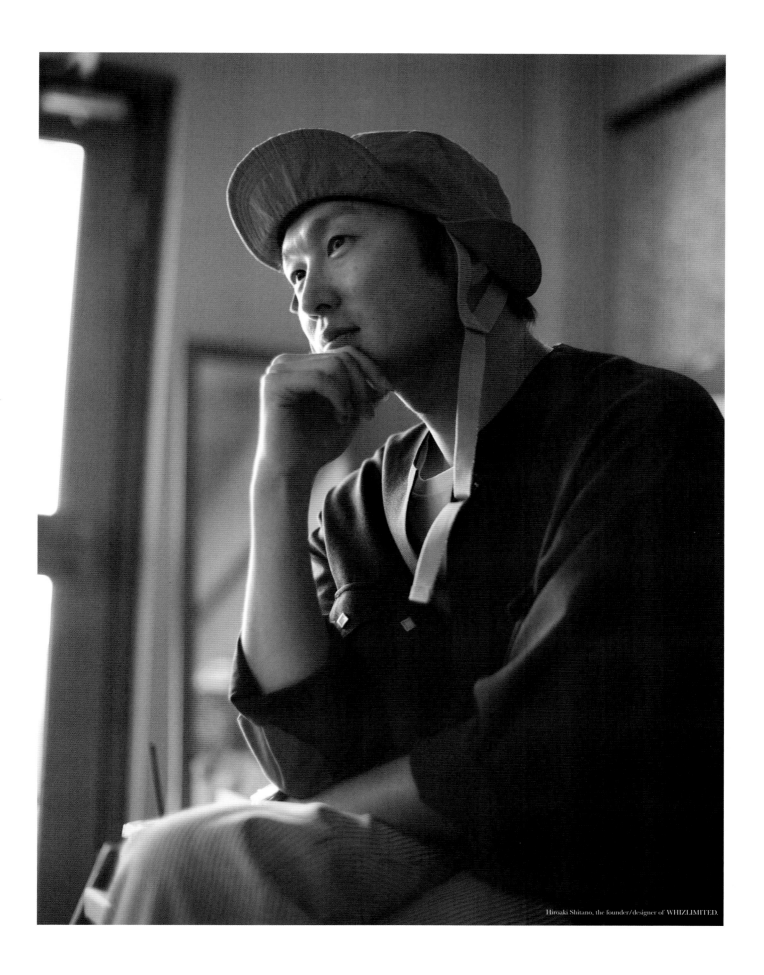

Hiroaki Shitano, the founder/designer of WHIZLIMITED.

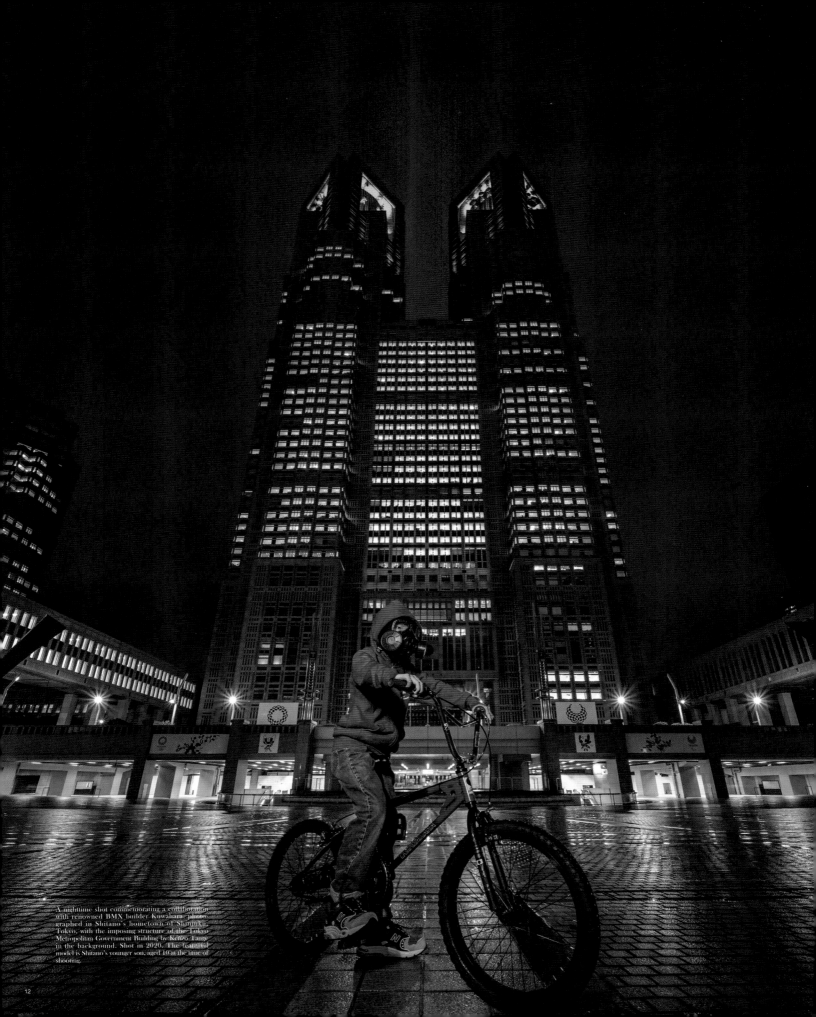

A nighttime shot commemorating a collaboration with renowned BMX builder Kuwahara, photographed in Shitano's hometown of Shinjuku, Tokyo, with the imposing structure of the Tokyo Metropolitan Government Building by Kenzo Tange in the background. Shot in 2020. The featured model is Shitano's younger son, aged 10 at the time of shooting.

of Rebirth, and Tomonori Banno, who went on to found Braitone. Iconic graphics passed down from Rookey to WHIZ for about a quarter of a century are still deeply loved by WHIZ fans and are featured in events such as the annual collaborative 76 Tee released every year on July 6th.]

In 2000, Shitano was gaining recognition as the designer of WHIZ. He received an enthusiastic invitation from Takahashi, and the two went on to join forces with Horiki to establish Lump. Directly translated from the word *katamari*, an aggregate mass, Lump was at this stage still largely unrealized and was envisioned both as a collective and a space to gather. While Shitano was working at Famouz, Rebirth was growing into a popular brand nationwide, largely because of the original designs by Takahashi and Horiki. While the label's shipment volume increased, there was no clear direction on marketing or program for seasonal product development, so the future seemed insecure. Shitano, who learned the fundamentals of making and selling clothes at Famouz, advised Rebirth and helped direct a path forward.

WHIZ was first officially unveiled with the 2000 Autumn/Winter collection. However, even before WHIZ's official launch, Shitano had in fact been making custom varsity jackets with leather sleeves which he sold personally, cultivating a select following for the budding brand. Under the slogan "individual clothing = items with individuality in their own right," WHIZ aimed to condense Shitano's accumulated experiences and understanding of "Tokyo Street" into a wearable expression.

The following year, 2001, Takahashi, who had formally been at the helm of Lump, handed the reins to Shitano. Shitano was entrusted with the day-to-day operation of Lump as well as his own label, and during this period Lump was able to evolve into a practical entity. With WHIZ and Rebirth at the center, Lump would come to encompass four brands, including Seesway Satiate (also led by Takahashi), and the aforementioned Braitone, presided over by Tomonori Banno. With each season, the constituent parts of Lump attracted a diverse and growing audience. In particular, the momentum of both WHIZ and Rebirth led directly to the opening of a flagship store, Lump Tokyo, which opened in Harajuku in 2003. At first, Shitano was reluctant to open a store because he knew the difficulty of running one from his experience at Famouz, but he was urged on by fans who supported the brand, and their input proved decisive. In making the leap, Shitano felt that: "While each brand is merely seen as part of the Lump collective, neither WHIZ nor Rebirth would become recognized brands in their own right."

As context, the streetwear movement gained the most momentum in the early 2000s, with the originators who had established the community in Ura-Harajuku at the forefront, and emerging brands venturing out, some south to Ebisu and Nakameguro in search of newer pastures. These upstart street brands each expressed its own worldview and developed collections every season, in an environment that was incomparably lively, enthusiastic, and manic—a time of optimism that bears little comparison with our pandemic-weary present.

In fact, the centripetal force generated by WHIZ and Rebirth saw

One of the entrances to Kabukicho, Japan's largest adult entertainment district. Teeming with hostess bars, sex establishments and even yakuza offices, it is a chaotic place governed by dark desires and intrigue. It is well known that Kabukicho's nighttime scenery, illuminated by its countless neon lights, became one of the motifs for the film *Bladerunner.*

The interior of the flagship store of WHIZ TOKYO, formerly known as Lump Tokyo, featuring framed art and fixtures by M&M Custom Performance. As a long-time admirer, Shitano had always fantasized about a collaboration with M&M if he ever managed to open a store in Ura-Harajuku—a dream that became a reality.

easy corollary in the length of the queue comprising around 600 people that spun around the block on Lump Tokyo's opening day in 2003. Set deep in Ura-Harajuku, the original shop and its future incarnations became the natural locus of WHIZ fandom, which at this point had already assumed an identity, one with its own unique culture, rituals and traditions within the collective. Since 2008, an annual "76 Summit" has been held on July 6 in Harajuku, and occasioned the release of highly sought-after collaborative WHIZ items, including the 76 Tee. For Shitano who also started producing limited editions and collaborations in line with the July 6 event, the years following the opening of Lump Tokyo as "the busiest years of my life." He'd also changed the name of WHIZ to WHIZLIMITED in 2003, and steadily guided the label into one of the brands that would come to represent Tokyo streetwear culture.

As a counter-motion to its core activities, WHIZLIMITED launched A.W.A., a sub-label focused on back-to-basics *amekaji* authenticity in 2008. Drawn from a diversity of American heritage garments and accessories, the basic silhouettes, the standard color palette, and items that most embodied this aesthetic—from the 100% cotton t-shirt to indigo-dyed rigid denim, drew on a nostalgia for the well-wrought and durable. As opposed to WHIZLIMITED's creation of Tokyo streetwear preoccupied with an ephemeral "now," A.W.A. attempted to capture the essence and universal appeal of "real" American clothes. It goes without saying that Shitano's reverential tweaking of these storied codes attracted and instilled loyalty in the traditional WHIZ fan.

In tandem with this approach, WHIZLIMITED started collaborating with sportswear and athletic brands

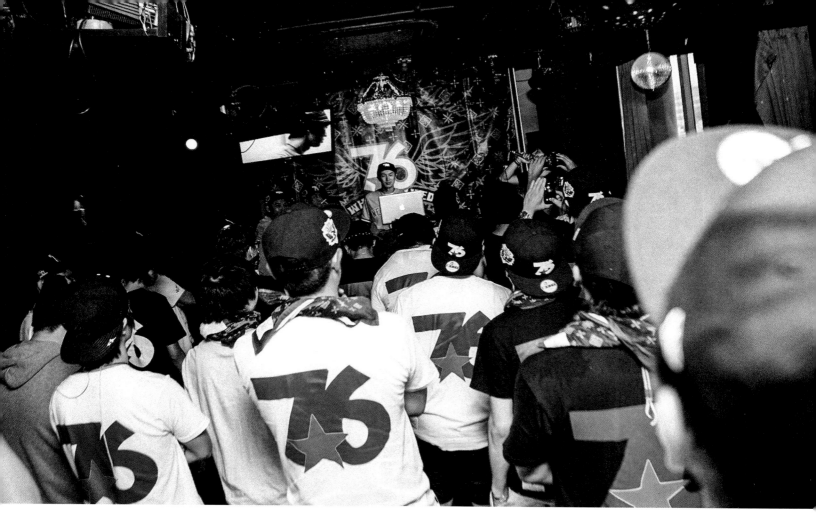

A scene from one of the "76 Summit" events held on July 6th every year since 2008 to mark the anniversary of WHIZLIMITED. The annual event embodies the brand's emphasis on maintaining a personal connection with its fans.

started collaborating with sportswear and athletic brands such as New Balance and Reebok through Mita Sneakers, a storied shop in Ueno, Tokyo—as well as Adidas through Felicity, a label jointly co-sponsored by fashion director Kazuki Kuraishi and Shitano himself. Over time WHIZ has also collaborated with Salomon, Stüssy, Fragment Design and Porter. These special items are released at anniversary events as well as other select dates, but Shitano and his team keep information about the nature of these items strictly confidential so that customers would only be able to find out by coming to the store on the day itself. This enforced secrecy is partly to discourage third-party resellers from snapping up the inventory, but is seen internally as a positive promotional strategy, one meant solely to excite fans by creating a sense of constant anticipation and surprise.

WHIZLIMITED is especially particular about collaborations to be released on its anniversary day. It is an unwritten rule that only 76 units of any type are produced even if the collaborative product is extremely topical and will be sought-after. In other words, brands who partner with WHIZLIMITED to create items for its anniversary, are effectively giving up the opportunity to earn sales for itself. "This means that for the brand collaborating with us, the amount of effort involved in production would be high while profits would be relatively low. I just cannot express how grateful I am to brands who still decide to work with us regardless," says Shitano. Such an unusual and idiosyncratic commitment to collaboration may well be an important key to understanding WHIZLIMITED.

WHIZLIMITED has sometimes even surprised itself and those who think they know the brand. In October

Fashion Week Tokyo for the very first time. It came as a surprise, even to me, that an insurgent label like WHIZ, which seemed to be on the same trajectory as established streetwear brands, would even stage a runway show—something that is more in keeping with a high fashion house. But it seems that even this is in keeping with Shitano's personality. The catalyst for this breakthrough was when the Contemporary Fix, a select shop run by fashion director Yuichi Yoshii began stocking WHIZLIMITED items, and this had led to Yoshii, who was also involved in the planning for Tokyo Fashion Week, to extend an invitation to Shitano to hold a runway show.

"In the days leading up to the runway show, I was absolutely overwhelmed by arrangements and whatnot, the likes of which I had never experienced in the more than ten years since I started running WHIZLIMITED. Before I knew it, the big day came and the runway show was over in a flash, just like that, and when my mind caught up with my body, I was saying goodbye to everyone. I realized that if I ended the experiment there, it would mean that I would go back without getting to know the inner workings of the system or learning how to properly manage a runway show. It was then that I decided that I had to keep doing it for at least four seasons," Shitano recalls.

WHIZLIMITED held runway shows in Tokyo Fashion Week from the 2012 Spring/Summer to the 2013 Autumn/Winter season. When asked why a brand like WHIZ would ever take part in such an endeavor, Shitano said, "Actually experiencing a runway show made me realize how much you could stir people's emotions with elements of performance and using the entire space to create an atmosphere. This was a realm of new sensations I had not been able to reach until then, even while organizing numerous exhibitions and events in the past. So, as a person who set out with a desire to bring people happiness in their day-to-day life through clothing, this discovery became a huge motivating factor. At the same time, while the runway shows provided an opportunity for new people to get to know WHIZLIMITED, it does not necessarily lead to a massive influx of new customers."

At the 2015 Autumn/Winter collection, which celebrated the 15th anniversary of the brand's founding, the shows resumed, and the runway was cast as a place where anything could be expressed. The proceedings commenced by introducing the archive. And with the 2016 Autumn/Winter collection the following year, Shitano showed his attitude as a street brand creator by trying out new approaches, such as combining the personal clothing of the models to appear with the new work of WHIZLIMITED.

It is uncertain to what extent staging runway shows influenced critical perceptions of the brand, but in 2015 Shitano was awarded the Tokyo Fashion Award for 2016, and was also accorded the privilege of holding an exhibition in Paris for the 2016 Autumn/Winter season. Shitano wryly recalled meeting with the last recipient of the fashion prize, Hiromichi Ochiai of Facetasm, and after being informed of the award's existence the day before the application deadline, he spent the night preparing his winning application. With serendipity like that, Shitano may well have been born under a special star because he has been graciously acknowledged by his peers and mentored and advised by so many. These include fellow designer Kazuki Kuraishi of the Fourness, Shigeyuki Kunii of Mita Sneakers and Hiroshi Fujiwara, whose collaborations with WHIZ command special attention. Also worthy of mention are Toshimi Murakami who

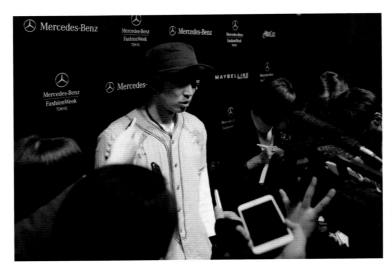

Designer Hiroaki Shitano being interviewed after the runway show at Mercedes Benz Fashion Week Tokyo. The event marked a decisive moment for WHIZLIMITED, previously a purely street-oriented brand, which found itself catapulted into the unfamiliar world of high fashion.

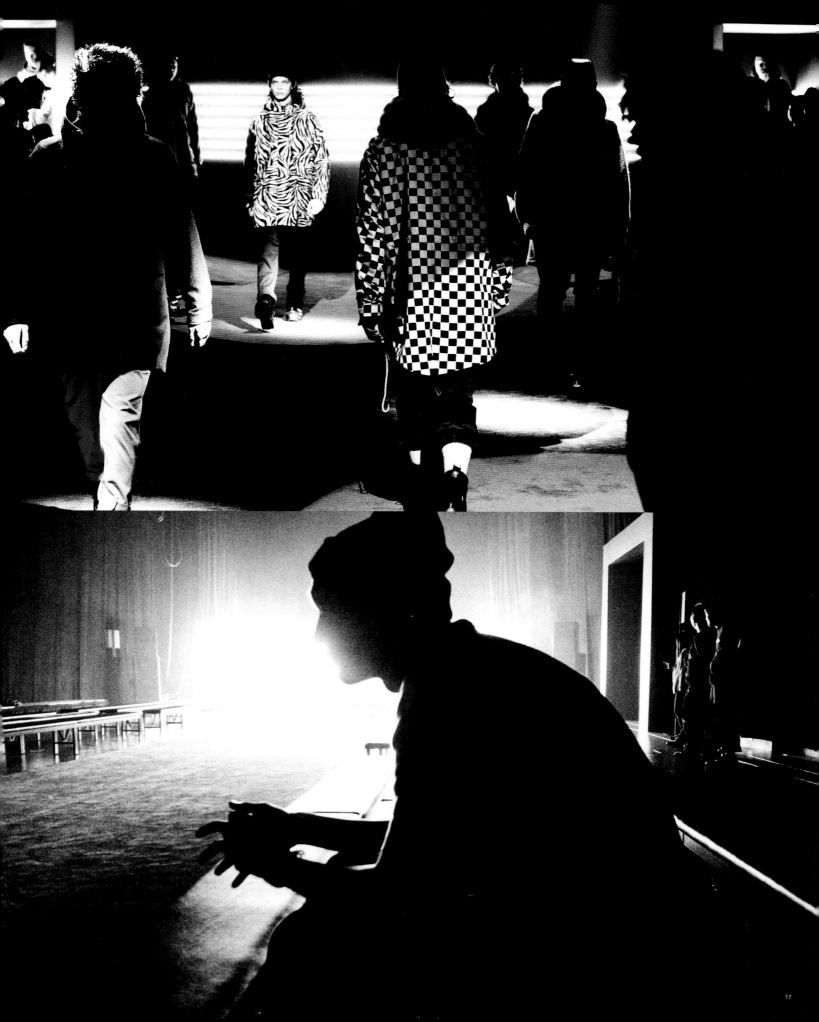

TOM PERFORMANCE

TRIBE OF WHIZ

TOKYO JAPAN

Hardcor

WAR
IS
OVER!

IF YOU WANT IT

Happy Christmas from John & Yoko

GOODENOUG

A prized collection of art pieces by originators 90s Ura-Harajuku culture including works by Goodenough and Kozik; a collaborative poster featuring WHIZLIMITED, Stüssy, M&M and 7 Stars Design; and, an Ukiyoe painting by Sneakerwolf. Shot at WHIZ TOKYO.

who fulfilled Shitano's dream of having an interior by M&M Custom Performance when the Lump shop relocated in 2010; and Yuichi Yoshii, who opened the doors for WHIZLIMITED to enter the world of runway shows.

At the exhibition in Paris, Shitano had the opportunity to present WHIZLIMITED's collection to overseas buyers and connect to people within the global fashion network. Looking back, he says "Buyers from all over the world come to Paris Fashion Week, and it seemed to me that compared to Japan, people there were more receptive to individuality from brands. At the same time, exhibiting in Paris didn't lead to a sudden increase in orders from overseas. It was just as well, because we have so few staff that we would have just been overwhelmed." Shitano went on to explain that exhibiting in Paris was never intended as a means of expanding the brand. The fact that WHIZLIMITED had basically operated as an independent brand and shop with only three full-time staff for the past ten years was the best proof of his worldview.

And it is this small group of like-minded collaborators and fellow travelers who subscribe to Shitano's fleet-footed management philosophy that have kept WHIZLIMITED true to its origins. Of course, the footprint is lighter in an organization where each person can take responsibility for multitasking rather than sharing the work with a large number of staff. According to Shitano, "Being a member of the shop's staff myself, I have the opportunity to serve customers at the store from time to time, and it's especially times like that when I'm directly interacting with people, that the importance of staying connected with our fans really hits home." That's why WHIZLIMITED emphasizes face-to-face sales, and online sales are limited to its homepage and some channels of Zozotown. WHIZLIMITED has also made a point of never conducting clearance sales or offering its products in the gray market at a discount. Without being bound by the conventions of the Japanese apparel industry, it's Shitano's highly personal approach to brand management that has carved out a unique presence for WHIZLIMITED.

Launched in an era when the tendency for street fashion around the world—including in Tokyo—was leaning toward more standardization, WHIZLIMITED dared to express Tokyo's street culture through design-conscious manufacturing. In 2020, Shitano celebrated the twentieth anniversary of the brand's founding, and despite being hit by a global pandemic, he still carries out his own approach to creativity in much the same way he always has. When asked about his vision for the future, he bashfully replies: "I'm kind of at a loss for an answer. I've never given much thought to future objectives. On the other hand, I don't regret anything in the past, and I'm always satisfied living in the present. So I don't have a future vision, as such."

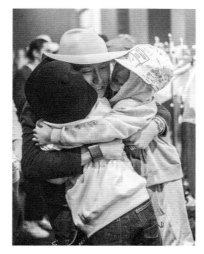

Shitano's sons giving him a hug backstage after they had performed as models at a runway show. A glimpse of Shitano's life as both a creator and a family man.

Nobukazu Kishi
Japanese fashion journalist Kishi started his writing career in 1993 with *Boon*, a magazine that defined Tokyo's street fashion throughout the late '80s to '00s. He is best known for his trend-setting features on sneakers, especially on the legendary Airmax series, and is regarded as one of the foremost experts on the subject in Japan. He is currently active as a freelance editor and curator of all things related to street culture.

A collage of memories from WHIZLIMITED's humble beginnings. At a time when it was still fairly uncommon for street brands to create look books, Shitano and his team got together and photographed each other in items from the 2000AW collection created shortly after WHIZ's debut.

2000 AW season	"MOVE"
2001 SS season	"WE HAVE IDEAL ZONES."
2001 AW season	"THE EDGE"
2002 SS season	"ROOM"
2002 AW season	"MAKE-BELIEVE"
2003 SS season	"ADAPT"
2003 AW season	"WHICH WAY AM I FROM...WHERE AM I HEADING AT?"
2004 SS season	"PURSUIT"
2004 AW season	"RULER"
2005 SS season	"LAST SUPPER"
2005 AW season	"TRANSPECZ"
2006 SS season	"NOWORNEVER"
2006 AW season	"SATISFUNCTION"
2007 SS season	"COLORS"
2007 AW season	"BORDER"
2008 SS season	"MINOR THREAT"
2008 AW season	"MIGRATION"
2009 SS season	"THE CHOICE IS YOURS"
2009 AW season	"BARTER TOWN"
2010 SS season	"WORKING CLASS HERO"
2010 AW season	"CURTAIN CALL"

2011 SS season	"FREAXZ"
2011 AW season	"WILDERNESS"
2012 SS season	"UNITED"
2012 AW season	"LOST"
2013 SS season	"OFF CITY"
2013 AW season	"LUST FOR LIFE"
2014 SS season	"ODELAY"
2014 AW season	"NO CODE"
2015 SS season	"RECOGNIZE"
2015 AW season	"RIGHT HERE"
2016 SS season	"ALTERNATIVE"
2016 AW season	"OUT OF THE BOX"
2017 SS season	"RIN"
2017 AW season	"URBAN TECH"
2018 SS season	"SHADOWS OF THE EMPIRE"
2018 AW season	"WHIZ SPORT"
2019 SS season	"SCREEN"
2019 AW season	"TOUGH-TECH"
2020 SS season	"RAVE"
2020 AW season	"WILL"
2021 SS season	"NEO"
2021 AW season	"DAYS"

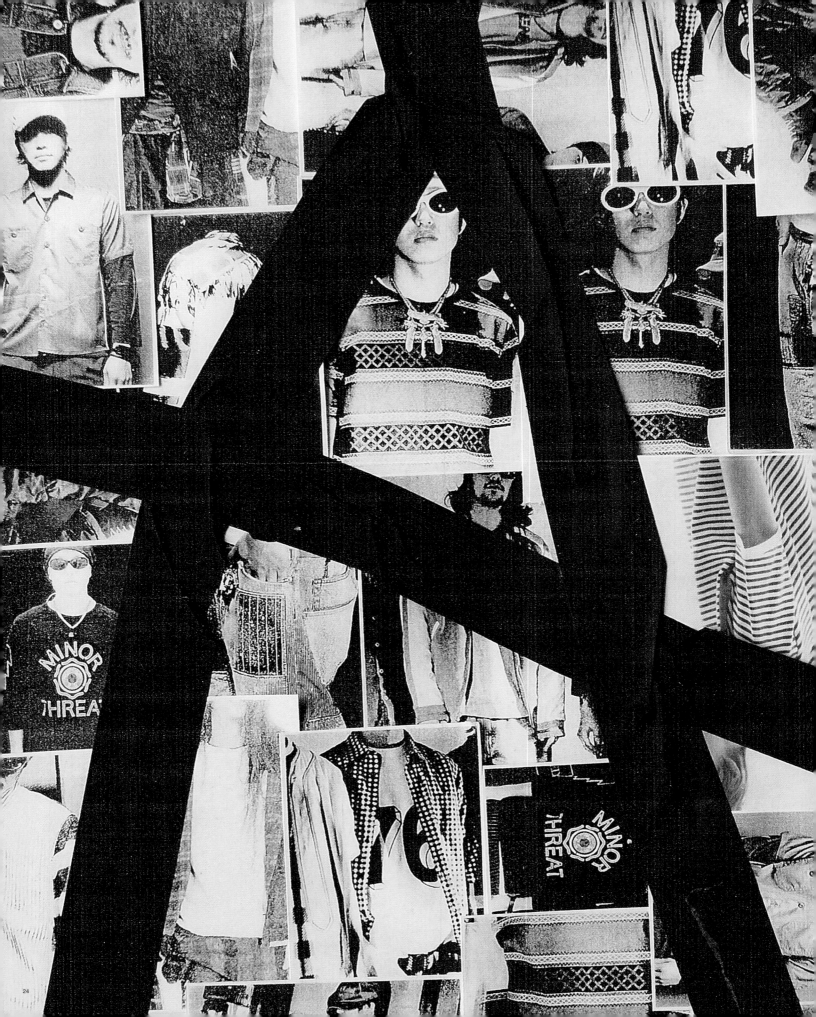

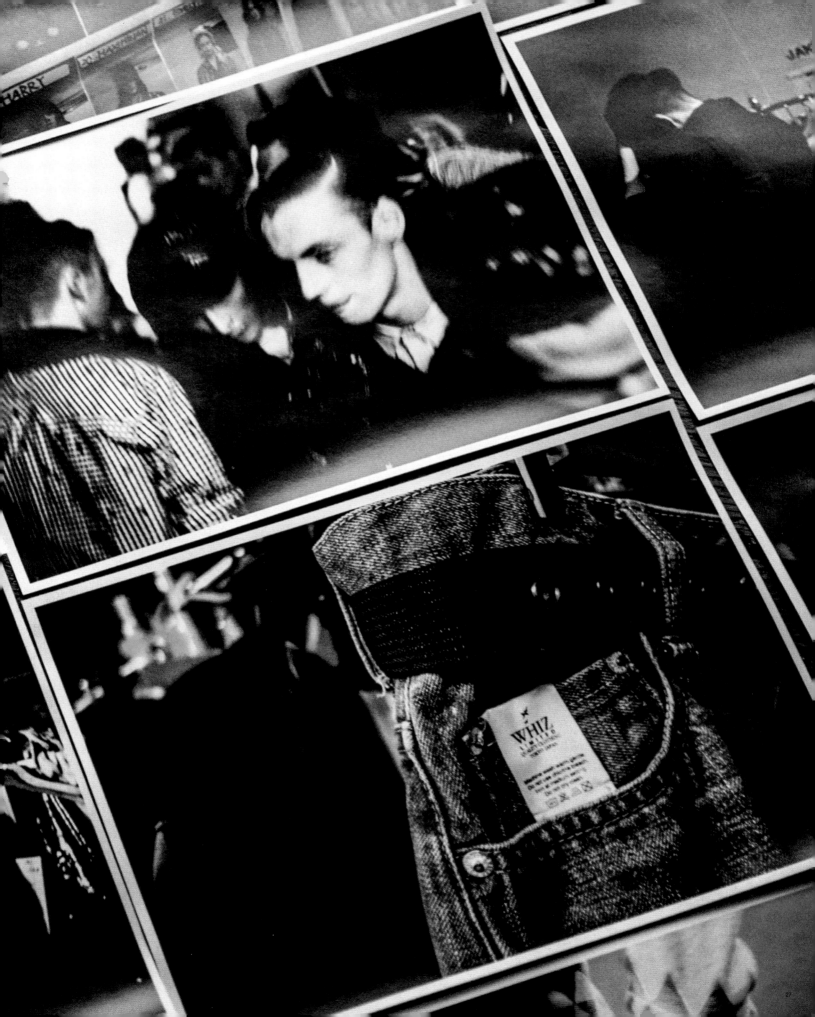

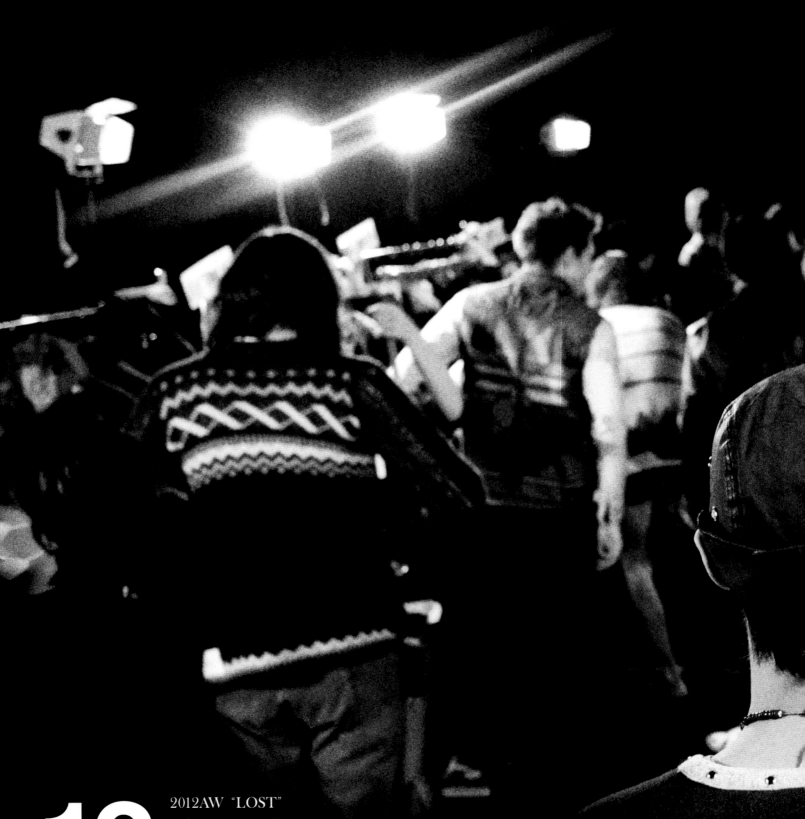

12 2012AW "LOST"

This collection was an attempt to express the yearning for feelings and things that can be unconsciously lost over time. During a winter family trip to the sea, Shitano was struck by the incongruousness of his children playing barefoot by the waves in the middle of December, and he was inspired to showcase the Autumn/Winter collection in a space resembling a sandy beach. A total of 8 tons of sand was laid over the runway, and the models appeared sporting shorts under winter outer wear. Some were even barefoot. The textiles featured in this season were original camouflage prints created from aerial photographs. Overall, the collection was characterized by the use of relatively light and soft fabrics—even for the outer wear—with the intention that the items be worn in multiple layers.

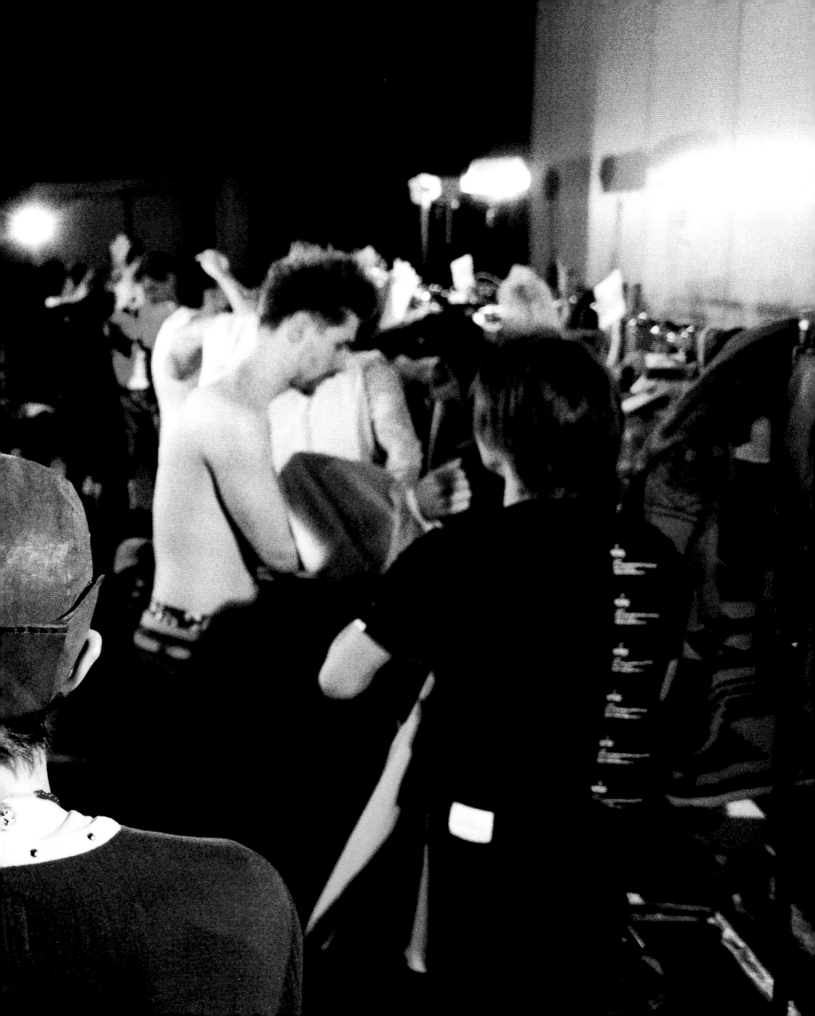

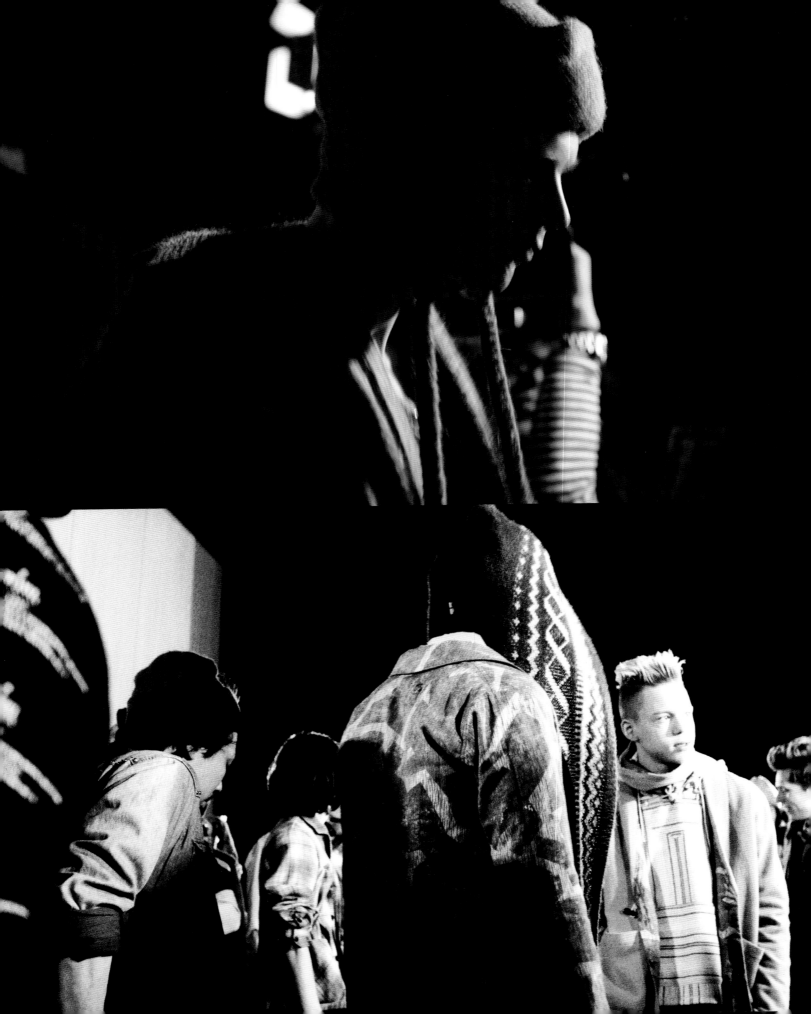

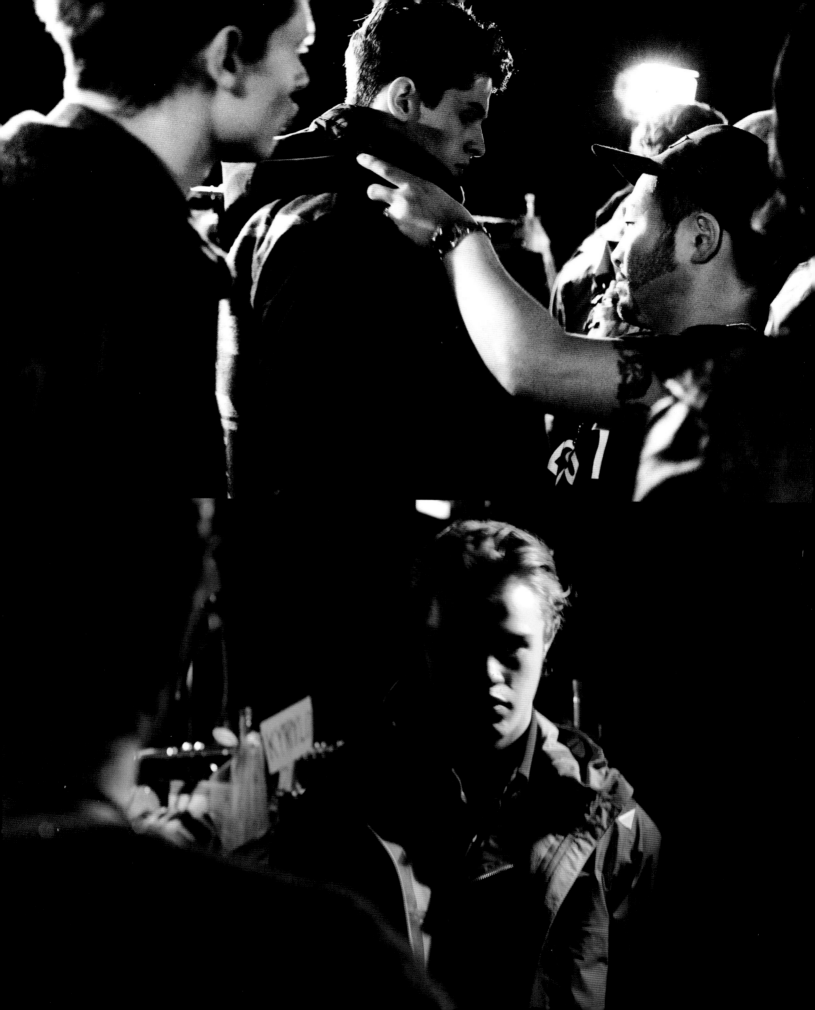

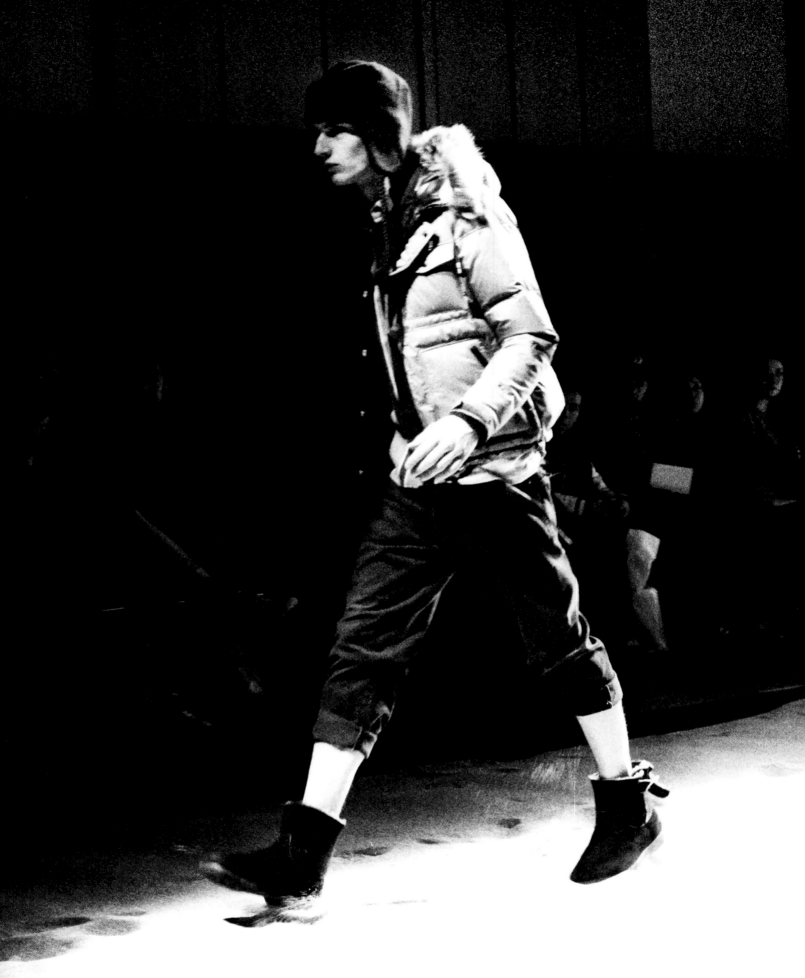

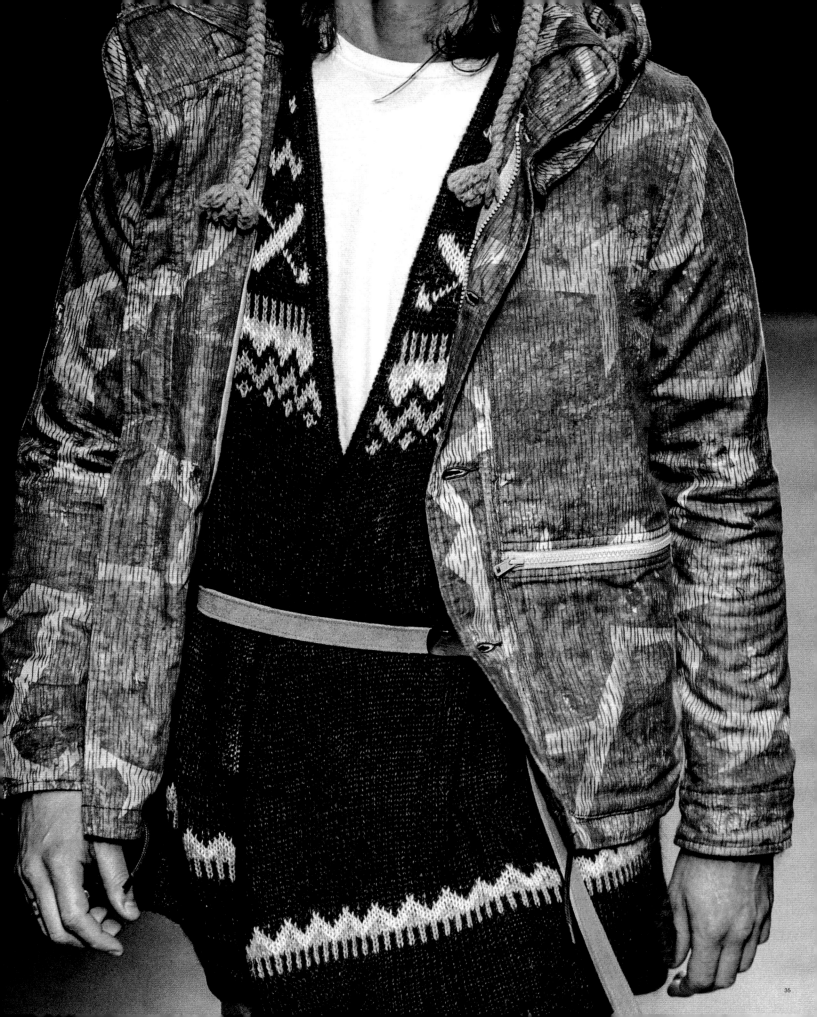

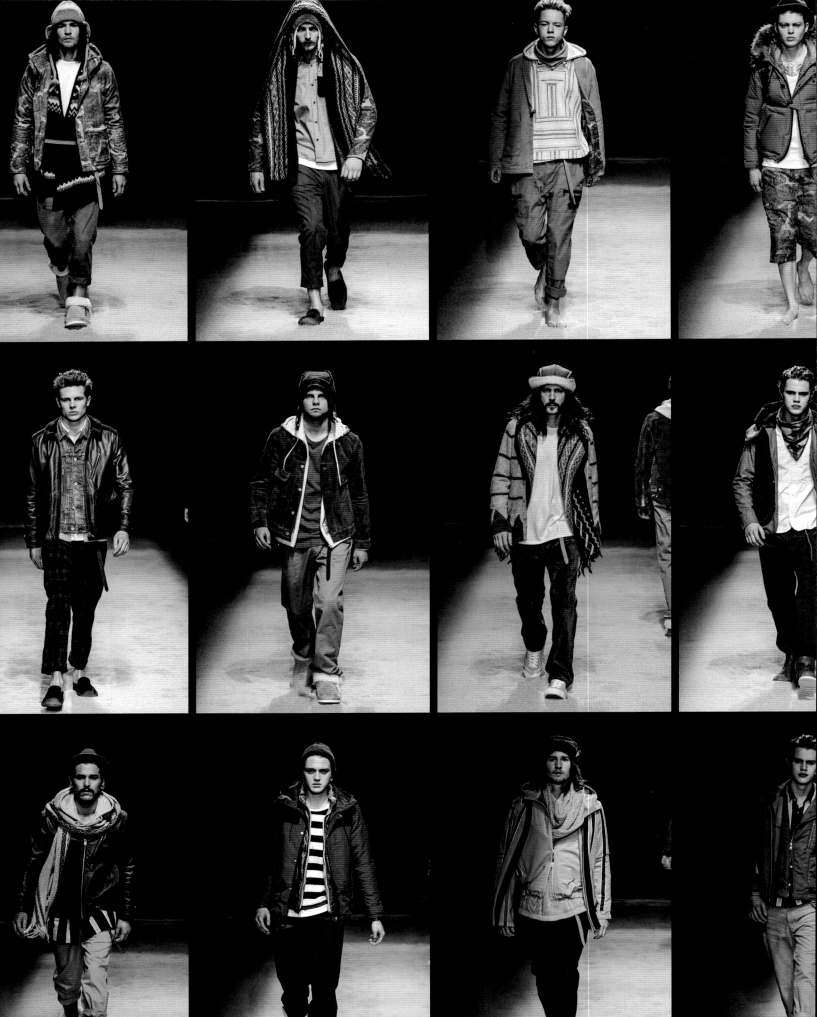

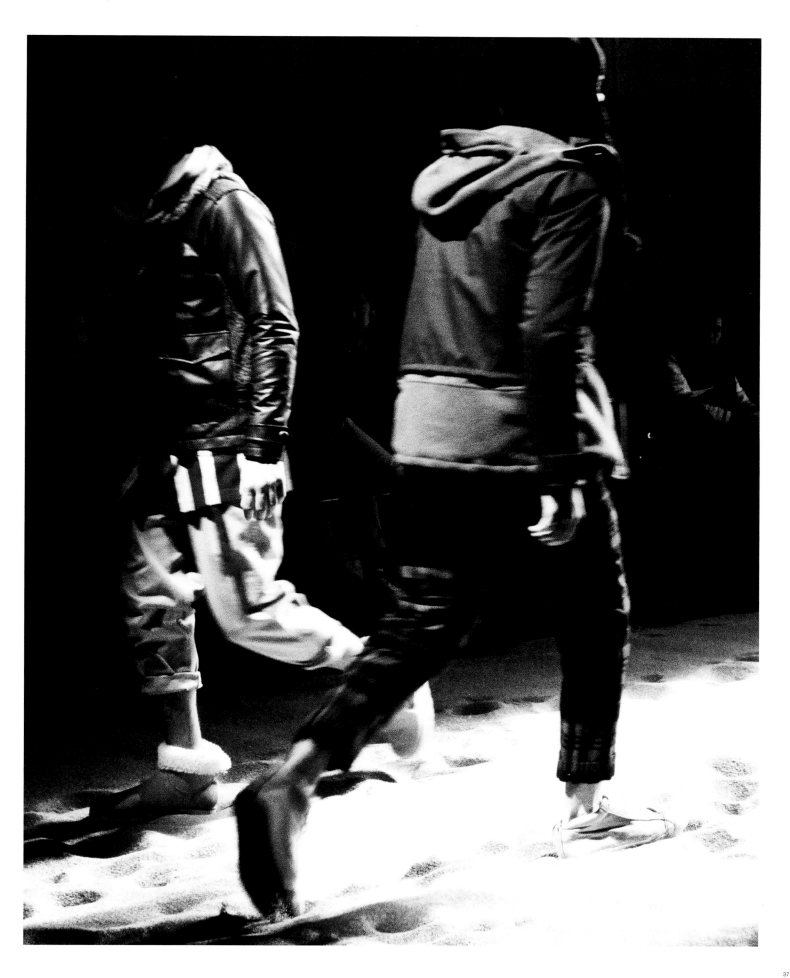

WHIZLIMITED 2012 AUTUMN / WINTER COLLECTION "LOST." At Tokyo Midtown Hall A. March 20, 2012. Mercedes-Benz Fashion Week Tokyo
Designer / Hiroaki Shitano. Show director / Takashiro Saito (KuRoKo inc). Stylist / Lambda Takahashi (Shirayama Office). Show stylist / Yumiko Ito
Hair and Make-up / Masanori Kobayashi (SHIMA). Backstage Photographer / Kabo. Casting / Bobbie (HYPE). Music / Shogo Soejima. PR / 4K

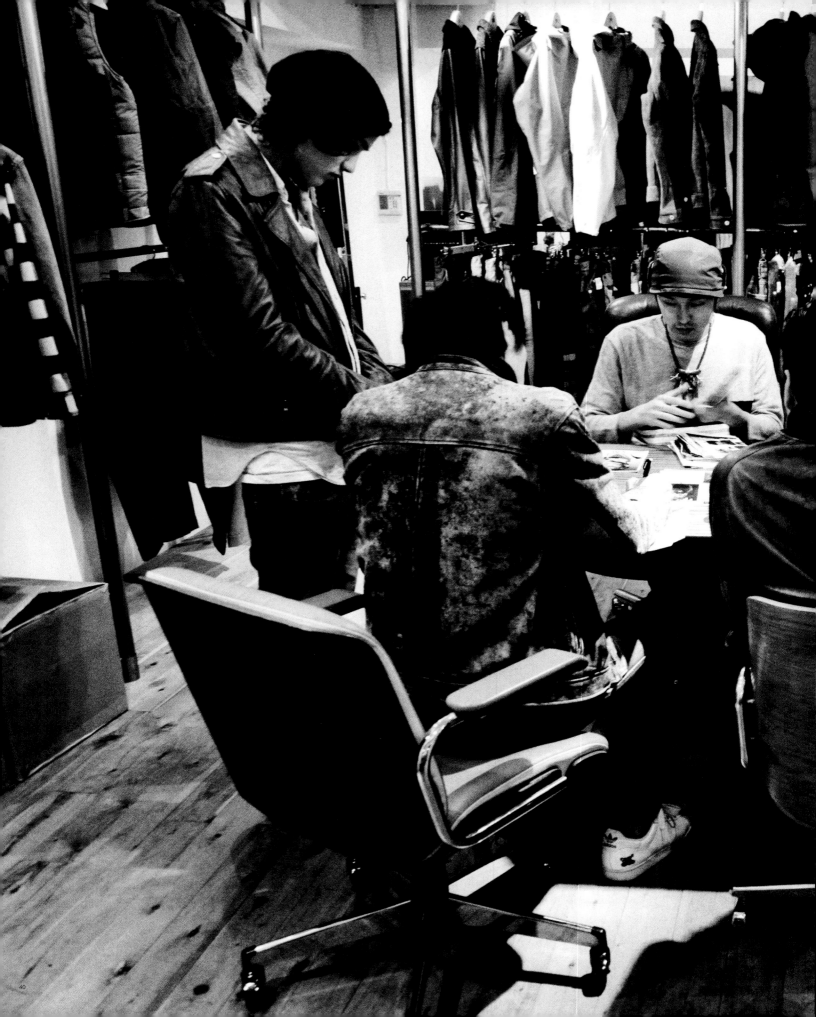

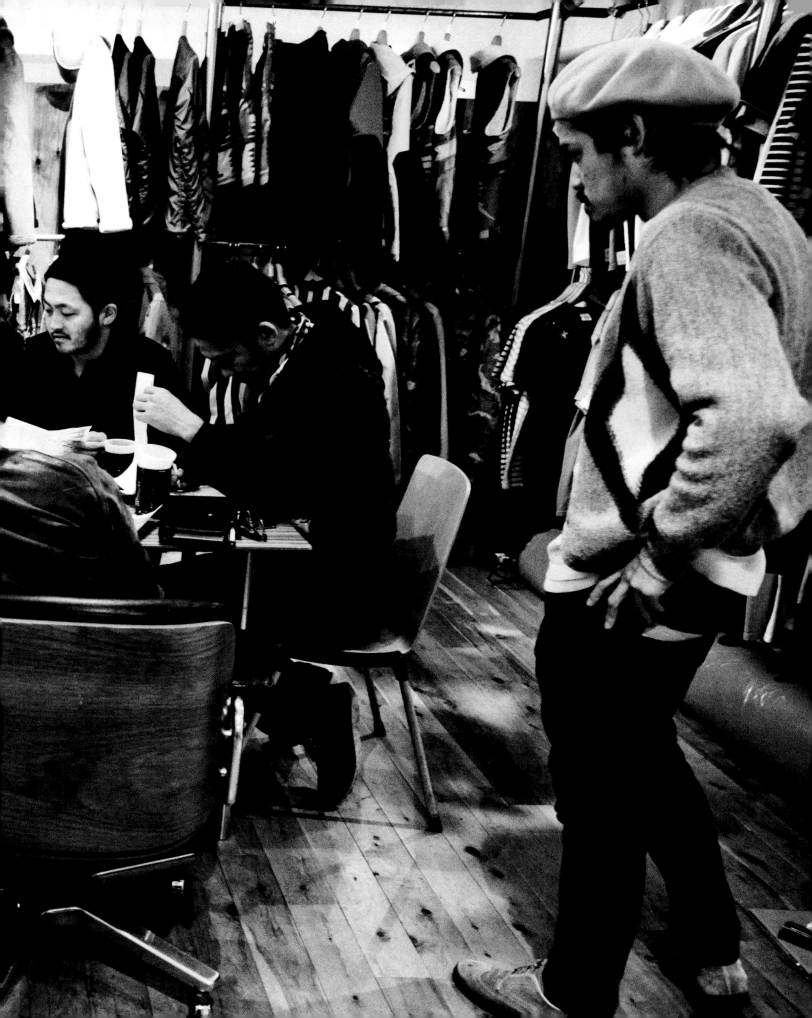

02

2002AW "MAKE-BELIEVE"

For WHIZLIMITED's fifth season after its inception, the brand showcased its collection in a promo video format for the first time. Among Tokyo-based brands, WHIZLIMITED was perhaps one of the pioneers in making use of this format. In this collection, the brand attempted to bring a luxury element to street wear with items such as outer wear with detachable furs and accessories inspired by precious stones.

03

"WHICH WAY AM I FROM...WHERE AM I HEADING AT?"

A promo video filmed in a traditional Japanese thatched-roof house. The Native American–inspired blanket on the shoulders of the models sitting around the fireplace are WHIZLIMITED original designs. Denim and corduroy apparel formed the core of the lineup while accessories like chaps, a deerskin bag, and a concho belt further complemented this reimagining of the Wild West with an offbeat urban Tokyoite sensibility.

03

2003SS "ADAPT"

The signature textile used in this collection featured an original pattern titled *Blade Leaf*, which was made up of tiger stripes and aloha patterns—elements that appear at odds with one another on their own but which created a subtle but distinctive visual aesthetic when combined. Jackets, shirts, pants, sneakers, towels, and caps were completely covered with the *Blade Leaf* pattern. The collection even included similarly adorned bikes and skateboards.

15

2015AW "RIGHT HERE"

The runway show organized to mark the 15th anniversary of WHIZLIMITED showcased combinations of archival items spanning the entirety of the brand's existence, demonstrating that products from past collections could withstand the test of time. After the archive segment, the screen displayed footage showcasing the themes of every season from the prior 15 years. This was immediately followed by a cacophony of sound as models wearing headgear and boxing gloves from the brand's latest collection burst onto the runway, then left just as abruptly. Many among the audience later said they thought this signified that WHIZLIMITED would be taking a hiatus.

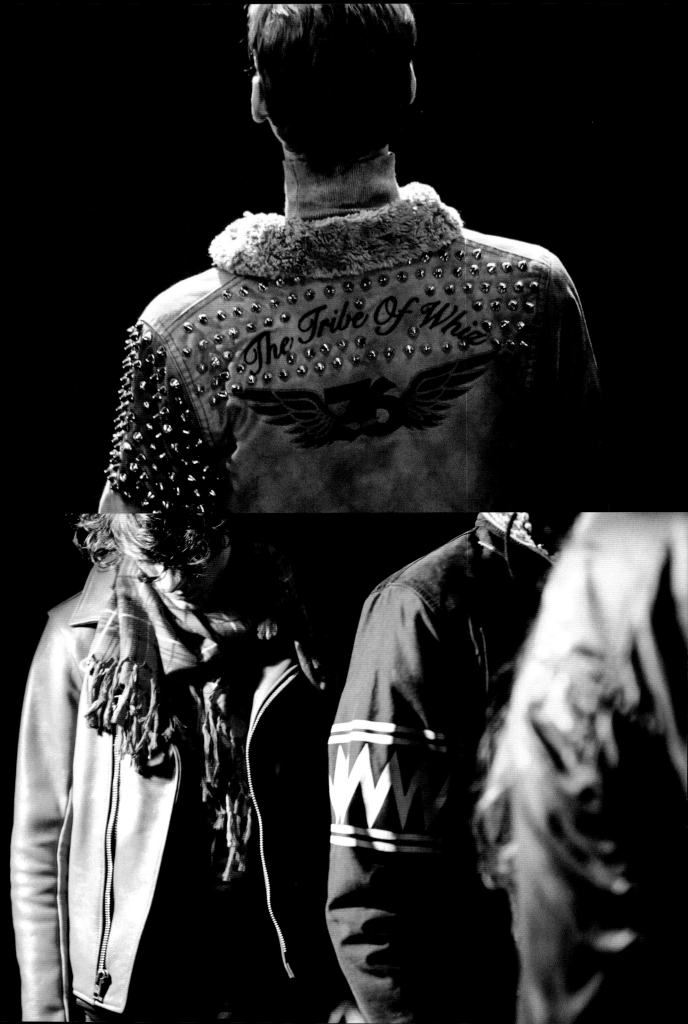

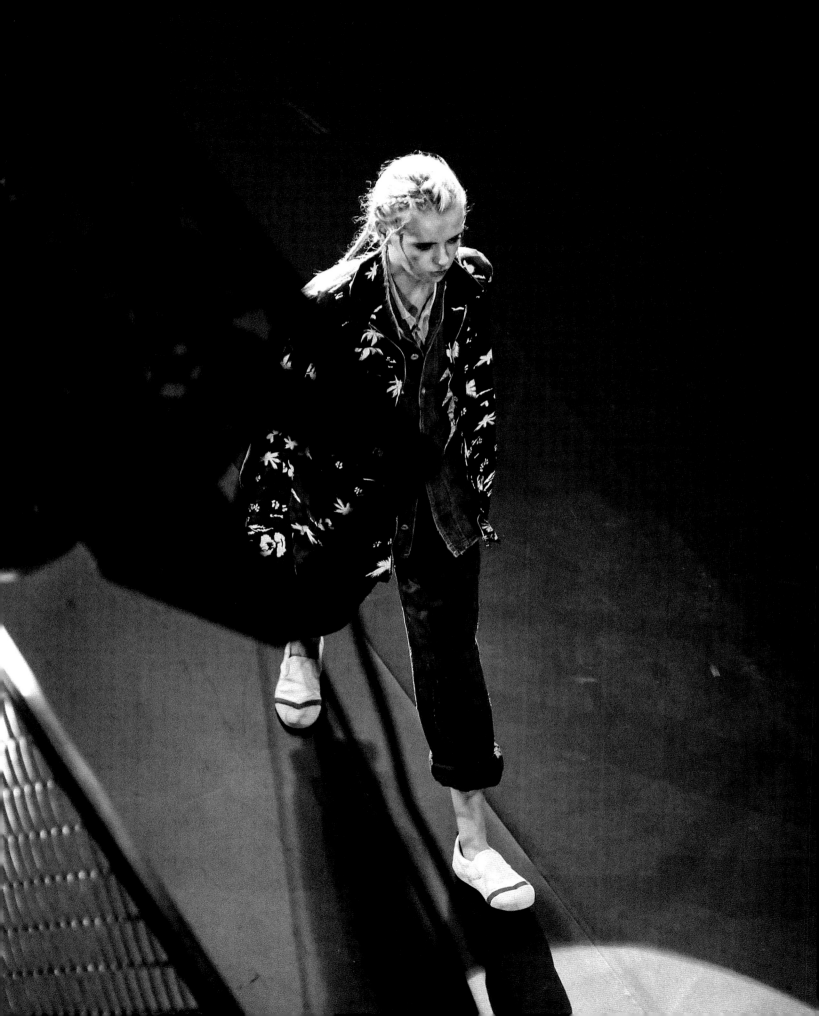

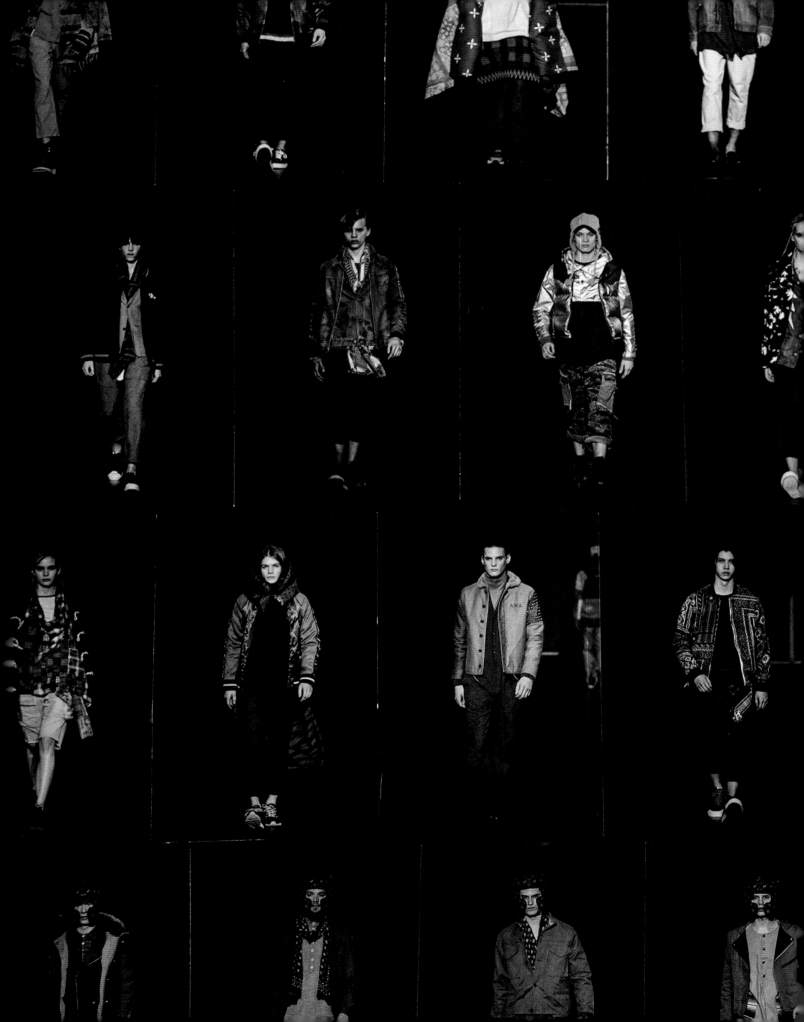

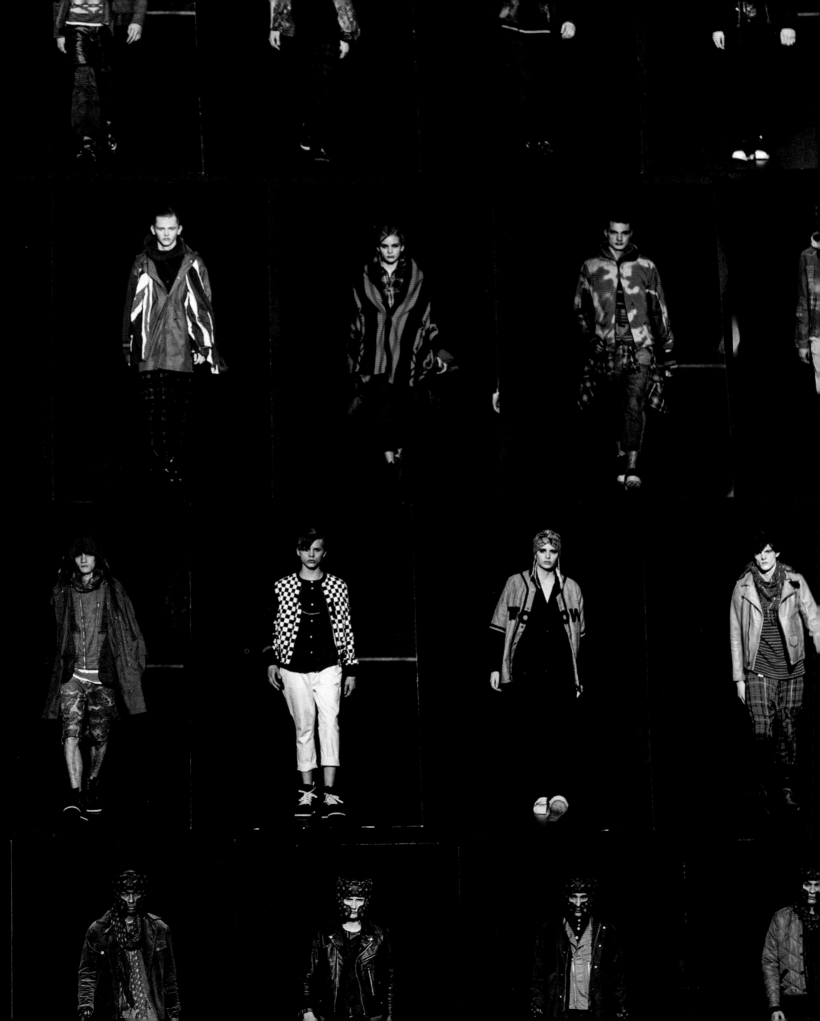

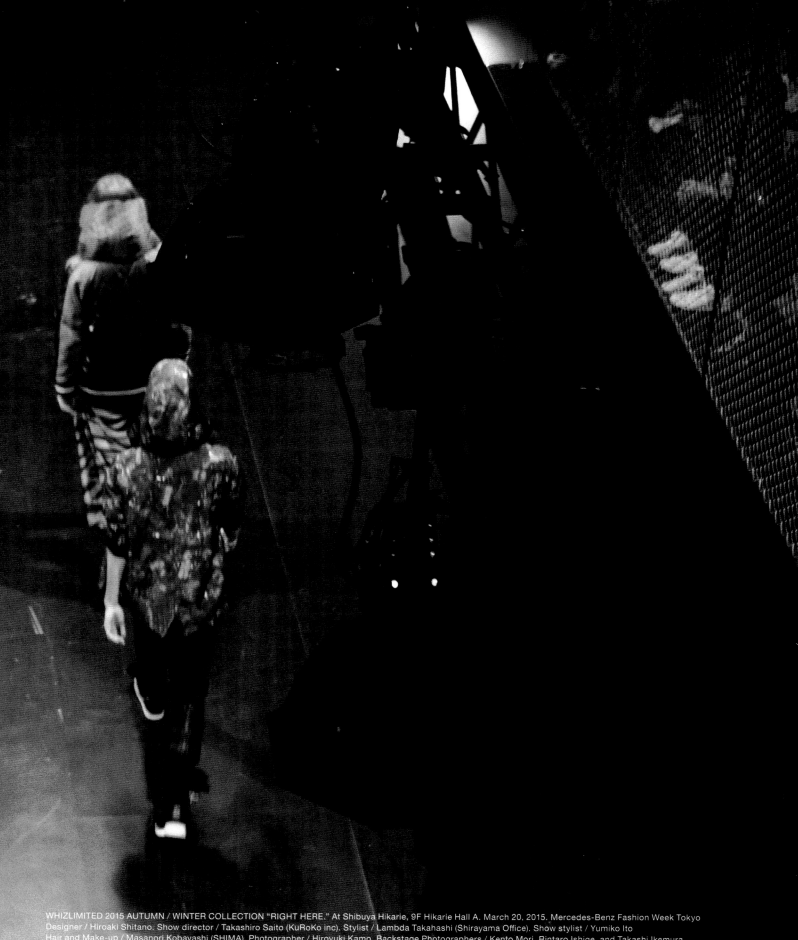

WHIZLIMITED 2015 AUTUMN / WINTER COLLECTION "RIGHT HERE." At Shibuya Hikarie, 9F Hikarie Hall A. March 20, 2015. Mercedes-Benz Fashion Week Tokyo
Designer / Hiroaki Shitano. Show director / Takashiro Saito (KuRoKo inc). Stylist / Lambda Takahashi (Shirayama Office). Show stylist / Yumiko Ito
Hair and Make-up / Masanori Kobayashi (SHIMA). Photographer / Hiroyuki Kamo. Backstage Photographers / Kento Mori, Rintaro Ishige, and Takashi Ikemura
Casting / Bobbie (HYPE). Music / Shogo Soejima. PR / 4K

THERMOTRON

REFLECTOR

06

2006AW "SATISFUNCTION"

The theme for this season was "SATISFUNCTION", an amalgam of "satisfaction" and "function". While high-performance materials with features like water resistance and breathability have been gaining wider acceptance in casual wear, WHIZLIMITED felt it needed to go beyond pure functionality. The brand's mission has always been to create technologically superior apparel for an urban environment.

SATISFUNCTION

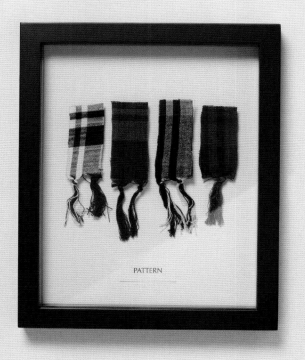

PATTERN

2007AW "BORDER"

A collection that explored the concept of "borders" or boundaries in apparel design. One item was a long coat that could be split with a zipper to be worn as a short coat. Other designs split individual items and connected them to one another. There were also a variety of items characterized by their ability to drastically change their functionality depending on the environment. WHIZLIMITED described the approach it used as "1+1=1 and 0.7+0.3=1".

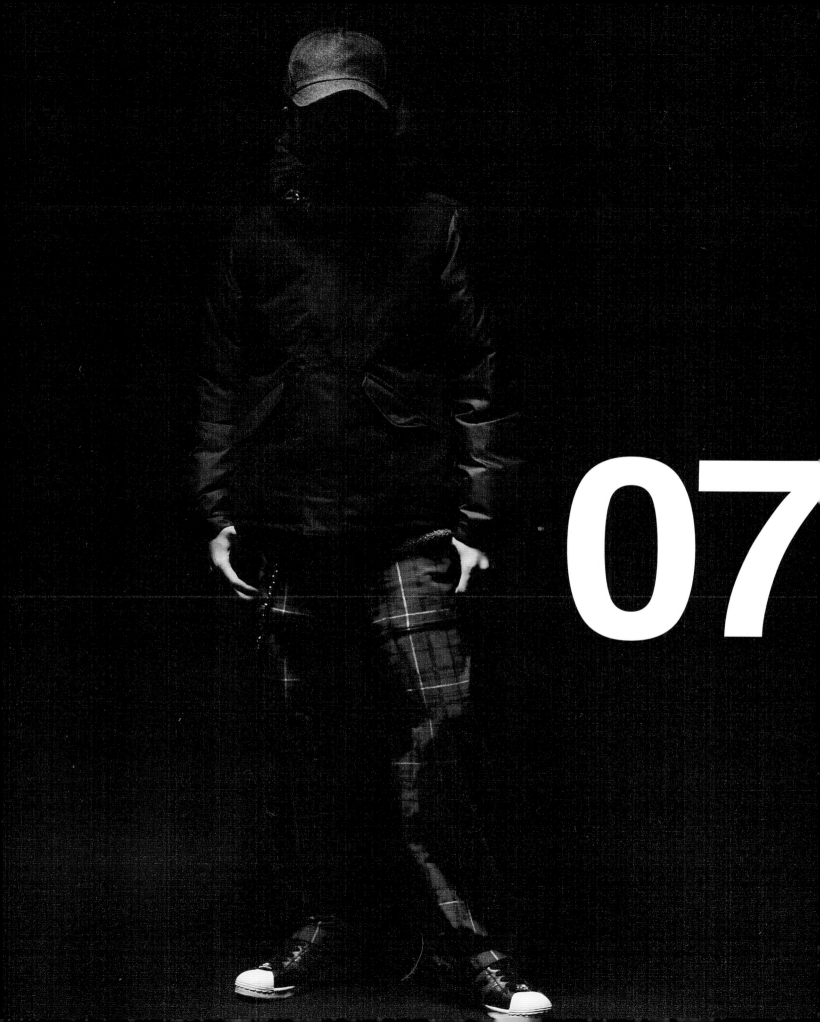

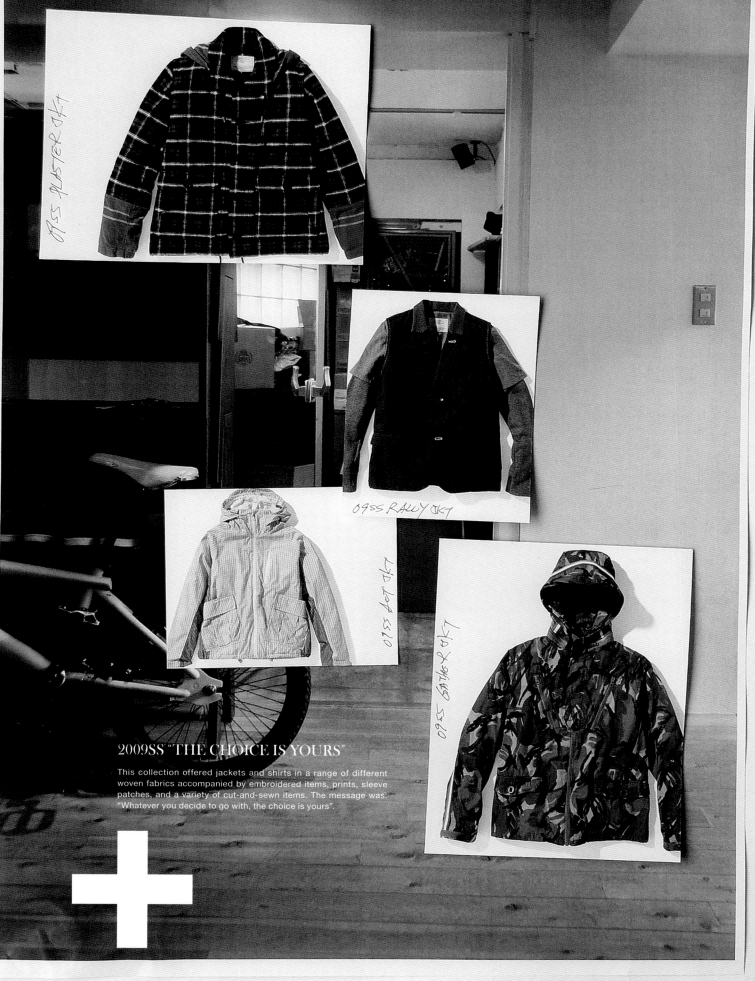

09SS PLASTER JKT

09SS RALLY JKT

09SS AOP JKT

09SS COATING JKT

2009SS "THE CHOICE IS YOURS"

This collection offered jackets and shirts in a range of different woven fabrics accompanied by embroidered items, prints, sleeve patches, and a variety of cut-and-sewn items. The message was: "Whatever you decide to go with, the choice is yours".

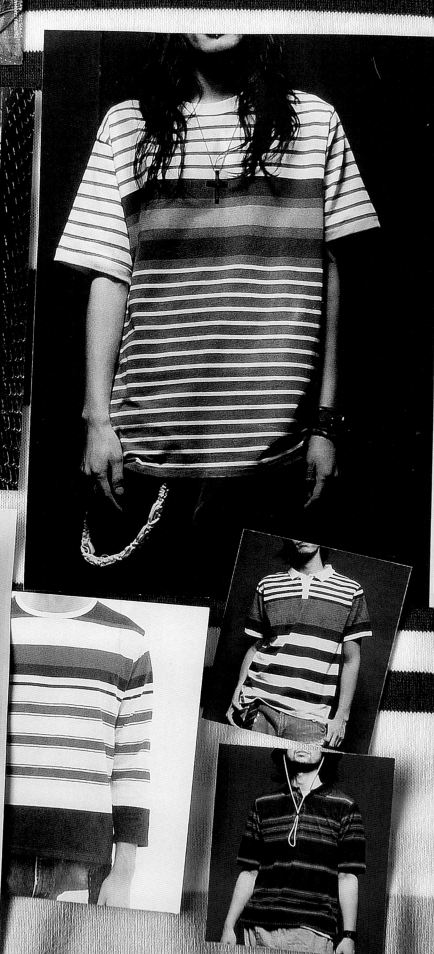

際立つパネルボーダーの魅力

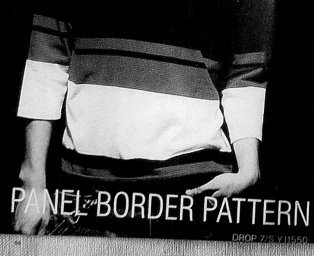

PANEL BORDER PATTERN

DROP 7/S ¥11550

10

2010AW "CURTAIN CALL"

2010 marked the 10th anniversary of WHIZLIMITED's establishment, and the AW collection was intended as an expression of gratitude to all the fans who had supported the brand up to that point. Archive items from the previous 10 years were spontaneously redesigned, giving new life to what seemed familiar.

PATTERN SHIRTS

素が色濃く反映されていますね。右の
チェック柄だし、左のマウンテンパーカ
デージパンツも展開しています

FELICI

PHASE

CK STAR SHIRTS ¥19950, CORD ARCT

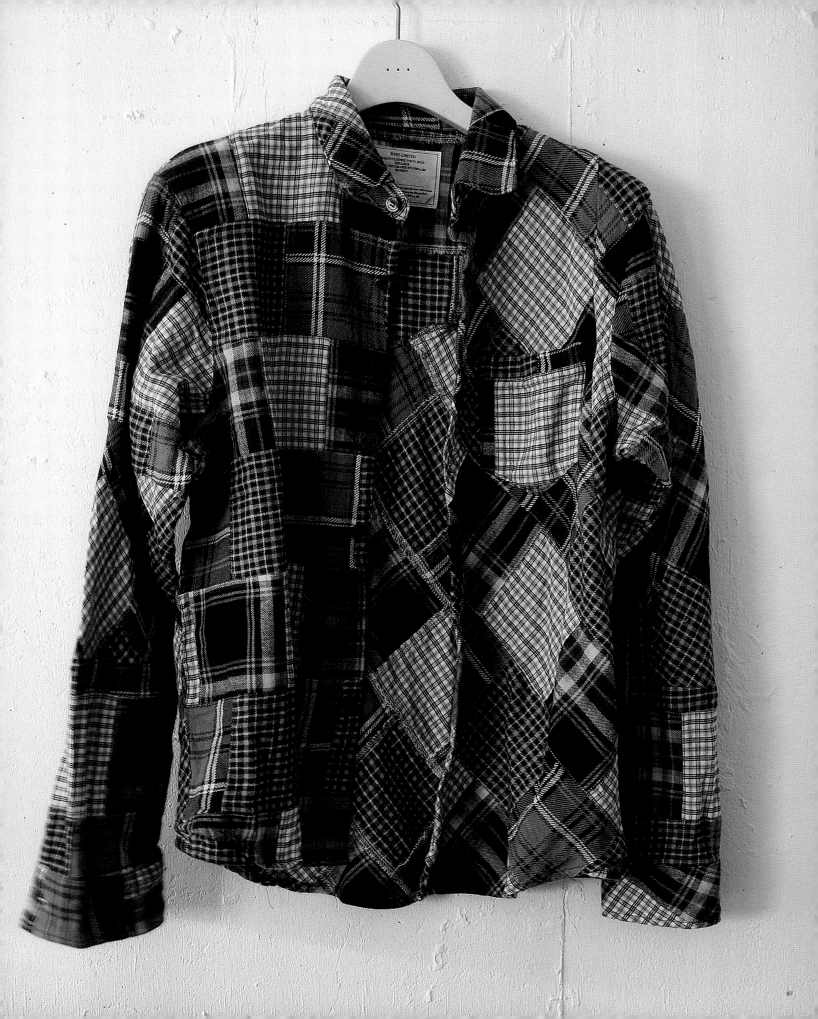

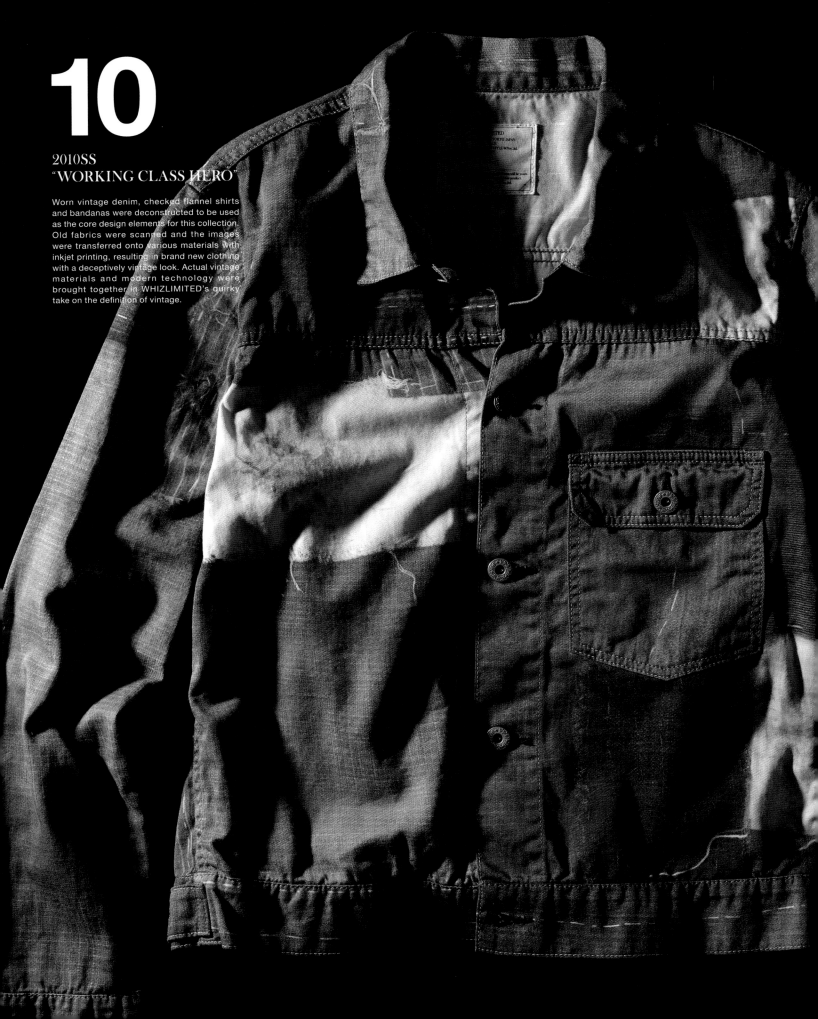

10

2010SS
"WORKING CLASS HERO"

Worn vintage denim, checked flannel shirts and bandanas were deconstructed to be used as the core design elements for this collection. Old fabrics were scanned and the images were transferred onto various materials with inkjet printing, resulting in brand new clothing with a deceptively vintage look. Actual vintage materials and modern technology were brought together in WHIZLIMITED's quirky take on the definition of vintage.

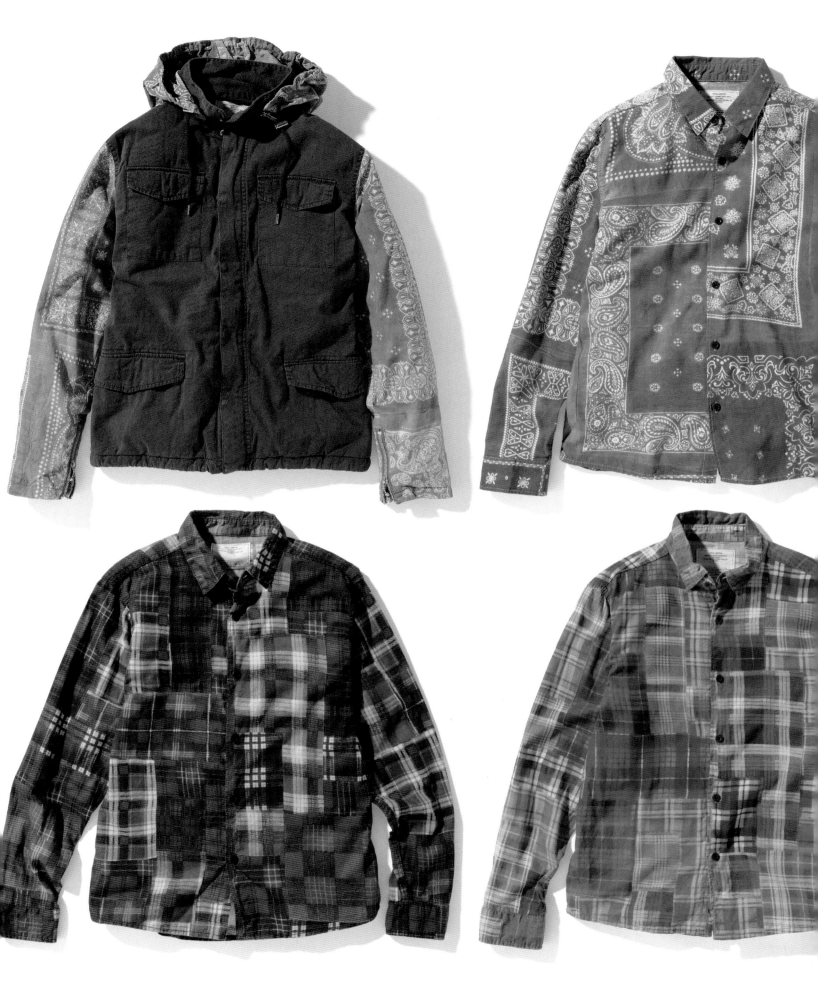

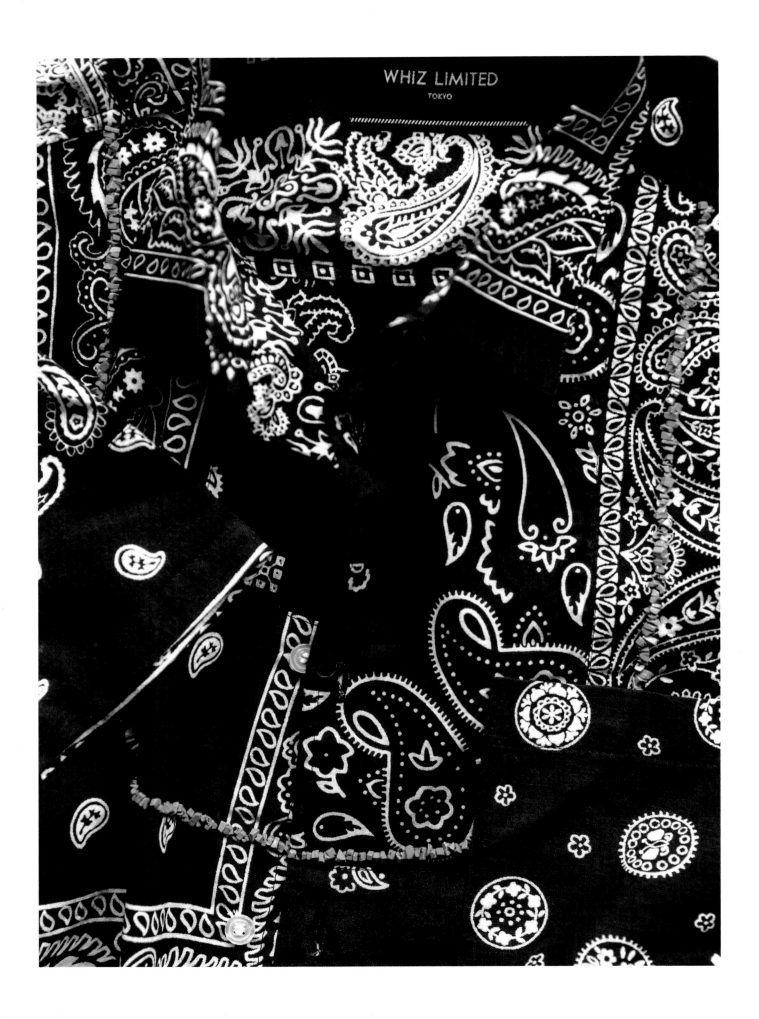

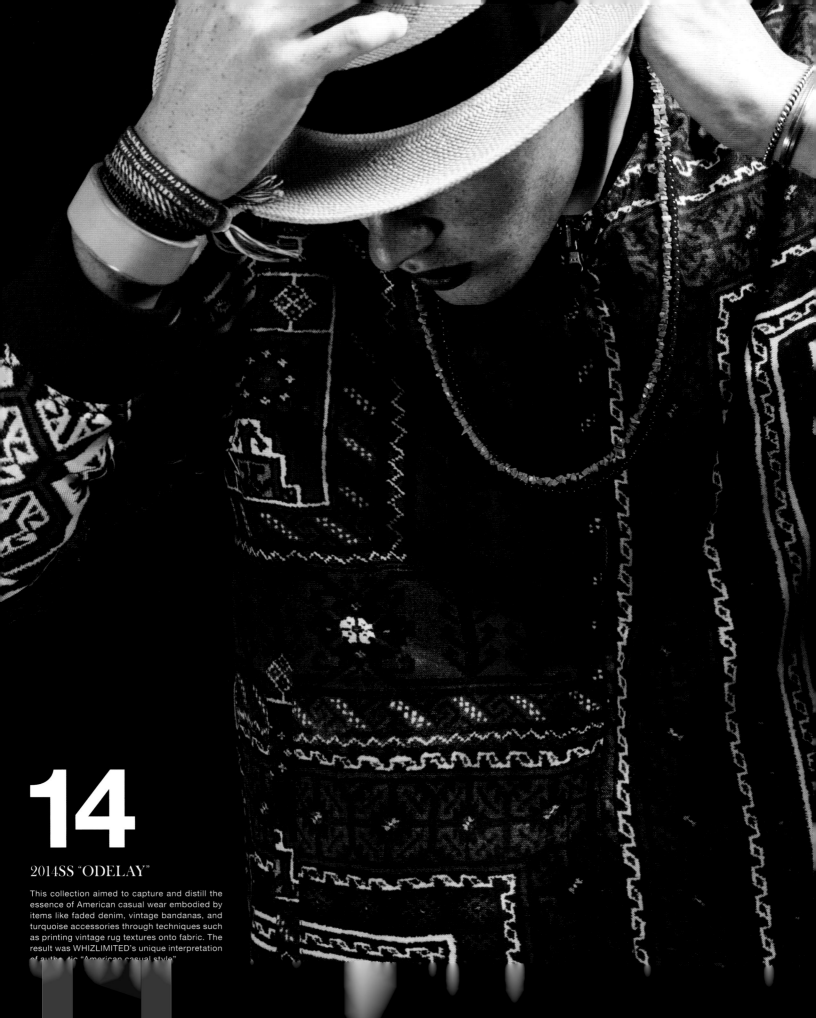

14

2014SS "ODELAY"

This collection aimed to capture and distill the essence of American casual wear embodied by items like faded denim, vintage bandanas, and turquoise accessories through techniques such as printing vintage rug textures onto fabric. The result was WHIZLIMITED's unique interpretation of authentic "American casual style".

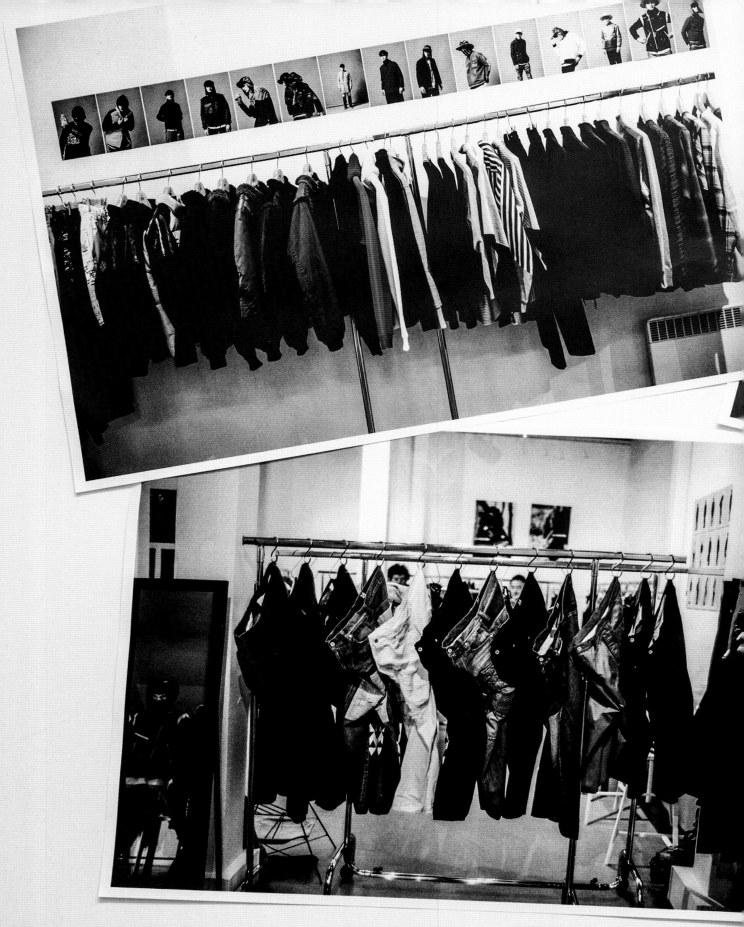

After receiving the Tokyo Fashion Award in 2016, WHIZLIMITED was invited to showcase its collections in the Marais district of Paris on a consecutive basis from 2016 AW to 2020 AW. The exhibitions in Paris placed WHIZLIMITED on the world stage and were a central platform for the brand until it was forced to forgo participation due to the ongoing COVID-19 pandemic.

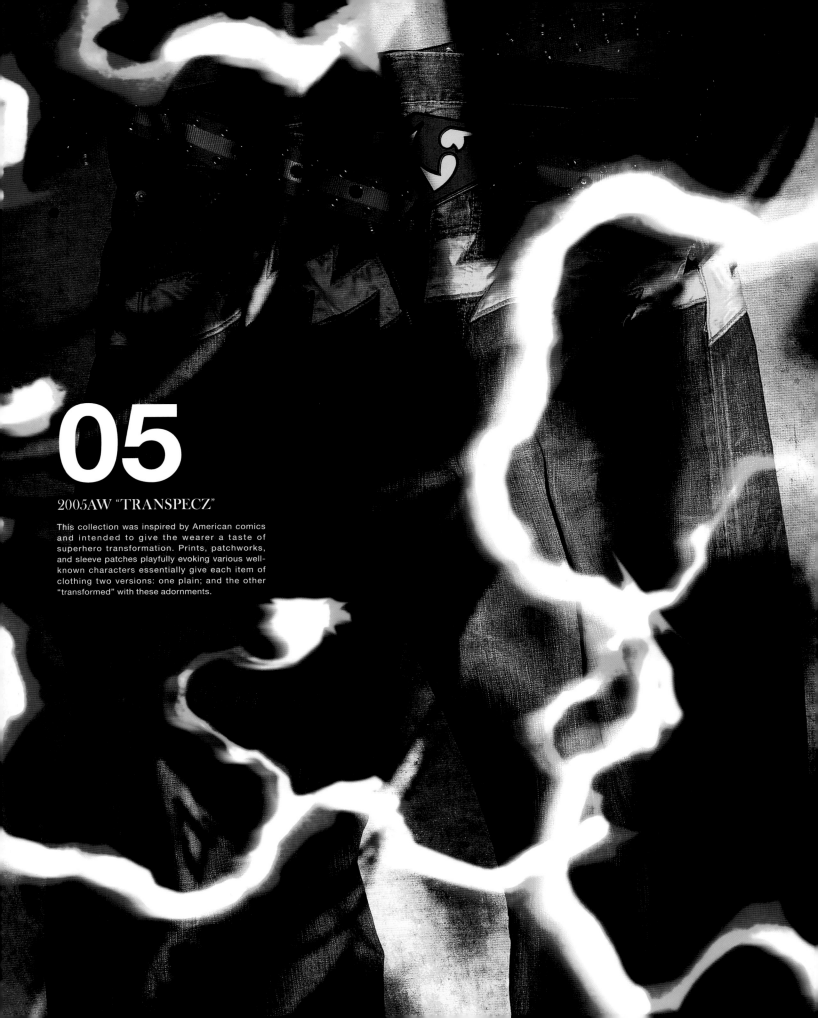

05

2005AW "TRANSPECZ"

This collection was inspired by American comics and intended to give the wearer a taste of superhero transformation. Prints, patchworks, and sleeve patches playfully evoking various well-known characters essentially give each item of clothing two versions: one plain; and the other "transformed" with these adornments.

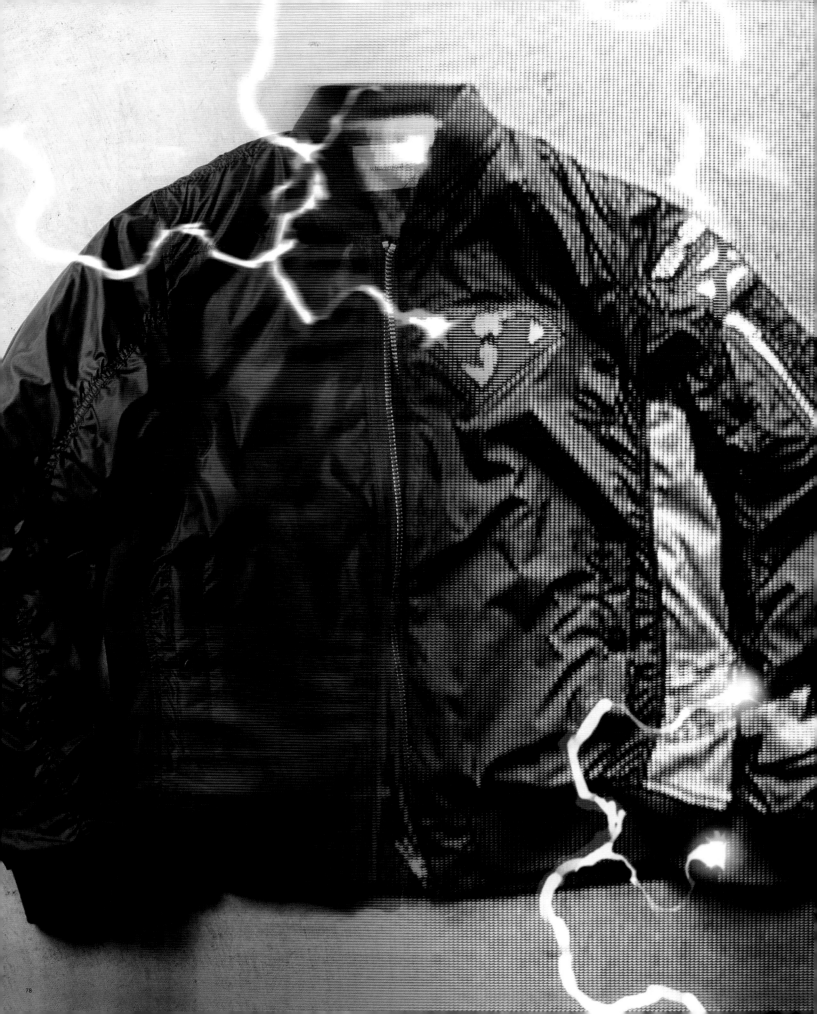

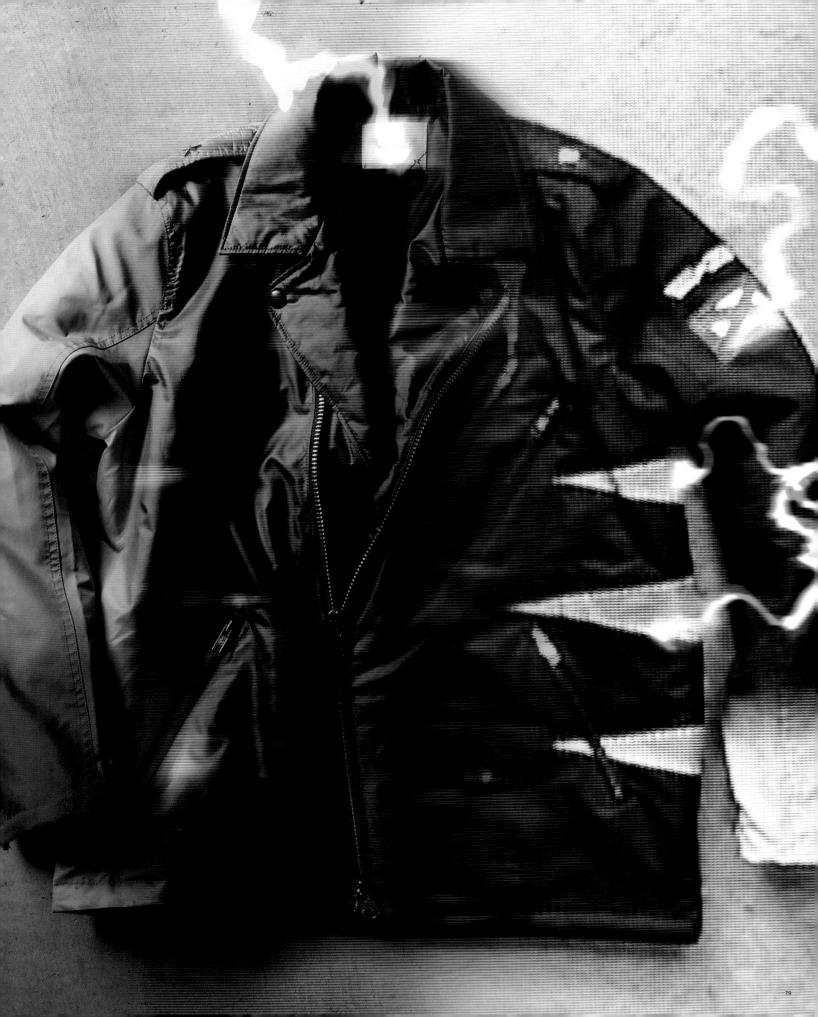

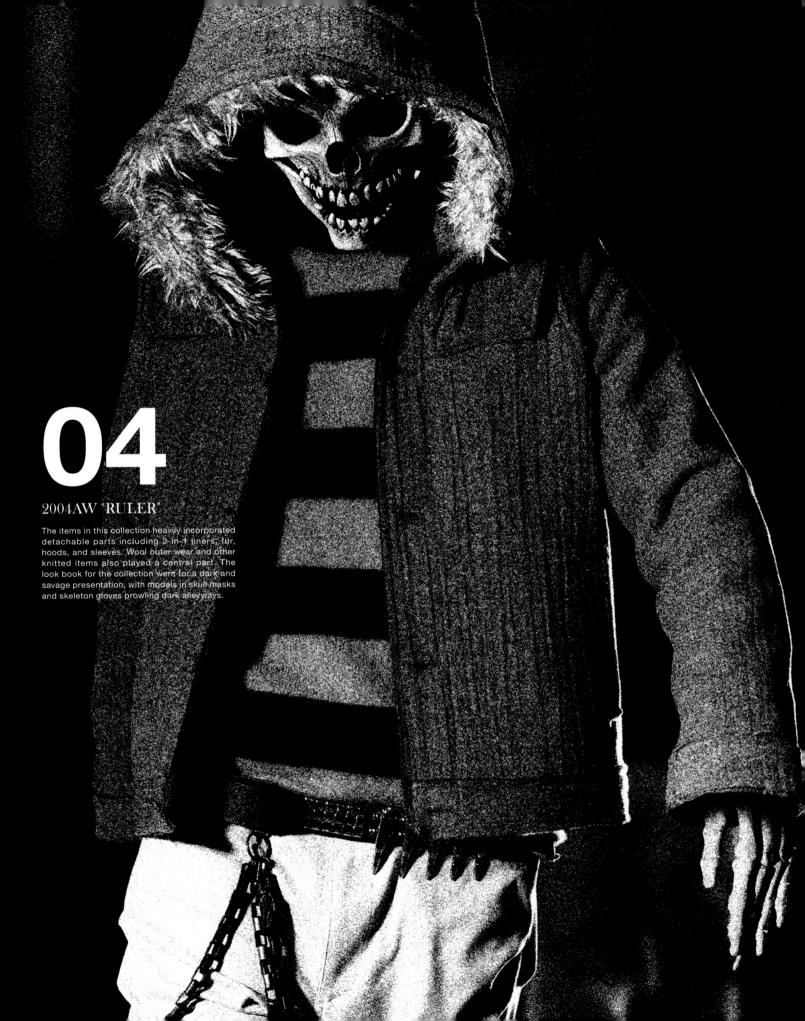

04

2004AW "RULER"

The items in this collection heavily incorporated detachable parts including 2-in-1 liners, fur, hoods, and sleeves. Wool outer wear and other knitted items also played a central part. The look book for the collection went for a dark and savage presentation, with models in skull masks and skeleton gloves prowling dark alleyways.

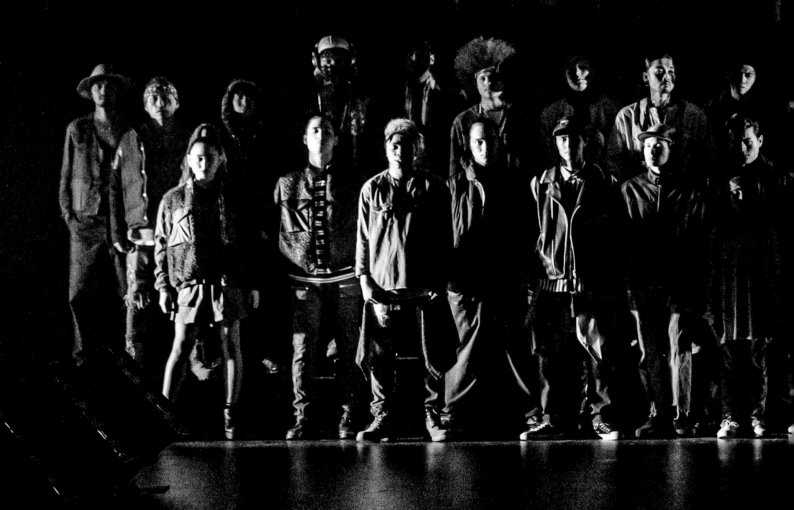

16

2016AW "STORY TO GENERATIONS"

A runway collection held to celebrate WHIZLIMITED receiving the Tokyo Fashion Award in 2016. The theme was titled "Story to Generations" to reflect the brand's desire to creative narratives that pass across generations. Not hired from agencies, the models were actually individuals making their lives on the streets, including rappers, musicians, dancers, skaters, BMX riders, and freestyle basketballers. To emphasize that WHIZLIMITED's products are for all generations, the models were also of varying age, with the oldest being over forty and the youngest—the designer's sons, in fact—were five and six years old. When the models were invited to the studio for fitting, they were asked to come in their own everyday attire so new items from WHIZLIMITED could be combined with their own clothing to achieve styling that was natural and realistic. This stemmed from the designer's wish to respect the way each model dressed and walked out on the street. As the curtains parted to announce the beginning of the runway show, all the models appeared simultaneously and began to walk freely, each to their own rhythm, to replicate the reality of Tokyo's urban individuality. The show's finale was an expression of freedom, with some models performing acrobatics and dances while others simply talked on the runway.

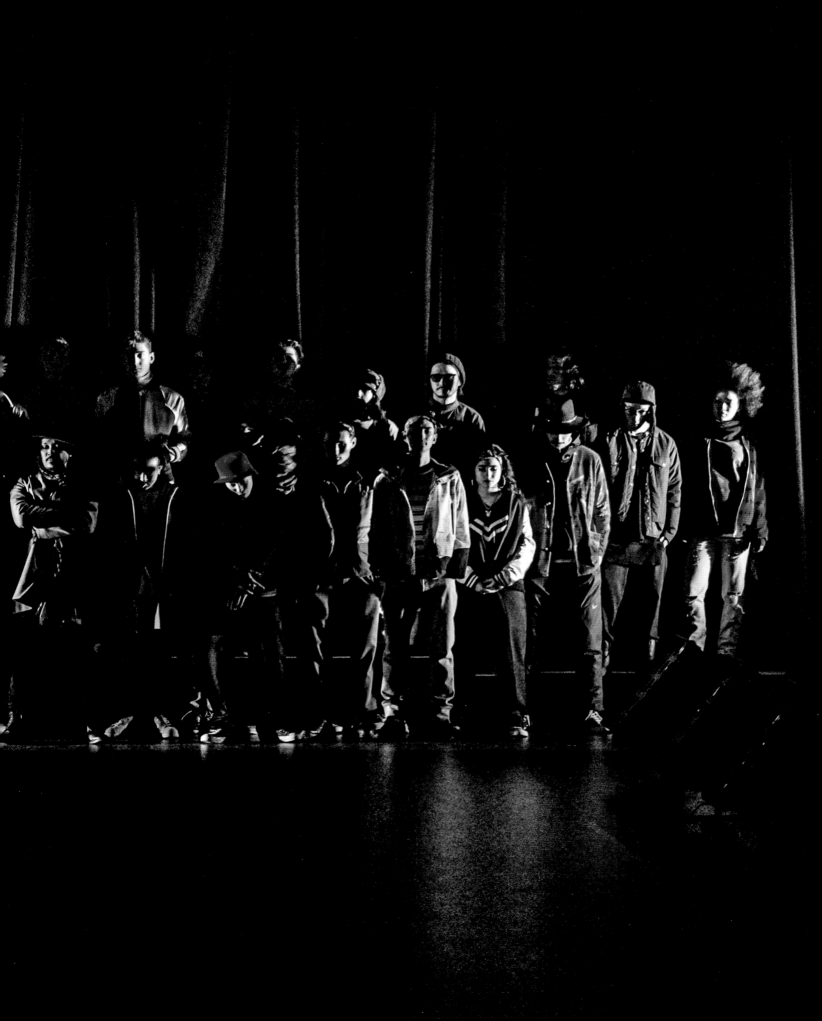

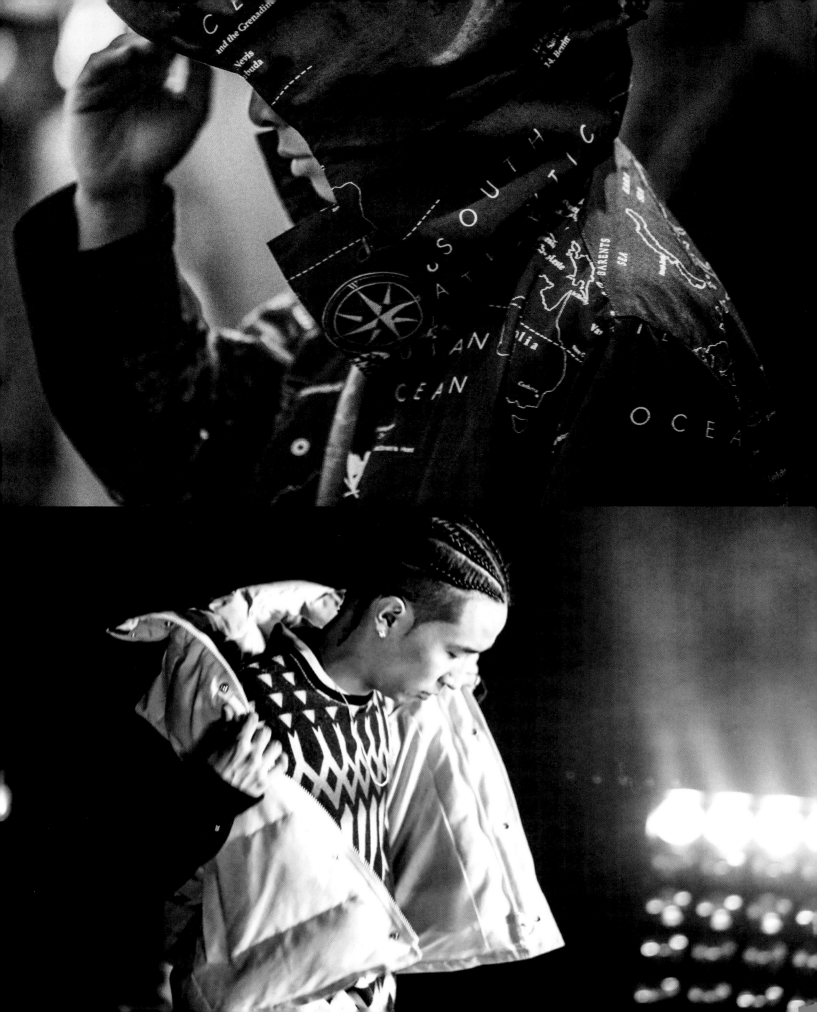

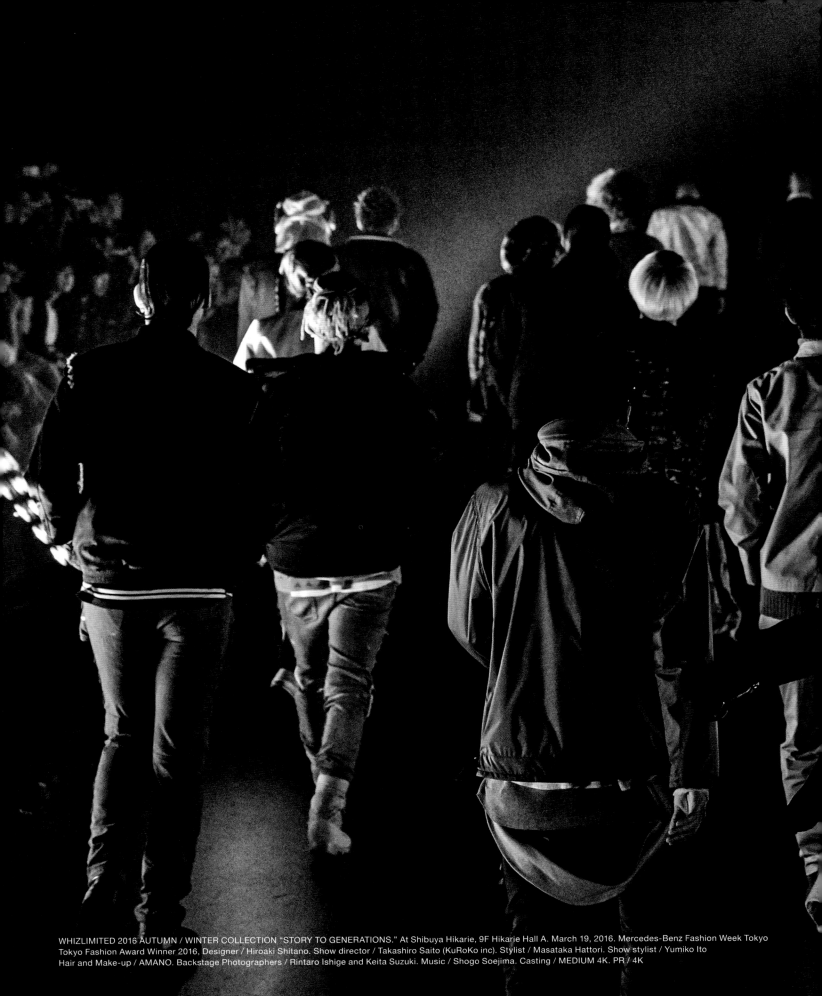

WHIZLIMITED 2016 AUTUMN / WINTER COLLECTION "STORY TO GENERATIONS." At Shibuya Hikarie, 9F Hikarie Hall A. March 19, 2016. Mercedes-Benz Fashion Week Tokyo
Tokyo Fashion Award Winner 2016, Designer / Hiroaki Shitano. Show director / Takashiro Saito (KuRoKo inc). Stylist / Masataka Hattori. Show stylist / Yumiko Ito
Hair and Make-up / AMANO. Backstage Photographers / Rintaro Ishige and Keita Suzuki. Music / Shogo Soejima. Casting / MEDIUM 4K. PR / 4K

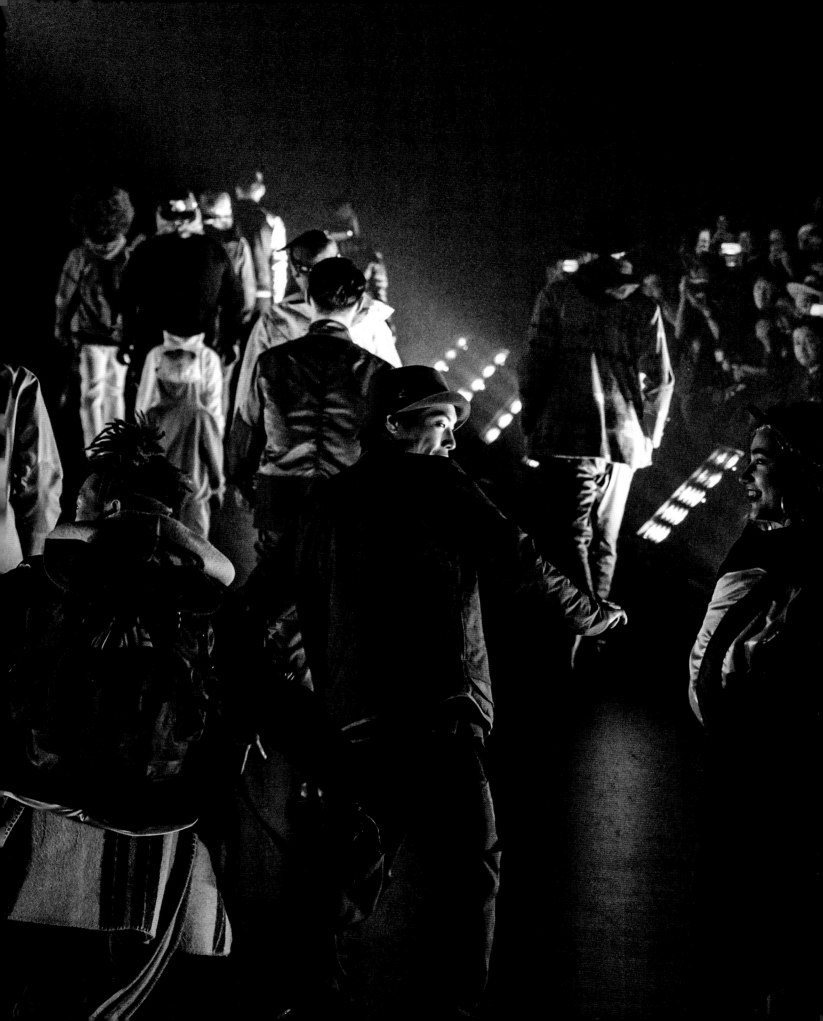

13

2013SS "OFF CITY"

The concept for Off City was a metropolis on a space colony in the not-so-distant future. Glow-in-the-dark wrist bands were handed out to runway attendees as passports into the void. Images of buildings from West Shinjuku, the designer's hometown, were used on the main textiles. Overall, this collection was characterized by elegant styling, glossy textures, and soft materials for ease of movement. A tailored jacket with a large slit on the back and a backpack that had a skateboard-carrying feature were produced with skateboarding as a daily means of transportation in mind. Puma Suedes with glowing heels were another stand-out item that contributed to the success of the runway show.

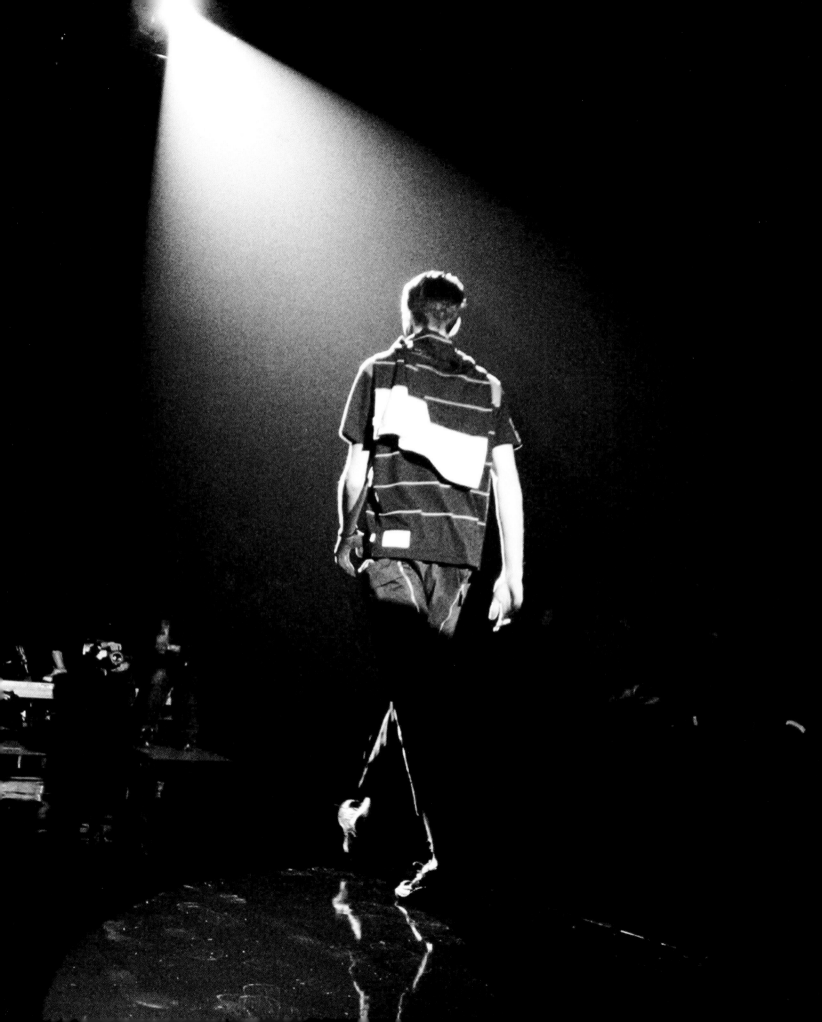

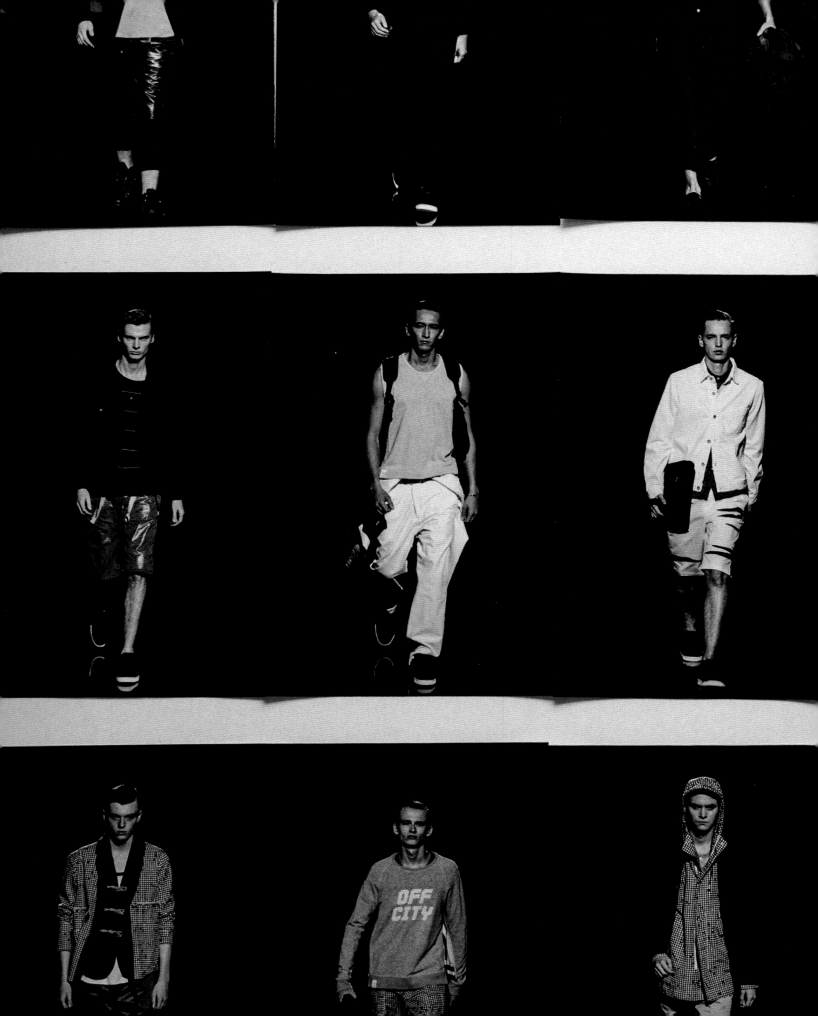

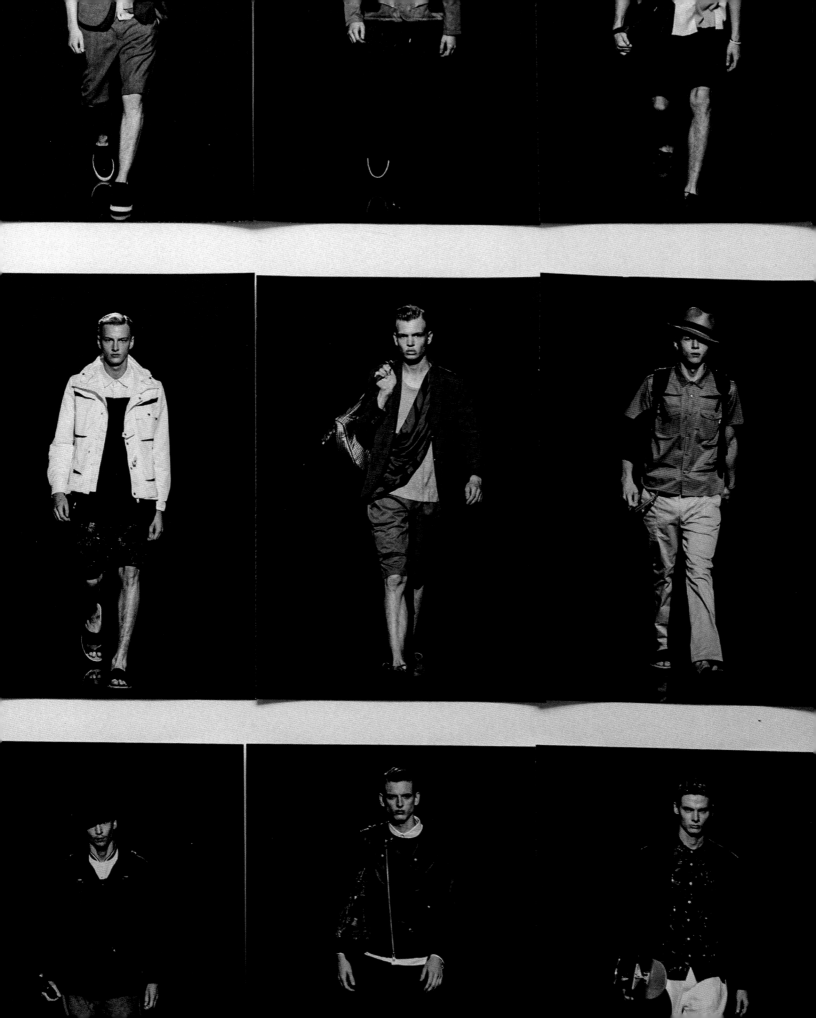

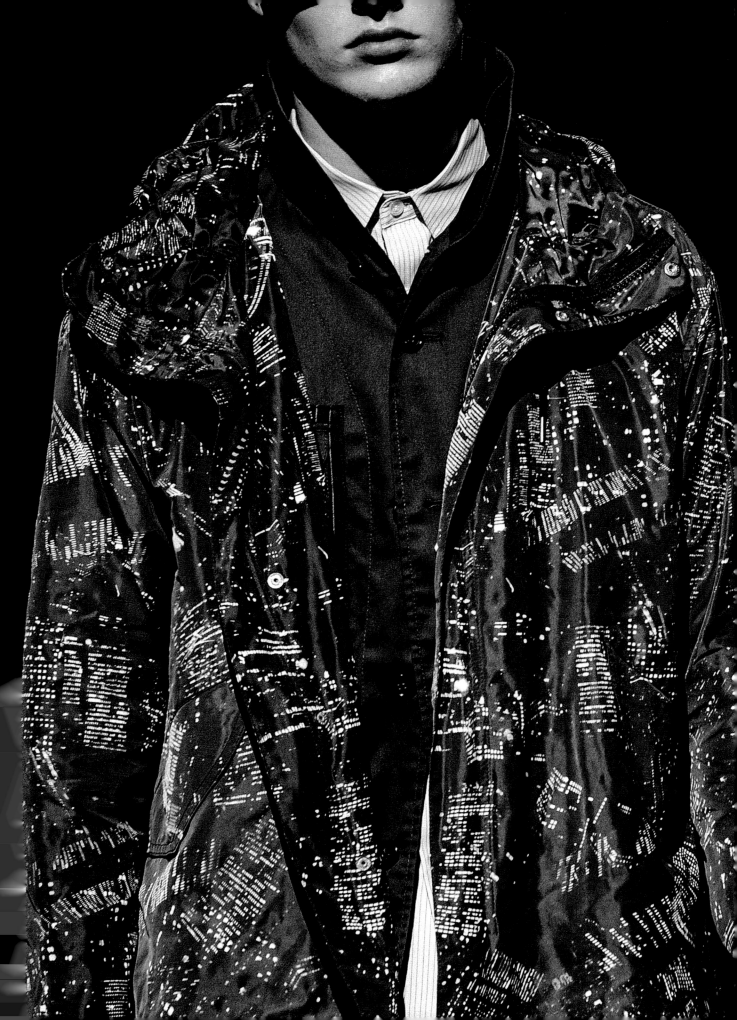

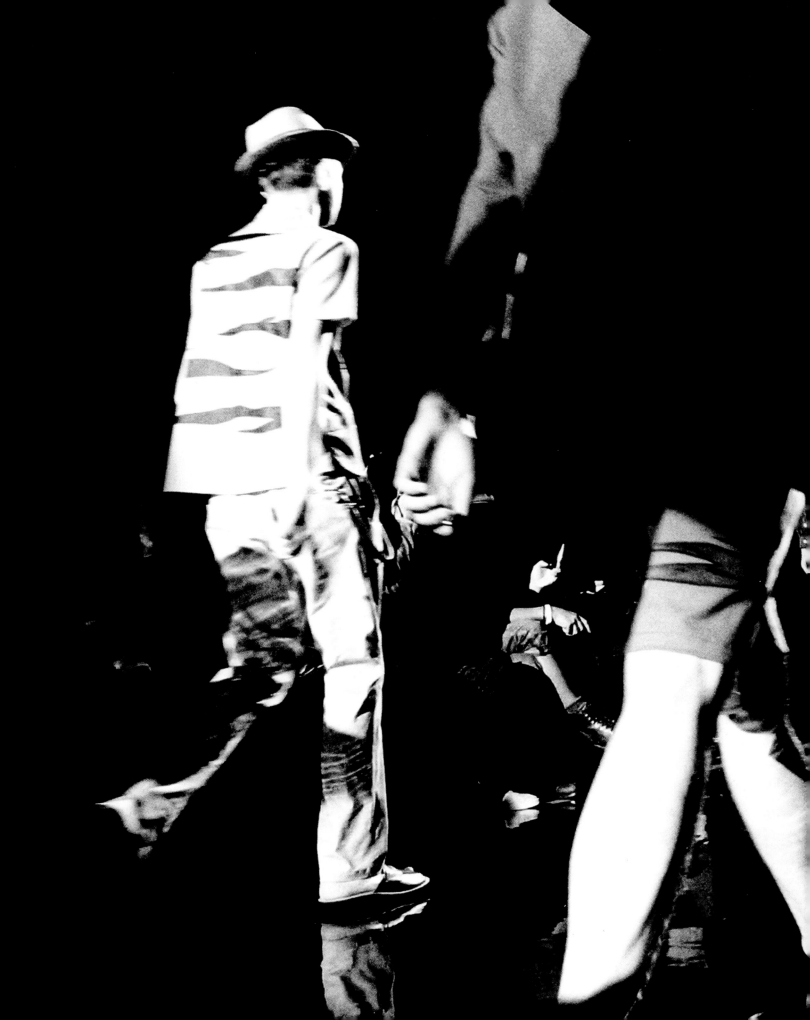

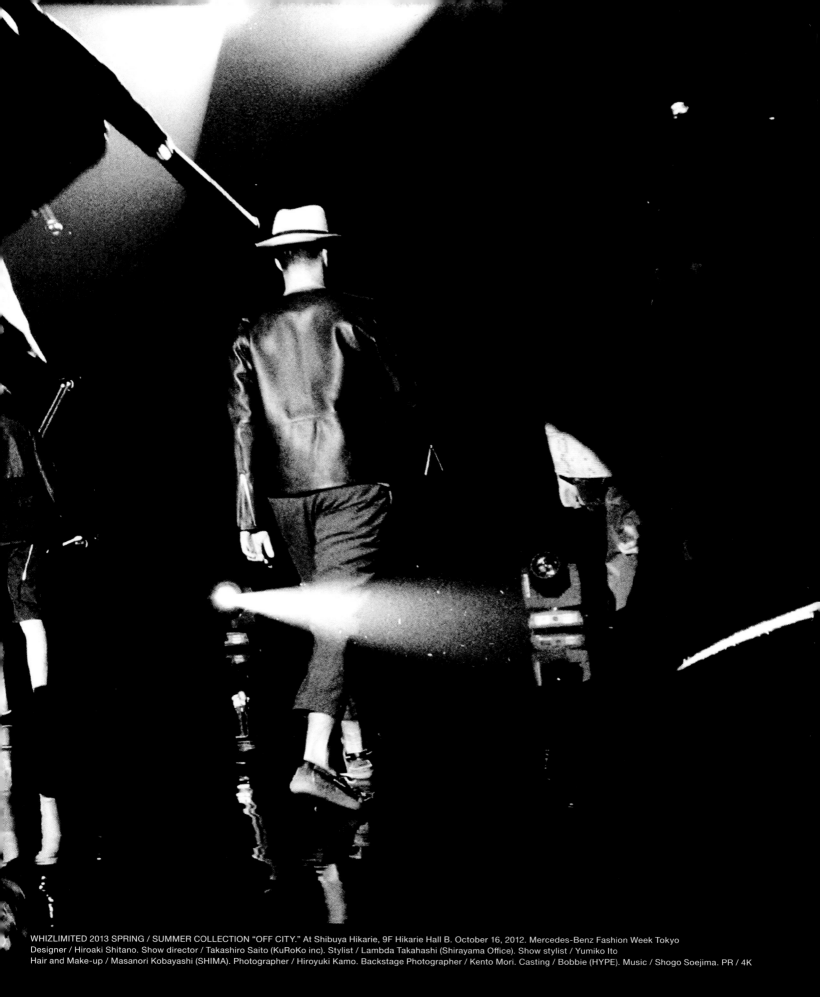

WHIZLIMITED 2013 SPRING / SUMMER COLLECTION "OFF CITY." At Shibuya Hikarie, 9F Hikarie Hall B. October 16, 2012. Mercedes-Benz Fashion Week Tokyo
Designer / Hiroaki Shitano. Show director / Takashiro Saito (KuRoKo inc). Stylist / Lambda Takahashi (Shirayama Office). Show stylist / Yumiko Ito
Hair and Make-up / Masanori Kobayashi (SHIMA). Photographer / Hiroyuki Kamo. Backstage Photographer / Kento Mori. Casting / Bobbie (HYPE). Music / Shogo Soejima. PR / 4K

12

2012SS "UNITED"

WHIZLIMITED's first ever runway collection commenced to the sound of *Kids Are United* by Atari Teenage Riot blaring at full volume. Repressed anger from the Great Eastern Japan Earthquake and Tsunami, which occurred on March 11th of the previous year, was channeled into the designs in this collection, as exemplified by the vividly colored stoles with barbed wire and sword motifs symbolizing "off limits". The three-headed eagle that remains part of the brand's identity to this day was also heavily featured in this collection. For WHIZLIMITED, which up until that point had focused solely on creating street wear, the 2012SS collection marked a pivotal moment when show production opened up a whole new world of possibilities for creative expression in apparel.

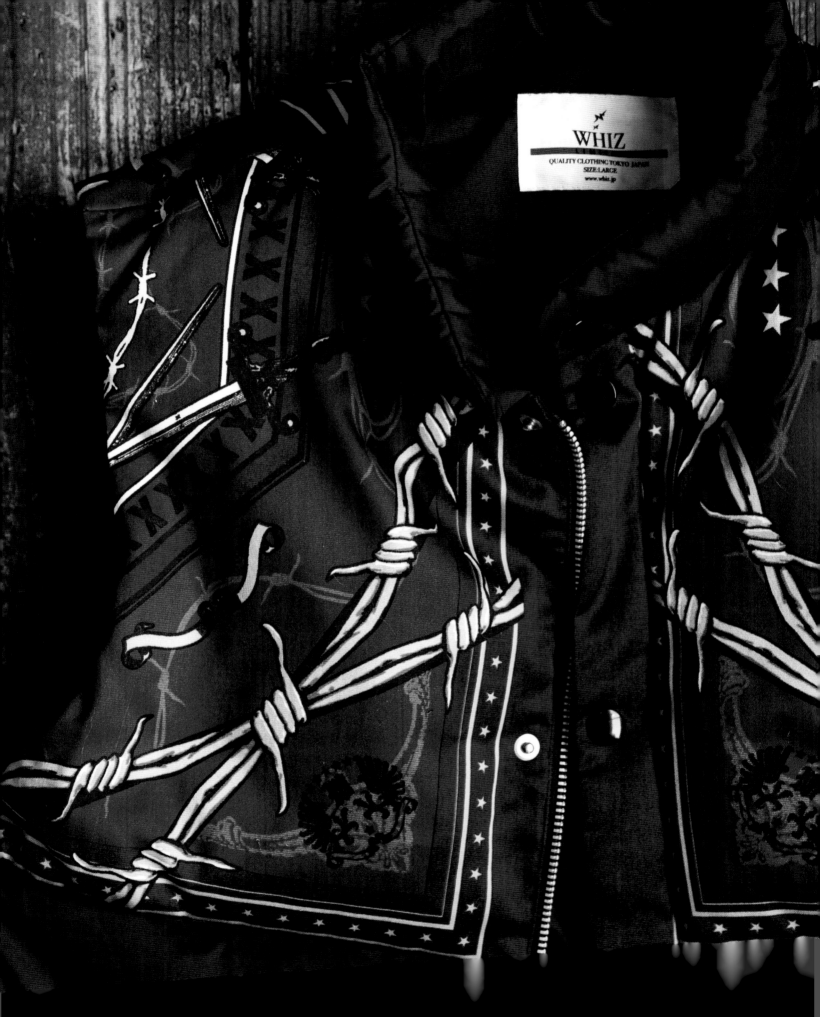

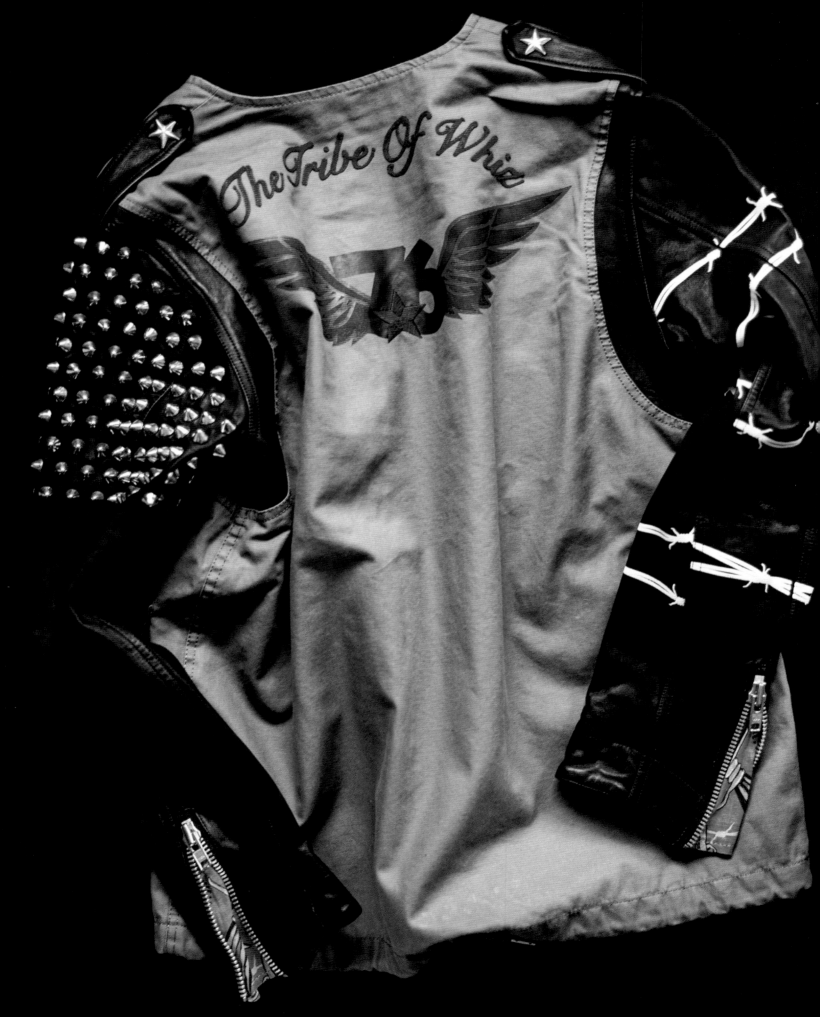

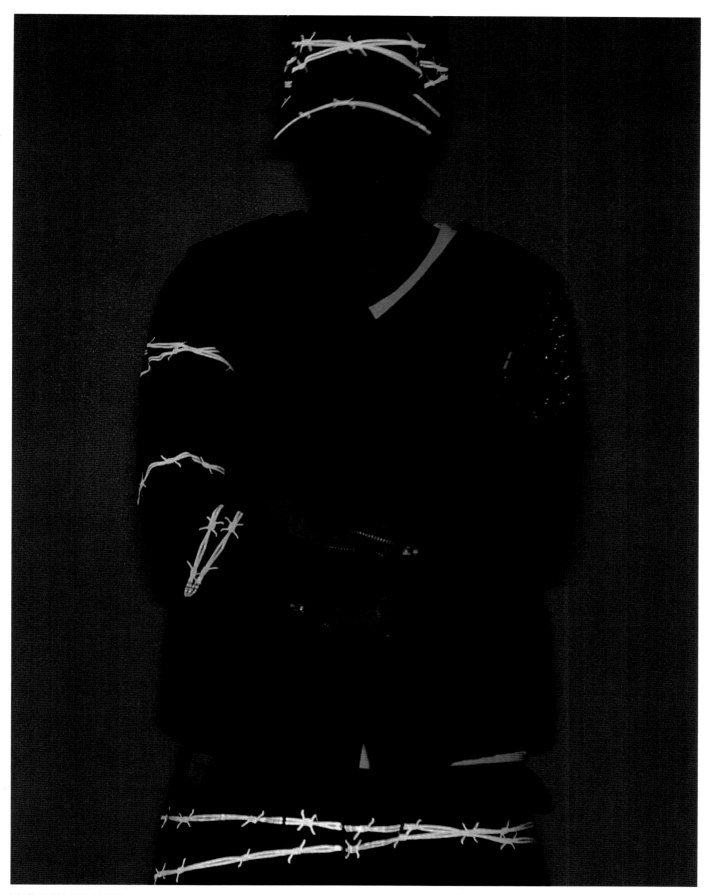

WHIZLIMITED 2012 SPRING / SUMMER COLLECTION "UNITED." At Tokyo Midtown Canopy Square. October 22, 2011. Mercedes-Benz Fashion Week Tokyo
Designer / Hiroaki Shitano. Show director / Takashiro Saito (KuRoKo inc). Stylist / WHIZLIMITED. Show stylist / Yumiko Ito. Hair and Make-up / Go Takakusagi
Backstage Photographer / Taichi Iwasa. Casting / Bobbie (HYPE)

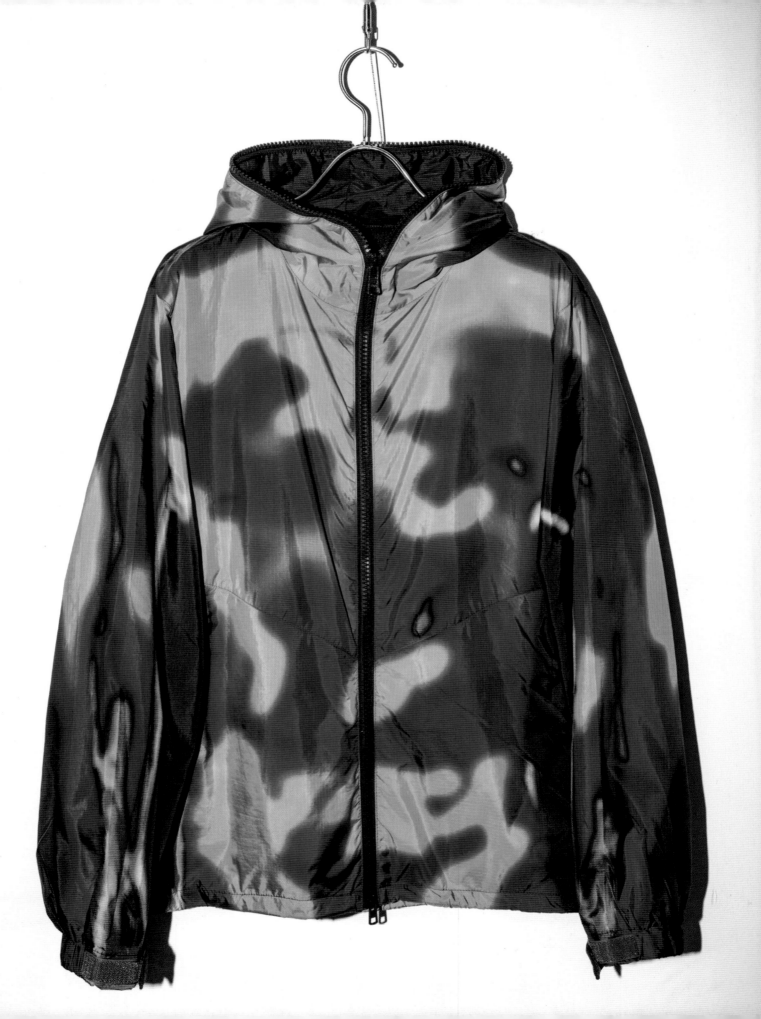

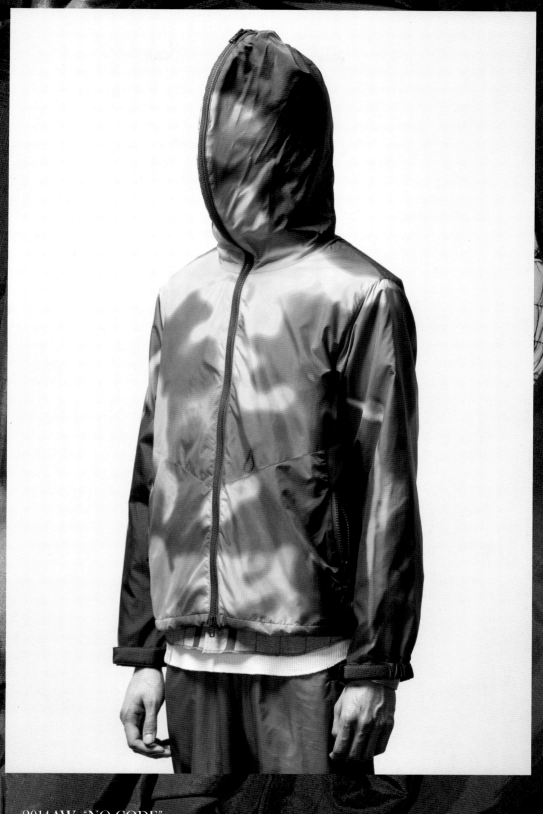

14

2014AW "NO CODE"

The concept for 2014 AW was "apparel for travelers". The signature textile used in this collection featured patterns inspired by thermal image scans at airport security. The thermal patterns on the jacket, pants, and stole were designed to replicate typical temperature distributions on the human body to create a whole thermal image when worn as a set. The collection focused on features useful for frequent travelers such jackets with plenty of storage options, clothing with pockets large enough to take a passport, and wrinkle-resistant fabrics.

音楽的砕

02

2002SS "ROOM"

The title of WHIZLIMITED's 4th season collection was inspired by the interstices between overlapping fabrics being cut on the stand that were envisioned as "rooms", or spaces full of new possibilities. The central theme was the link between the movements of the spaces created in fabric during the draping process to those of the human body. The emblematic *kanji* script on the garments, as above ("acts of musical destruction") appeared throughout this collection.

破壊行為

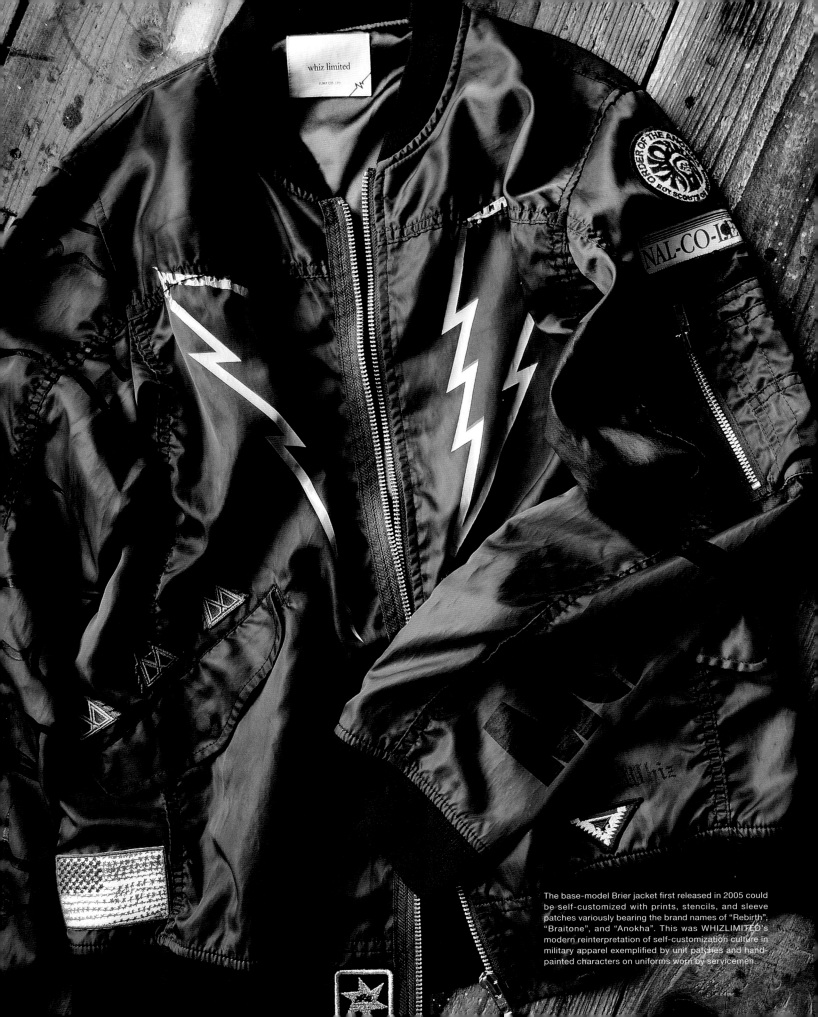

The base-model Brier jacket first released in 2005 could be self-customized with prints, stencils, and sleeve patches variously bearing the brand names of "Rebirth", "Braitone", and "Anokha". This was WHIZLIMITED's modern reinterpretation of self-customization culture in military apparel exemplified by unit patches and hand-painted characters on uniforms worn by servicemen.

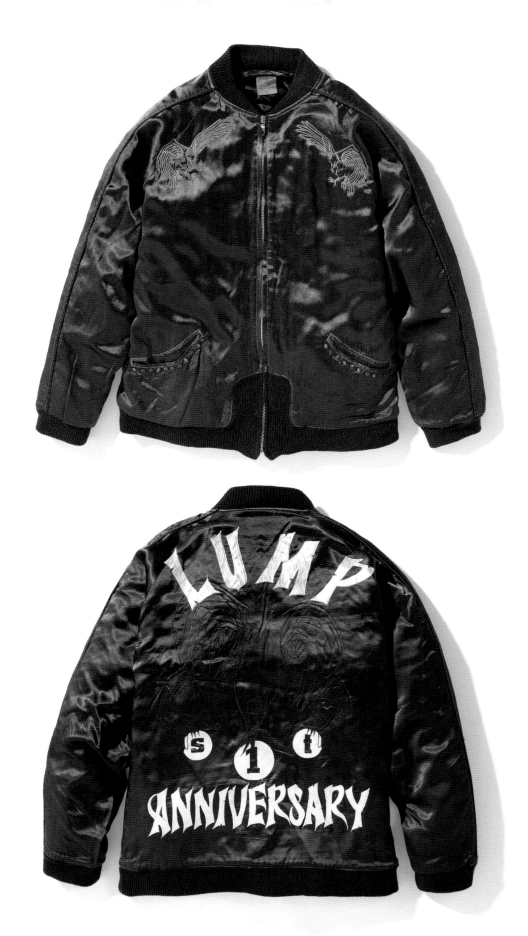

A souvenir jacket released by Rebirth in 2004 customized by WHIZLIMITED. The front featured embroidered eagles and the back was emboss-printed with another eagle and a graphic marking the first anniversary of Lump Tokyo.

20

2020AW "WILL"

A special collection marking the 20th anniversary of WHIZLIMITED. The entire wardrobe was created by going back through archives spanning the prior two decades, selecting items that felt most appropriate for the occasion, and updating them by redesigning silhouettes and details. Combining archive items with each other was also a key production method for this collection.

13

2013AW "LUST FOR LIFE"

A collection heavily inspired by the Mods style and culture that WHIZLIMITED mixed with its distinctly Tokyo vibe. The runway was covered with red carpet, and the lighting at the back of the stage threw overlapping rays of light to create a futuristic atmosphere. Over 700 people turned up to a venue with a maximum capacity of 300, which meant many had to be turned away at the door. An apologetic WHIZLIMITED later sent out DVDs of the show to those who were unable to get in. According to insiders, WHIZLIMITED was barred from renting venues with a seating capacity of less than 1,000 due to this episode. Items in this collection had a notably European air about them, including the checkered MA-1 jacket, a dot-pattern drizzler jacket, a Mods-style coat printed with a lightning bolt, a Chesterfield coat lined with a short nylon vest, and a quilted pair of shorts with an apron. The footwear worn by the models were lace-up boots made in collaboration with the North Face, adding an off-center element to the ensemble.

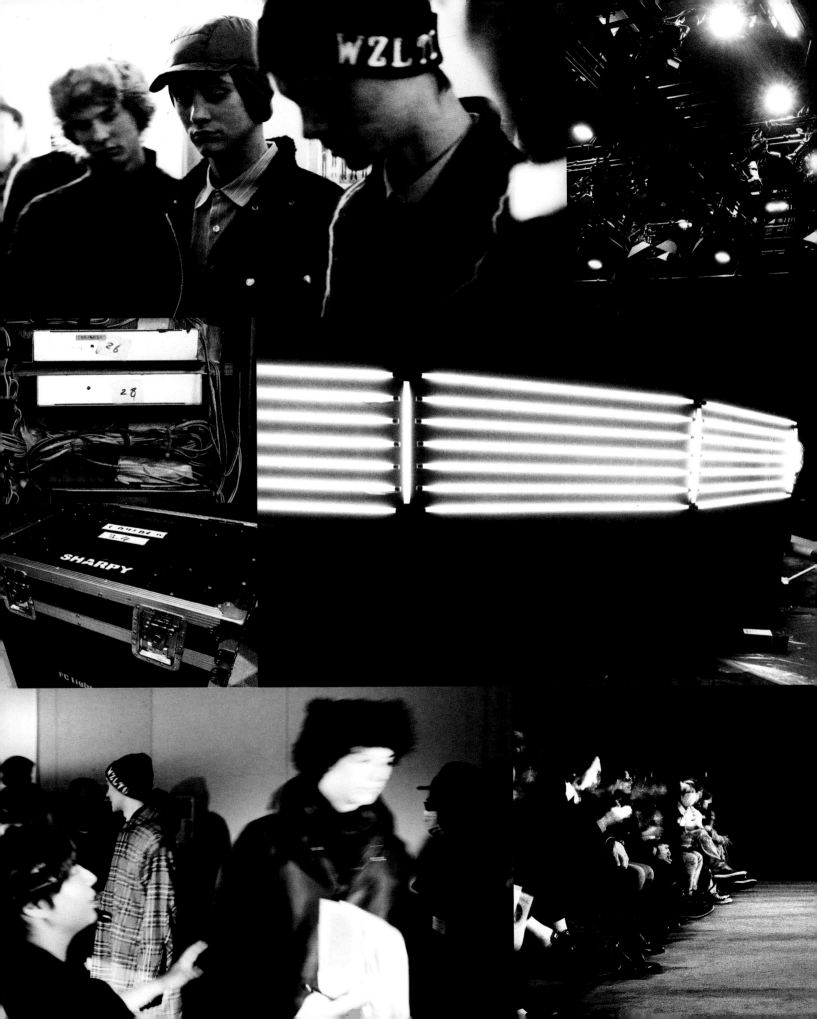

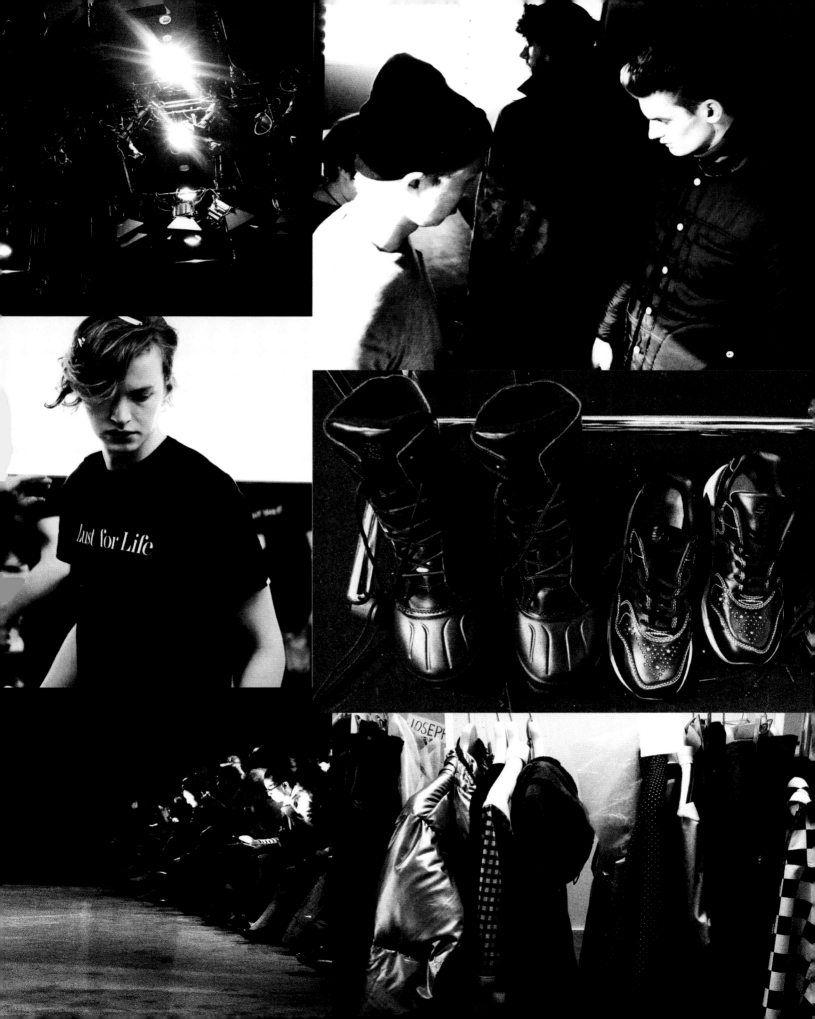

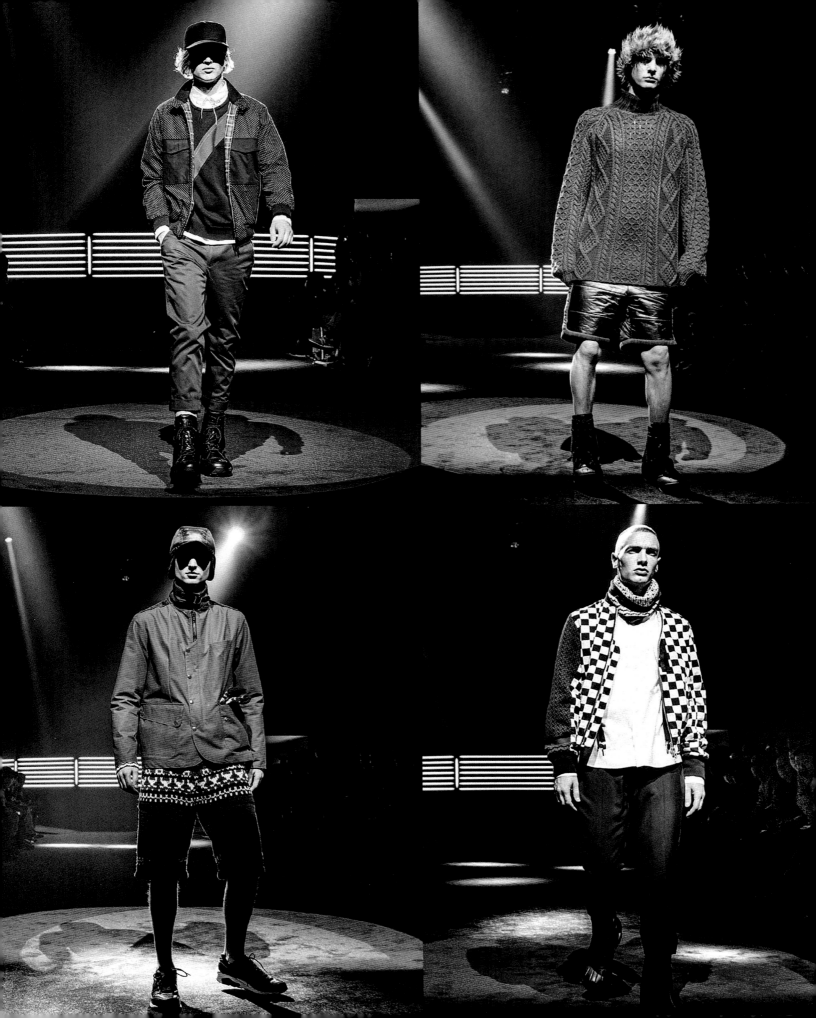

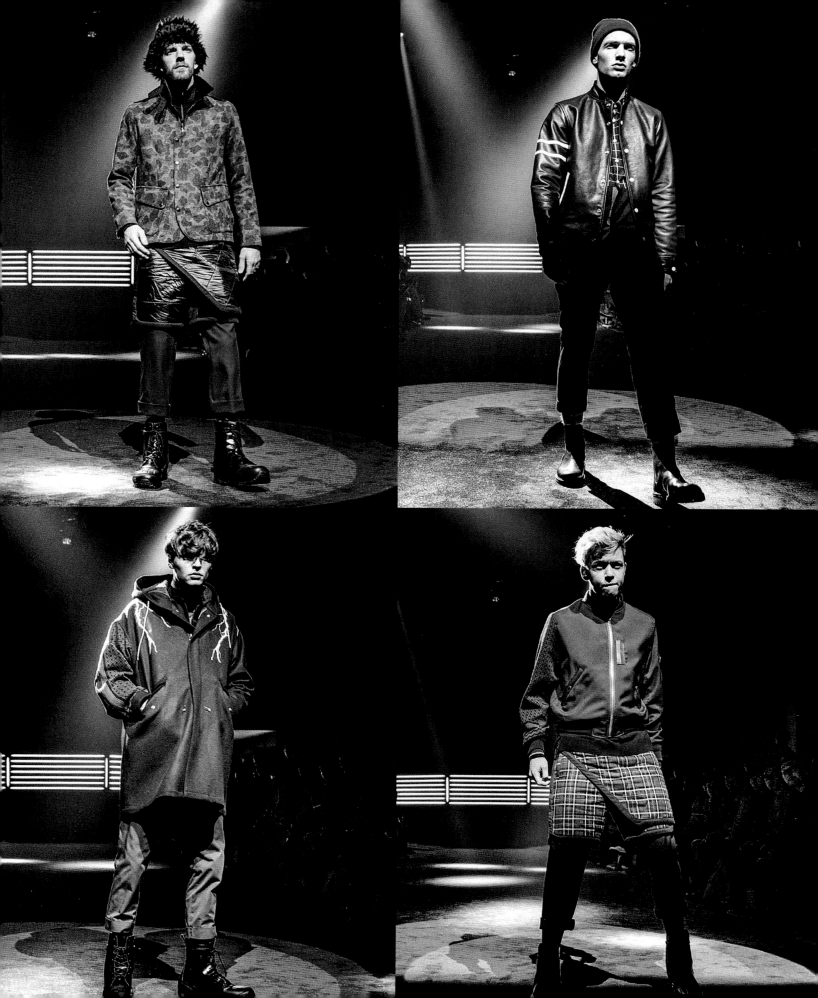

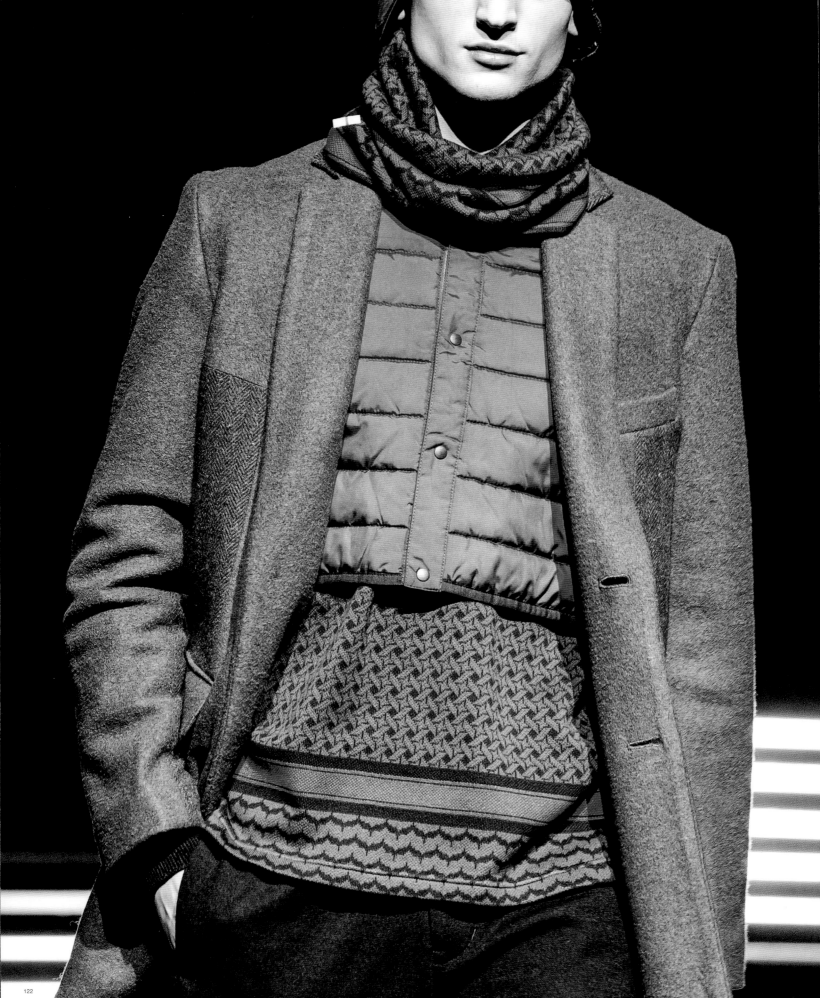

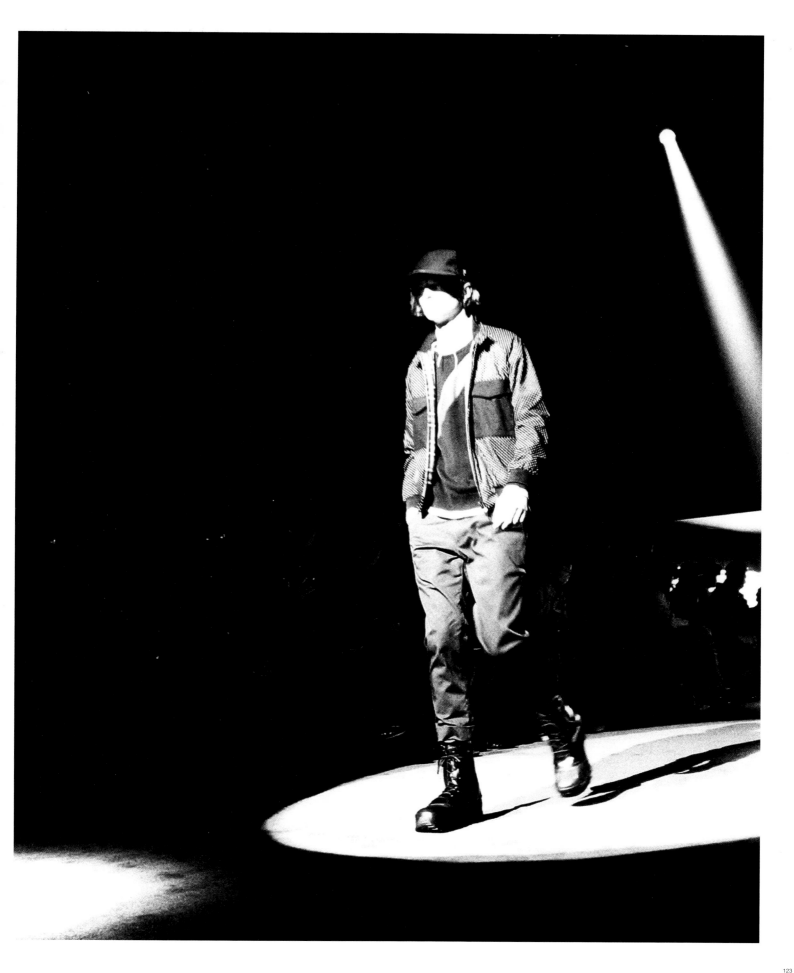

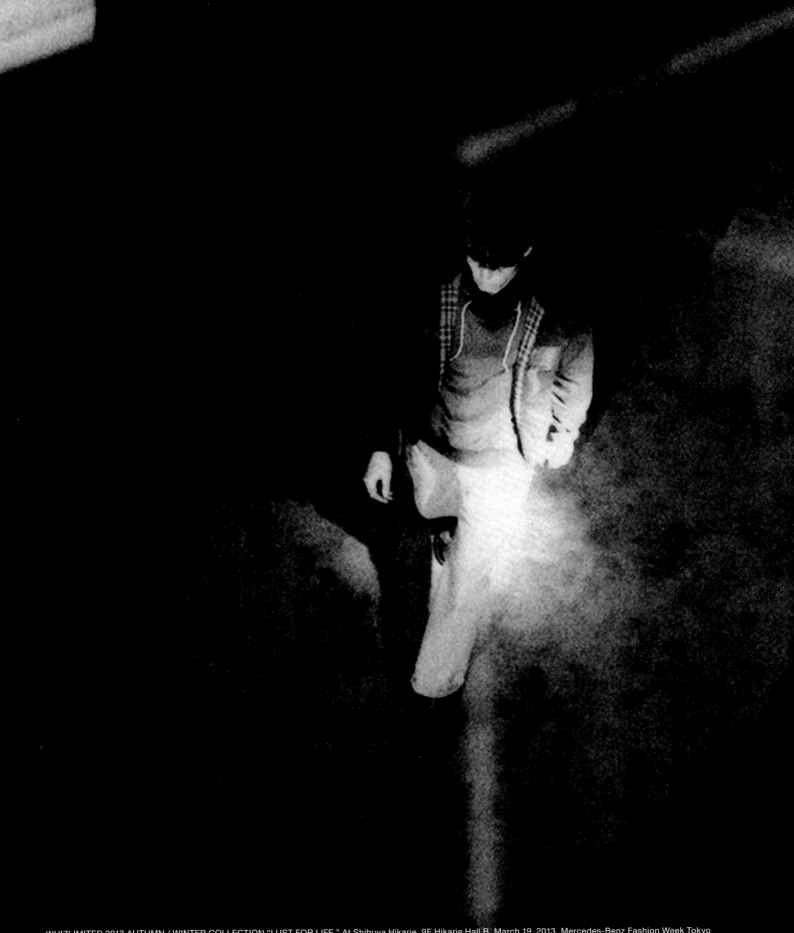

WHIZLIMITED 2013 AUTUMN / WINTER COLLECTION "LUST FOR LIFE." At Shibuya Hikarie, 9F Hikarie Hall B. March 19, 2013. Mercedes-Benz Fashion Week Tokyo
Designer / Hiroaki Shitano. Show director / Takashiro Saito (KuRoKo inc). Stylist / Lambda Takahashi (Shirayama Office). Show stylist / Yumiko Ito
Hair and Make-up / Masanori Kobayashi (SHIMA). Photographer / Hiroyuki Kamo. Backstage Photographer / Kento Mori. Casting / Bobbie (HYPE). Music / Shogo Soejima. PR / 4K

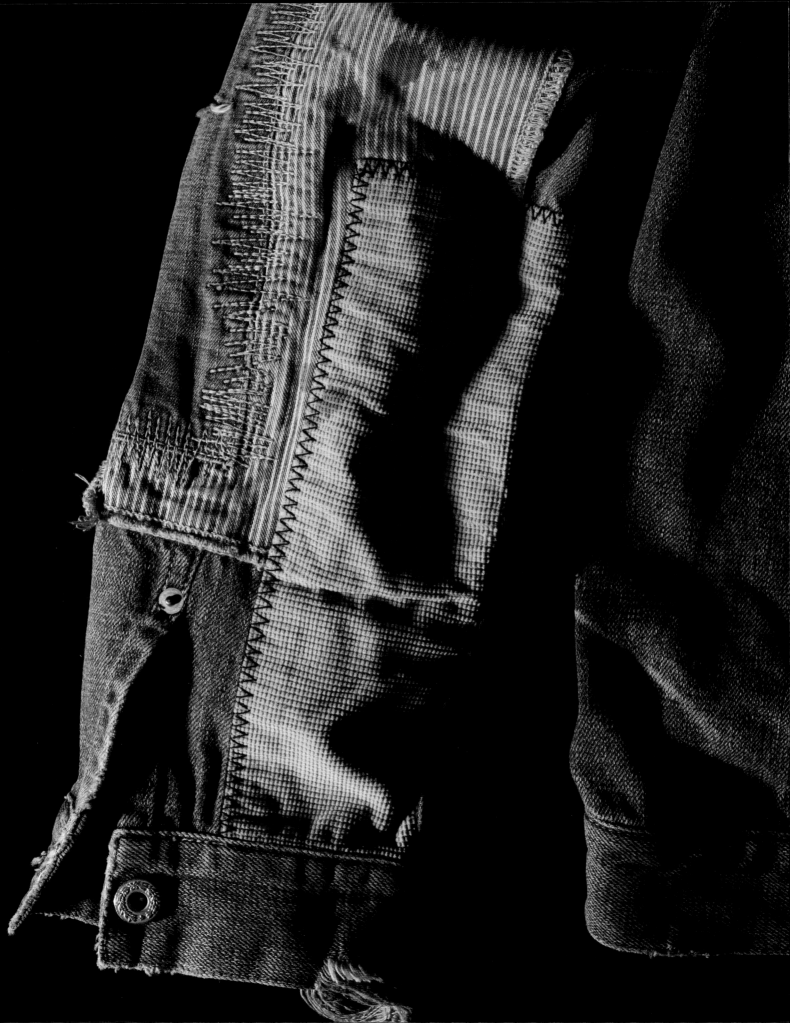

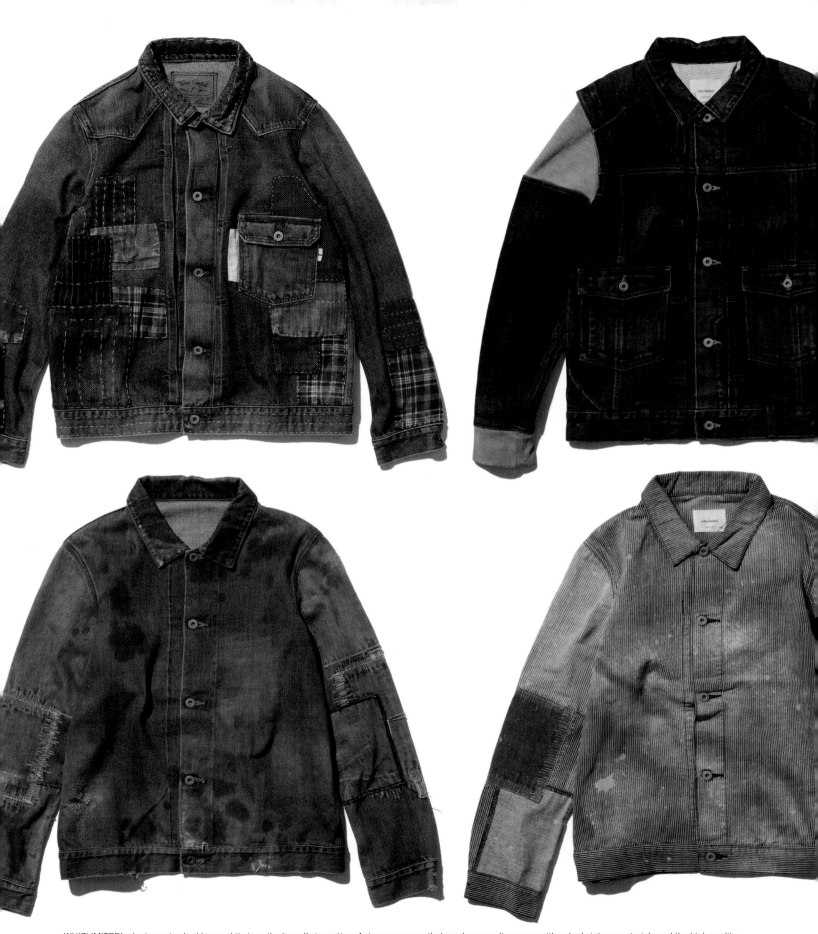

WHIZLIMITED's denim series had been a hit since the brand's inception. Aging processes that produce results on par with actual vintage materials and the high quality of craftsmanship on reworked denim remain hallmarks of the brand. After the basic form of each denim item is made individually, the design evolves organically as various patches of different fabrics are sewn on—a process requiring a high degree of creativity.

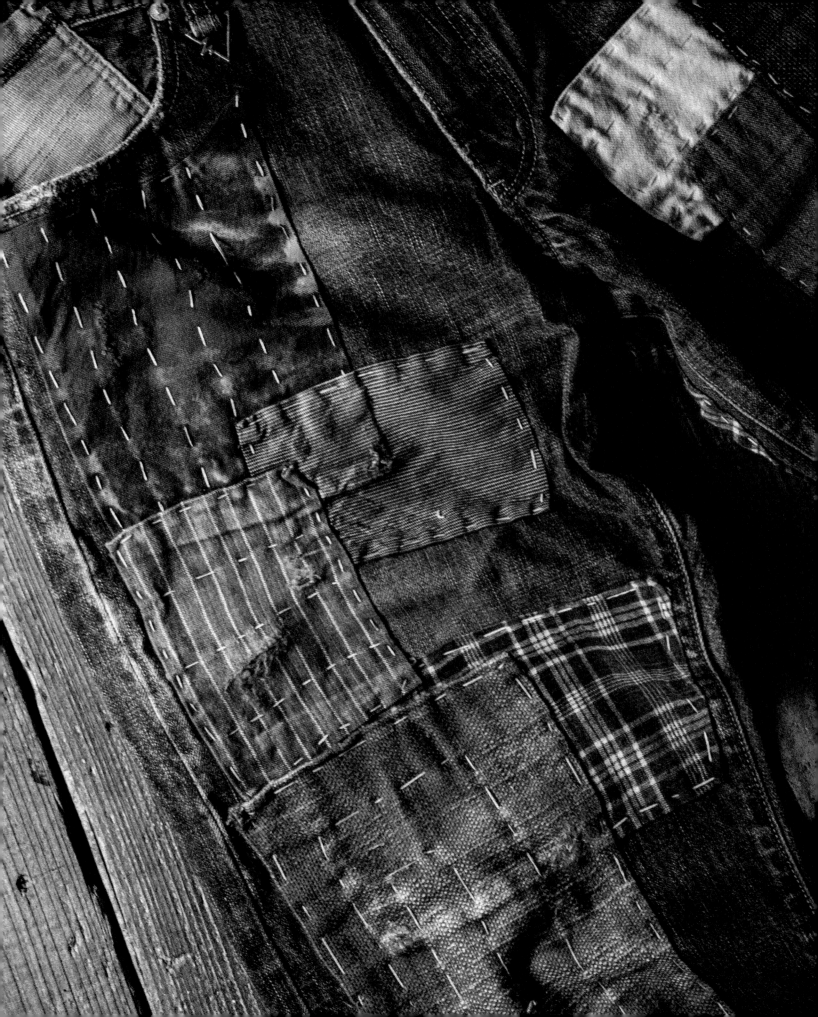

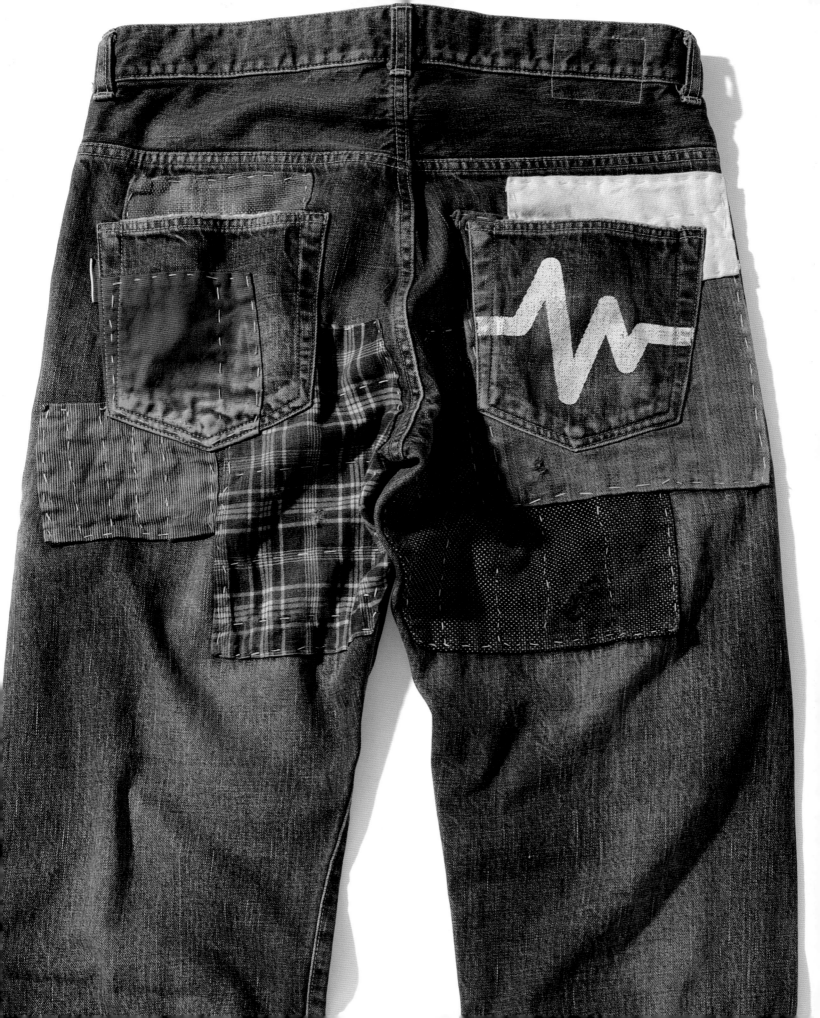

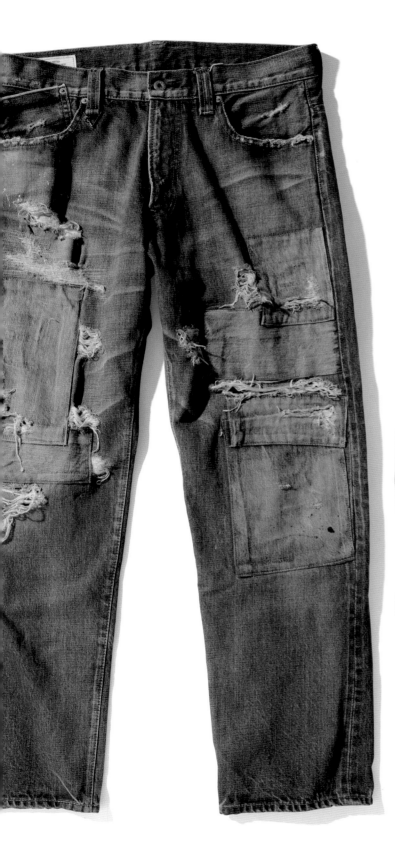
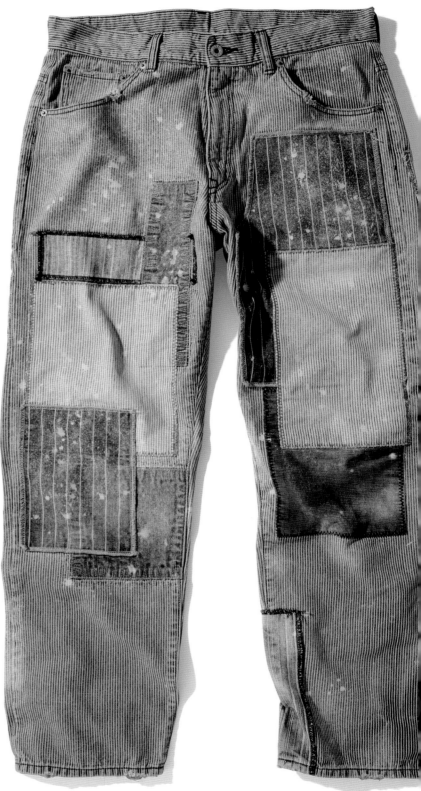

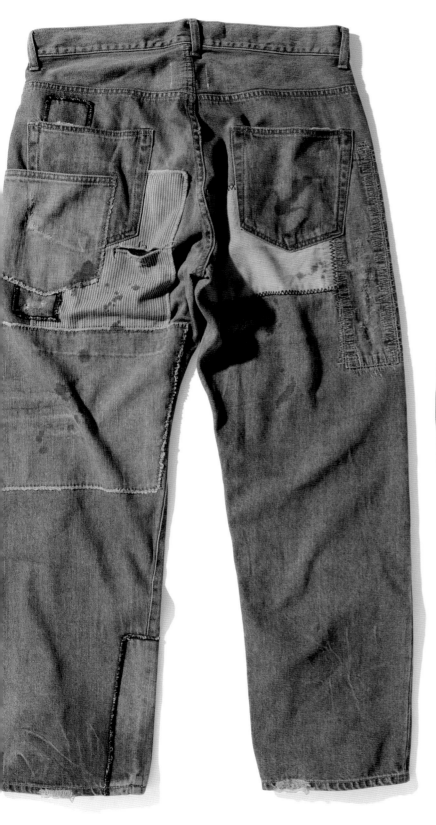
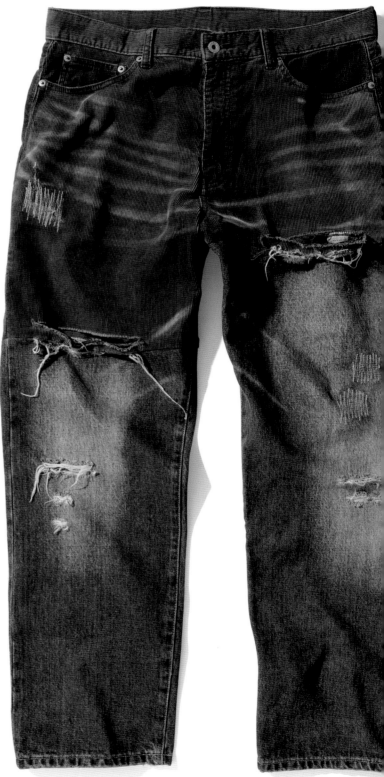

2016SS "ALTERNATIVE"

16 A collection that merged state-of-the-art production methods with streetwise sensibilities. One of the signature fabrics was made by using inkjet printing to transfer Native American–inspired patterns with a distinctive color gradient onto raised fabric. From the faux-classical multi-colored collage shirt to the patinaed flock print sweatshirt, the collection was made possible by the evolution of apparel production technology.

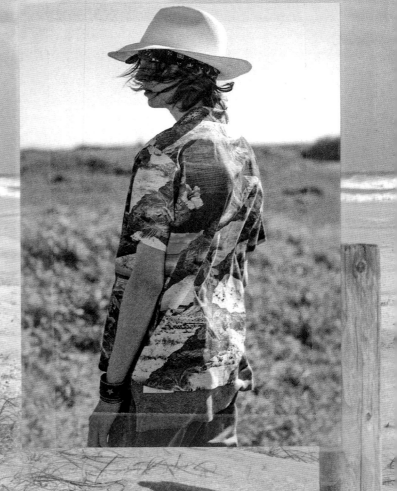

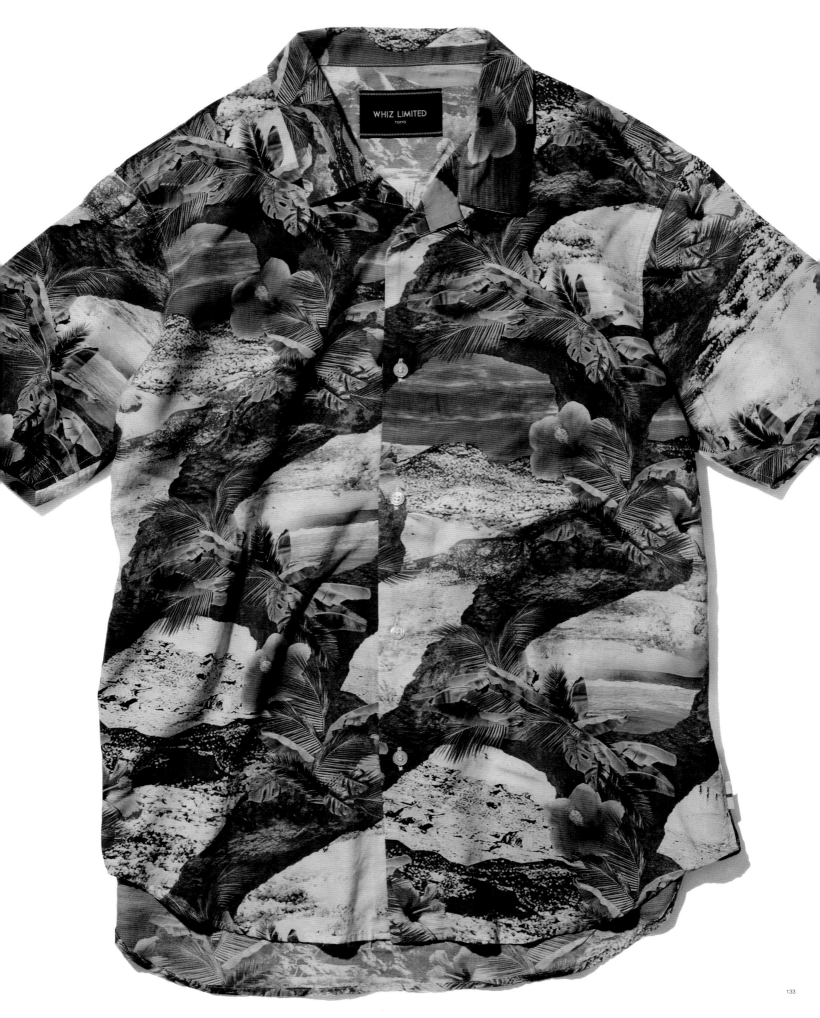

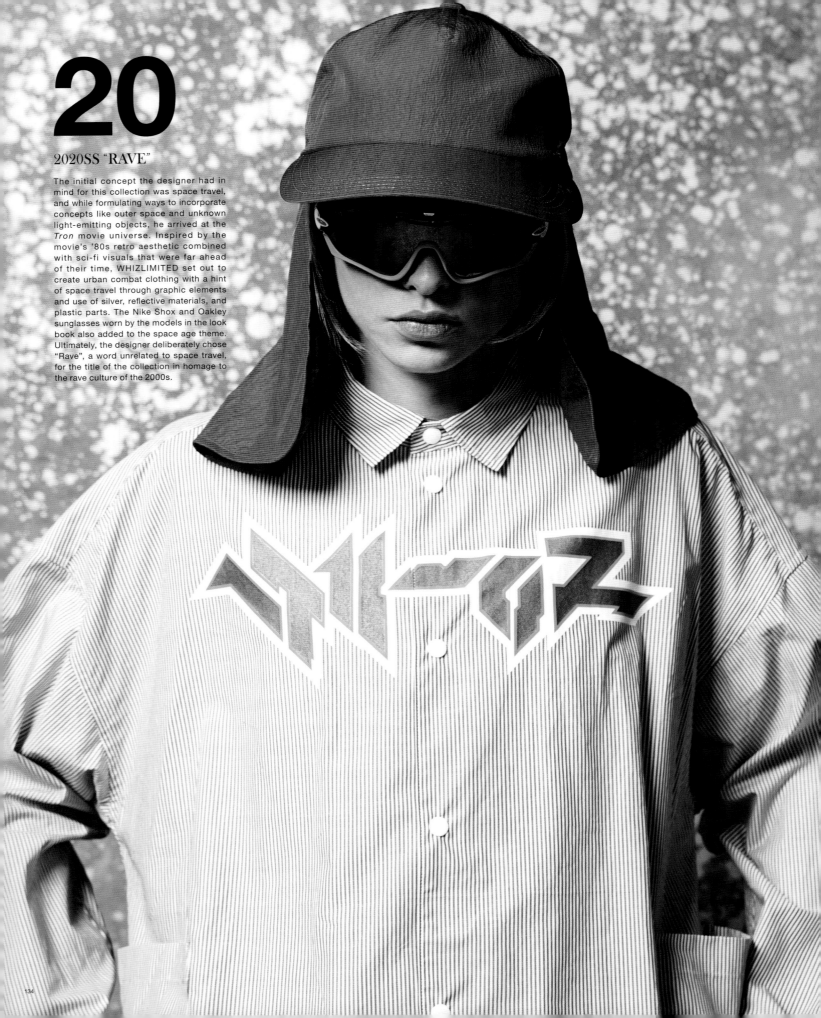

20

2020SS "RAVE"

The initial concept the designer had in mind for this collection was space travel, and while formulating ways to incorporate concepts like outer space and unknown light-emitting objects, he arrived at the *Tron* movie universe. Inspired by the movie's '80s retro aesthetic combined with sci-fi visuals that were far ahead of their time, WHIZLIMITED set out to create urban combat clothing with a hint of space travel through graphic elements and use of silver, reflective materials, and plastic parts. The Nike Shox and Oakley sunglasses worn by the models in the look book also added to the space age theme. Ultimately, the designer deliberately chose "Rave", a word unrelated to space travel, for the title of the collection in homage to the rave culture of the 2000s.

COAT / WL-J-38 QUILTING JACKET
URTLE / WL-P-49 LINE PANTS

E SHIRTS/WL-C-78 LONG T SHIRTS
PANTS

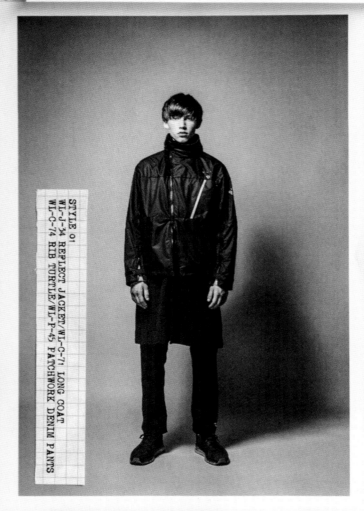

STYLE 01
WL-J-34 REFLECT JACKET/WL-C-71 LONG COAT
WL-C-74 RIB TURTLE/WL-P-45 PATCHWORK DENIM PANTS

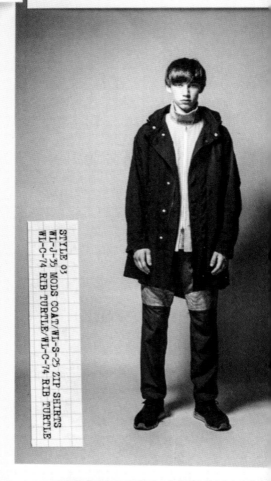

STYLE 03
WL-J-35 MODS COAT/WL-S-25 ZIP SHIRTS
WL-C-74 RIB TURTLE/WL-C-74 RIB TURTLE

18

2018SS
"SHADOW OF THE EMPIRE"

A collection based on military uniforms of
an empire in a sci-fi universe as imagined by
WHIZLIMITED. Designs explored the concept of
uniforms for a monolithic organization through
the use of dark colors, glossy textures, emblems,
and motifs resembling national flags.

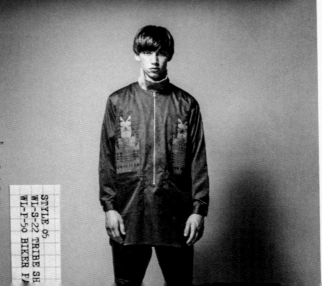

STYLE 05
WL-S-22 TRIBE SH
WL-P-50 BIKER PA

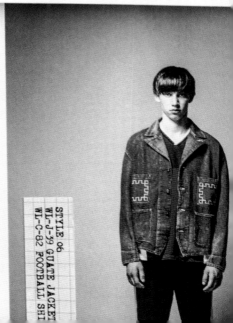

STYLE 06
WL-J-39 GUATE JACKET
WL-C-82 FOOTBALL SHI

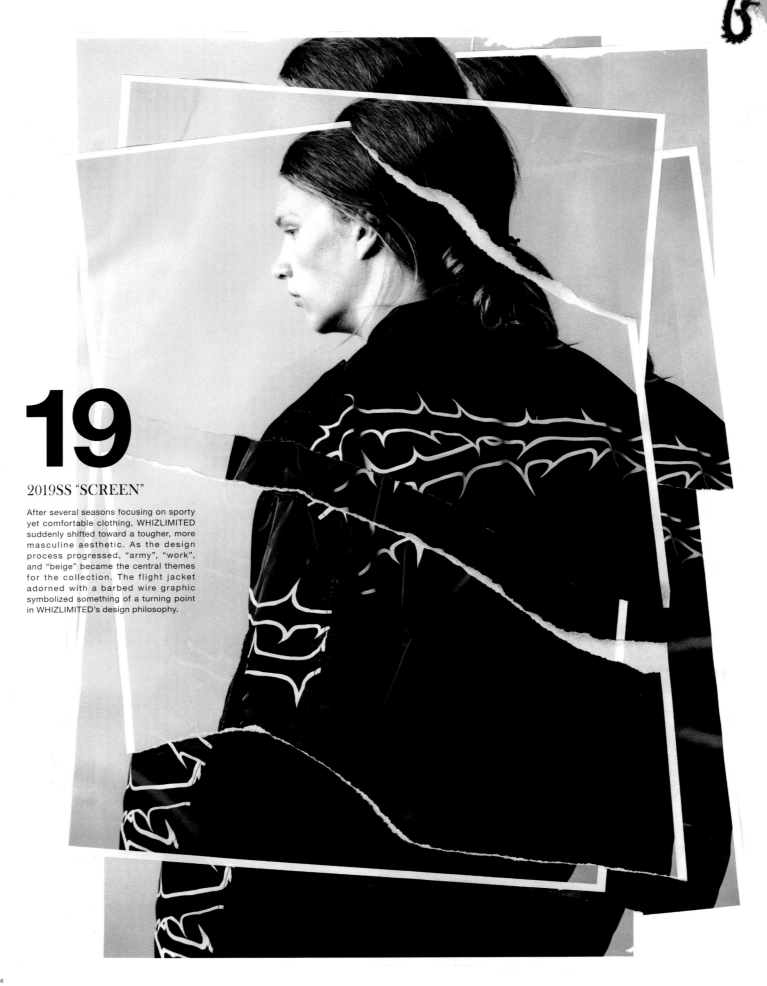

19

2019SS "SCREEN"

After several seasons focusing on sporty yet comfortable clothing, WHIZLIMITED suddenly shifted toward a tougher, more masculine aesthetic. As the design process progressed, "army", "work", and "beige" became the central themes for the collection. The flight jacket adorned with a barbed wire graphic symbolized something of a turning point in WHIZLIMITED's design philosophy.

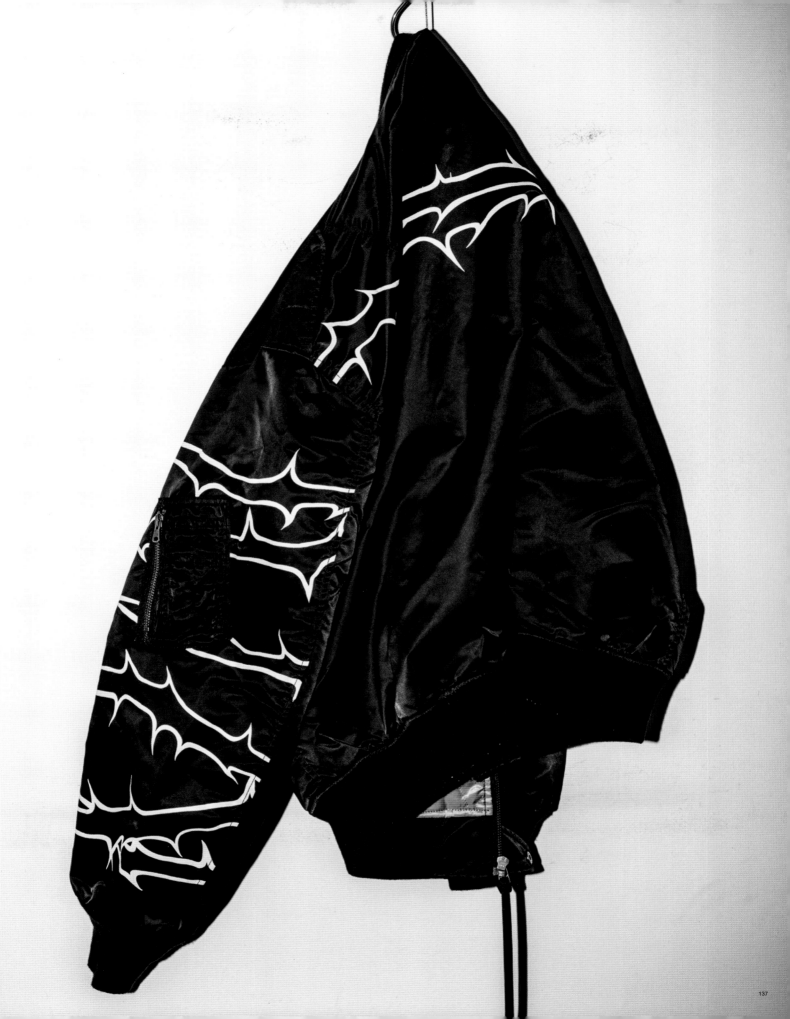

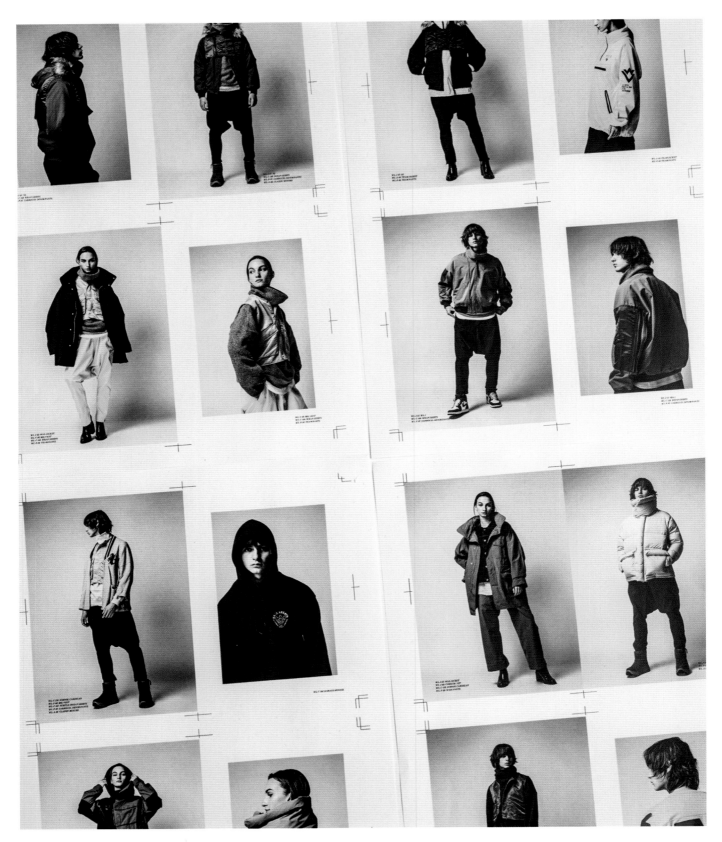

19

2019AW "TOUGH-TECH"

A continuation from the previous season, the keywords "army", "work", and "beige" were the core ideas used to create a collection conscious of a certain type of masculinity. In the search for fabrics offering durability and matte textures, Cordura was selected for its sheer toughness and versatility in its ability to be used in anything from denims to cut-and-sewn items. When the first samples arrived, Shitano felt the colors had come out "too matte and subdued". However, during the styling and photography process for the look book in which female models appeared for the first time, he became convinced that it would work. The collection was the culmination of the pursuit of what would actually work on the streets while expressing something unique fashion-wise.

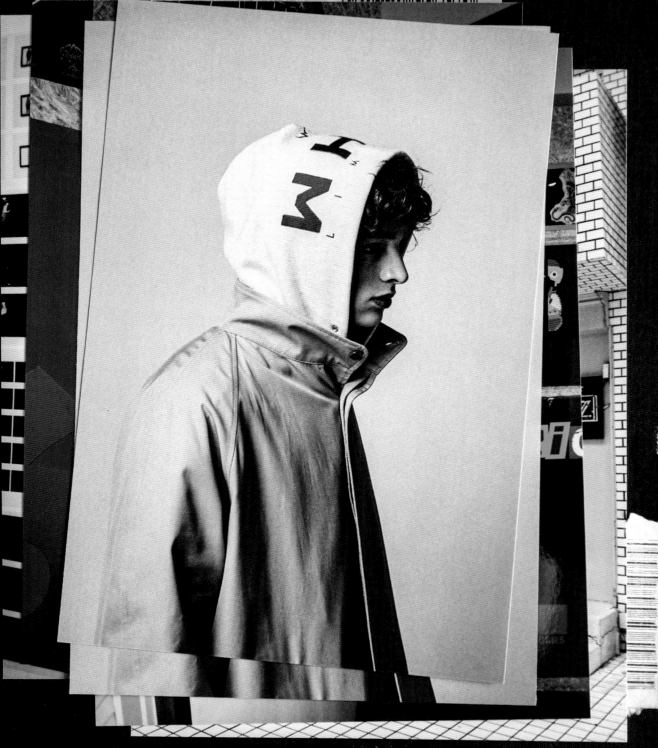

21

2021AW "DAYS"

The behavior will change if the mind changes. Habits change if action changes. Personality will change if the custom changes. The destiny will change if the personality changes. Taking this quote from philosopher William James as inspiration, this collection was an expression of the designer's acceptance of the changes in a stagnant society in the "new normal" brought about by the COVID-19 pandemic. "Kindness" and "soccer" were also key themes, with items such as knitwear and sweatshirts produced with materials that are soft on the skin. The general aesthetic could be described as street wear with elements of soccer while steering away from overly casual aesthetics or pure sporting functionality. According to Shitano, he attempted to create WHIZLIMITED's definition of classic with combinations such as a balmacaan coat over knitted bottoms and a soccer uniform top.

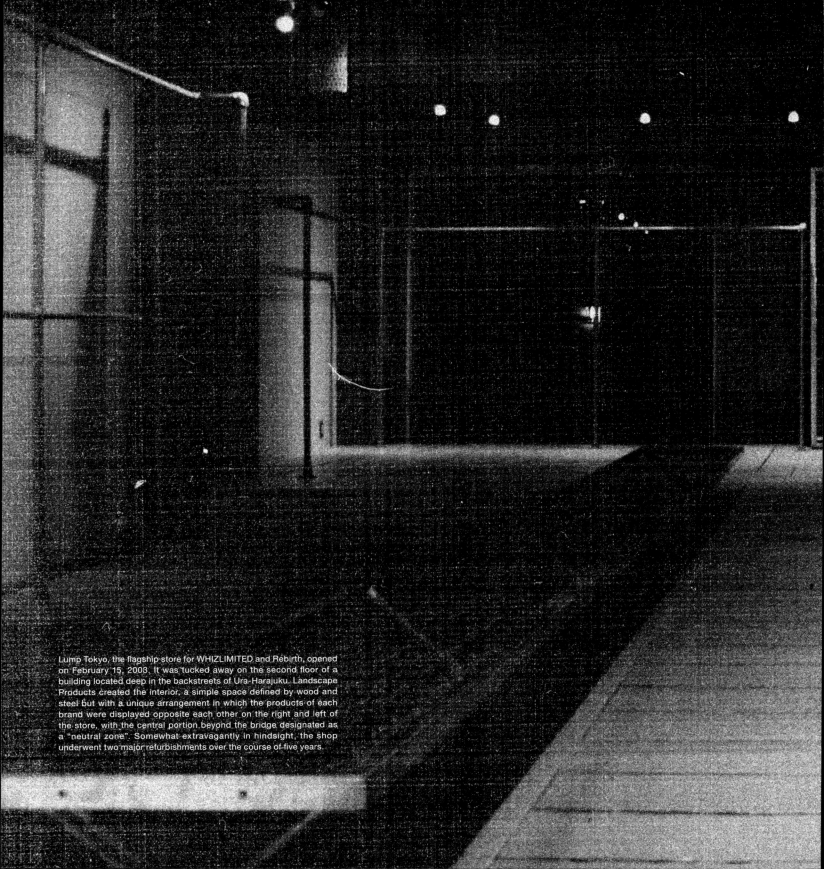

Lump Tokyo, the flagship store for WHIZLIMITED and Rebirth, opened on February 15, 2003. It was tucked away on the second floor of a building located deep in the backstreets of Ura-Harajuku. Landscape Products created the interior, a simple space defined by wood and steel but with a unique arrangement in which the products of each brand were displayed opposite each other on the right and left of the store, with the central portion beyond the bridge designated as a "neutral zone". Somewhat extravagantly in hindsight, the shop underwent two major refurbishments over the course of five years.

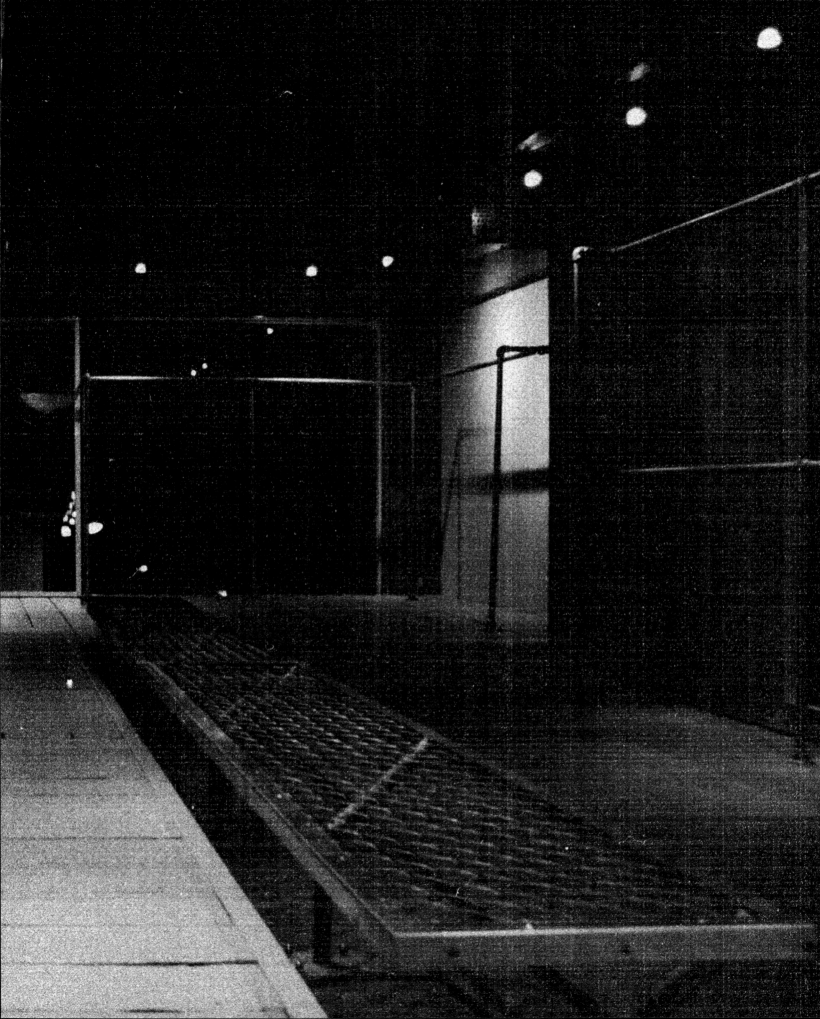

A sign painted on the side of the stairs to the second floor by Nuts Art Works was commissioned when Lump Tokyo relocated in 2008. Landscape Products were responsible for the interior once again. In August 2010 Lump Tokyo relocated once more, to its current location. The interior work was taken over by M&M Custom Performance, with a rustic interior made according to M&M's philosophy of intentionally leaving blank spaces in the design to give the user as much freedom as possible. The wooden components have held up remarkably well after over 10 years while simultaneously taking on a rich hue with age.

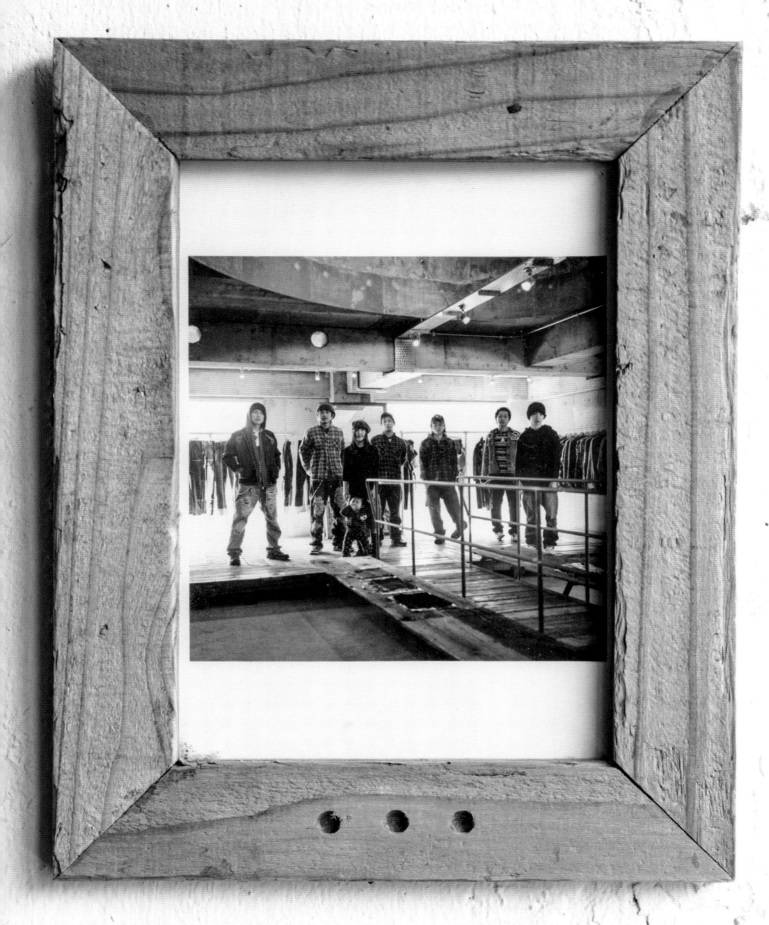

An obligatory "posse" photo of all the staff to mark the first anniversary of Lump Tokyo in February 2004. WHIZLIMITED, Rebirth, and the store representing them, were run entirely by just seven people. This 'by the select few' attitude has endured to this day. The average age of the staff at the time was 25.

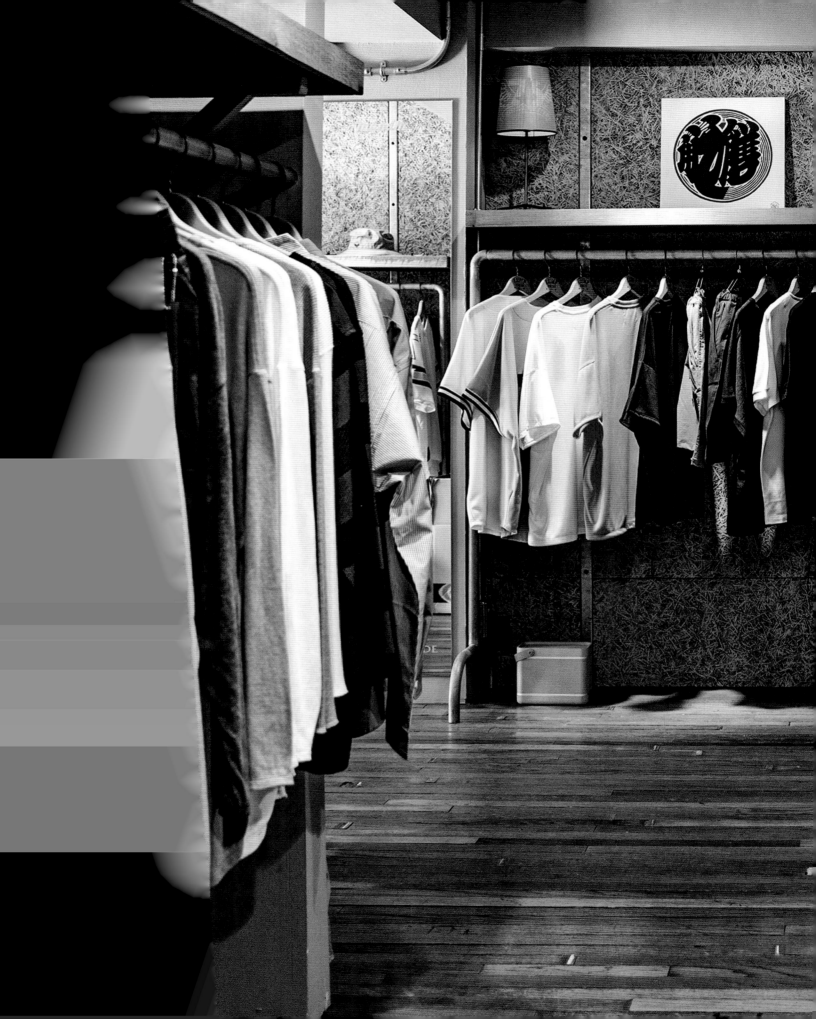

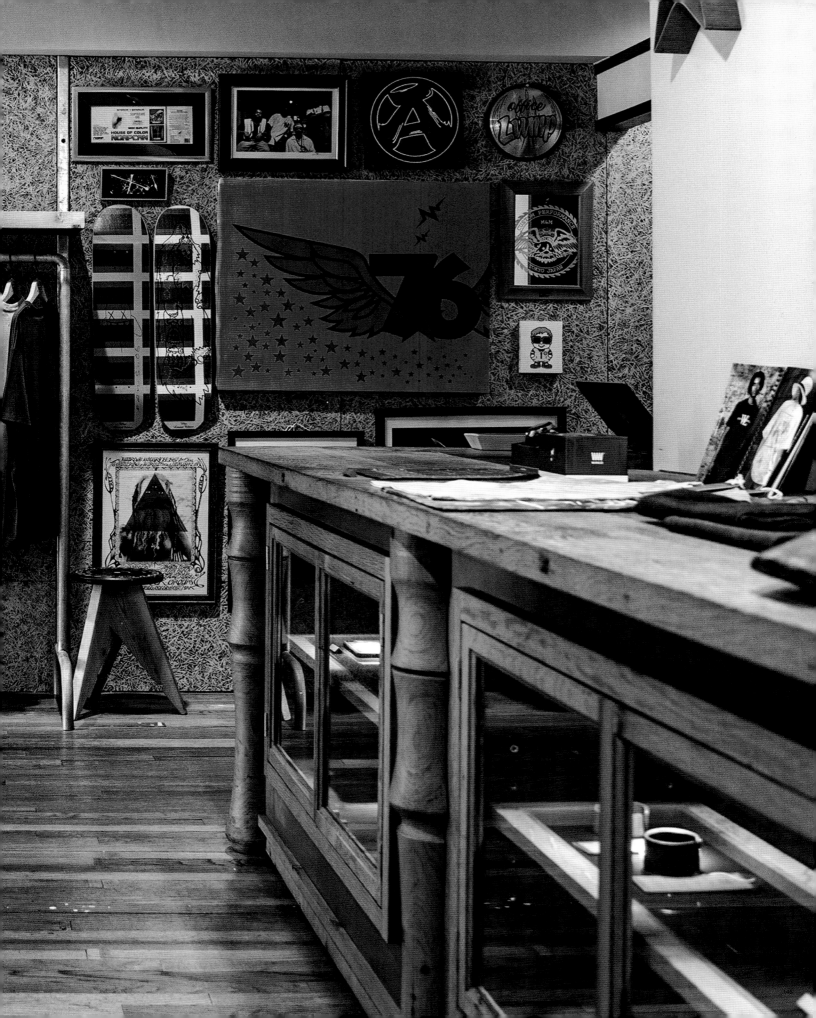

THE SPACE WHICH UNITED

AFTER 5 YEARS, SHOP L

IN ORDER TO OPEN THE DOO

SHOP JUMP" WHICH SUDDENLY APPEARED IN A CORNER OF HARAJUKU

CLOSED IN 2008.

THE NEW STAGE...

KICKS TALK

The Collaborator

A Visit to Shigeyuki Kunii, Mr. Mita Sneakers.

Shigeyuki Kunii, the creative director of Mita Sneakers in Ueno, Tokyo, is an intermediary who sets up "triple collaborations" by connecting manufacturers and creators who previously had no contact with each other. All the while disseminating many bespoke models to the global sneaker market, he is a vital force in the industry.

For Hiroaki Shitano, he is an irreplaceable partner and ally. The collaboration between WHIZLIMITED and Mita Sneakers—which has been developed with major athletic shoe manufacturers such as New Balance, Reebok, Puma, Asics, etc.—is not limited to simple colorway changes and brand-logo embroidery, but is a truly innovative custom-made lineup.

What collaborative ethic does the pair apply when they work on bespoke sneakers? By tracing the history of successive collaborations and touching on the challenges brought about by the production process on such extreme customizations, we look behind the scenes of WHIZLIMITED x Mita Sneakers.

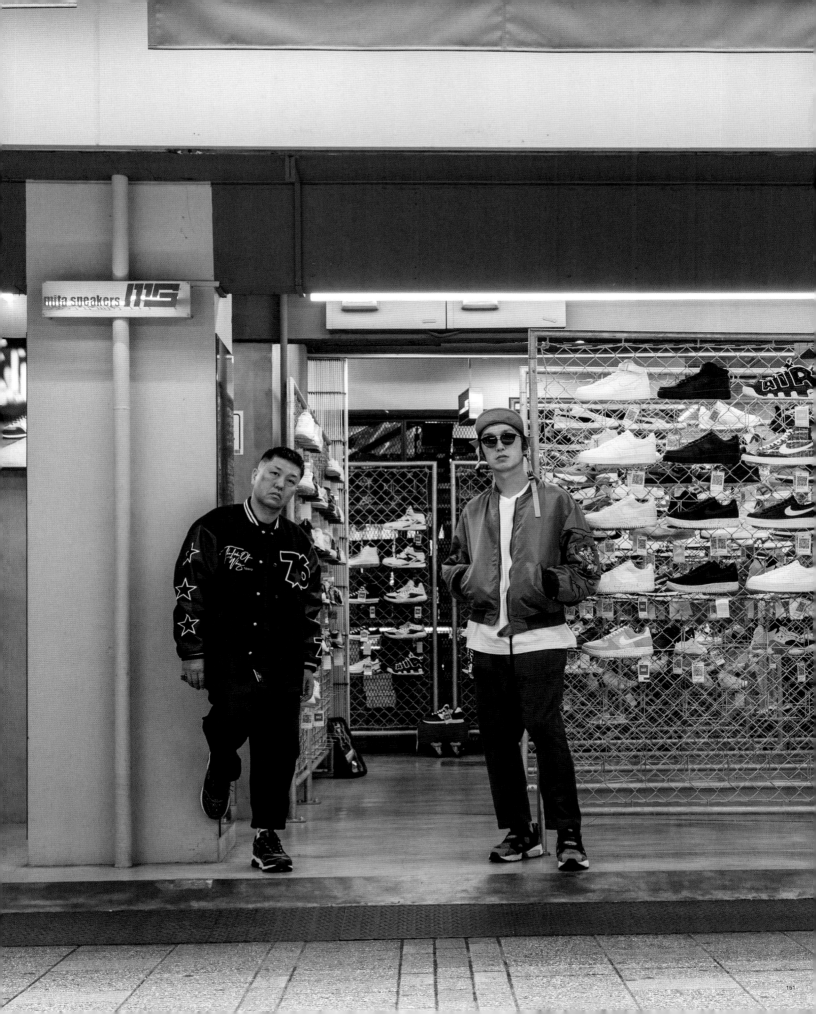

—Please tell how you met.

Shigeyuki Kunii: I met Shitano-kun just before I turned thirty. At that time, I asked an editor that I knew who he thought was the best designer among people of my generation, and Shitano-kun was on the top of his list. Naturally, I was already aware of Shitano-kun's work through the media, and I wanted my editor friend to introduce us to each other when the timing was right, so I was happy when I was invited to a WHIZ exhibition. When I met him for the first time, I was thrilled to learn that we were born in the same year, 1976, and we immediately hit it off. I recall chatting away with him in the office until the morning. Since then, we ate out, went to reception parties, went to baseball night-games, and generally joked around. That kind of relationship—without work—continued for a while.

Hiroaki Shitano: We didn't meet because of a specific business purpose, such as a collaboration, so that kind of thing didn't really come up in conversation at first. It was only after quite some time since we got to know each other that he approached me about a collaborative project with New Balance.

Kunii: At that time, all the models in the WHIZ homepage were all wearing the New Balance 1300, and with that image in my mind, I thought, "My first collaboration with Shitano-kun has to be on a New Balance project."

Shitano: I recall it with some ambiguity, but Kunii-kun, do you remember that I wanted to collaborate with New Balance through a magazine article? At that time, New Balance wasn't very fashionable. Rather than being fashion-driven, it had a more artisanal approach focused on comfort.

Kunii: The three color variations of New Balance WZ576 released in February 2005 became our first collaboration. Working with Shitano-kun was extremely refreshing. Prior to that, I had the opportunity to collaborate with my seniors, who were firmly established in Harajuku. But while they were mostly subculture figures who happened to also be making apparel, Shitano-kun was a fashion person from the ground up. I felt that, from the way he made clothes, he designed in three dimensions, and it was completely different from anyone else. At the same time, it was clear that he had a rich background in different cultures; for example, I was surprised to learn how much of a hip-hop fanatic he was. The idea of designing sneakers from such a purely fashion-oriented perspective seemed really interesting to me. On a personal level, our birthdays are only a few weeks apart which was another plus, because I've always enjoyed working with people who grew up under the influence of the same cultural trends and have similar interests.

—What other brands were you collaborating with, besides WHIZLIMITED?

Kunii: We had been collaborating with Hectic in Harajuku for over 10 years on a specific model called the MT580, also from New Balance. That's why I felt that when working WHIZ, which is also based in Harajuku, we should try to collaborate on different models from various brands instead. Shitano-kun is someone who is able to take an in-depth look at manufacturers and models without being bound by preconceptions, so I felt that he would be receptive to working on different products from various brands.

Shitano: But WHIZ also custom-ordered the New Balance 580 from you.

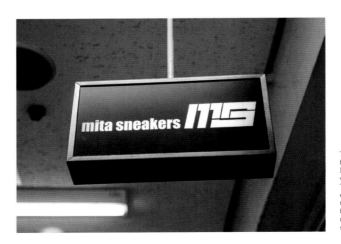

The sneaker shop, Mita Sneakers, which has sales floors on the 1st and 2nd floors of the Ameyoko Center Building, is a 3-4 minute walk from JR Ueno Station, which is known as the gateway to eastern Japan and the Tohoku region. With roots in the manufacturing and sale of traditional Japanese footwear dating back six decades, the business shifted towards the sale of sneakers some forty years ago just as sneaker culture had begun to take root in Japan, making Mita Sneakers one of the longest-standing stores of its kind.

Kunii: Yes! I did make a bespoke 580. Shitano-kun called me. "The 580, isn't it good?" He then found a basketball shoe called the P580, which had nothing to do with the MT580. I mean, at the time, no one wanted to do bespoke with New Balance basketball shoes [laughs]. This was our second collaboration, but in fact there was a 'phantom' 574 between the WZ576 and P580 collaborations which unfortunately did not see the light of day. The material selected by Shitano was too challenging due to its physical characteristics, and we had to give up the idea of putting it into production.

Shitano: You mean the 574 that used shirt fabric for the upper, right? It looked crisp because it was lined, but it would tear where it was stitched. There were quite a few cases like that we'd only reach the sample stage and it would end there.

—How do your collaborations start in the first place?

Kunii: It varies from time to time, but most often, it's the manufacturer who approaches us about collaborating on a particular model. Another way is when Shitano-kun and I would recall an earlier conversation where we would fantasize about bespoke models of this, that, or other brand, then decide to contact the manufacturer directly to see if they would be willing to work with us. Such cases are really extensions of us shooting the shit, and start from a place that has nothing to do with what you would call a business mindset.

Shitano: When a manufacturer approaches me through Kunii-kun, I will get on board if I find the project interesting. If not, I will just politely decline.

Kunii: In our case, we basically propose a base model, let Shitano-kun design it freely, and then I take care of the technical behind- the-scenes work, such as adjusting the details necessary for the structure of the sneaker and selecting materials. I then convey the ideas and images from Shitano-kun as accurately and concisely as I can to the manufacturer. If I can't explain what we are trying to achieve to them in an understandable way, they might just turn around and say, "Sorry, we can't do this." Then, the person taking care of the project on the manufacturer's end also needs to convey the design to the production factory, and it's like a message-game in which slight differences in nuance along the chain of communication can lead to huge cumulative changes which only become apparent when the sample arrives. Shitano-kun is constantly trying new things, so the process of communicating his ideas to the manufacturer without missing subtle nuances is gratifying and challenging at the same time. In a sense, by ordering a bespoke model, we are borrowing something from the manufacturer, so I always have a conscious desire to leave them new, useful ideas in return.

Shitano: I'm not conscious of anything. As with my clothing, I am pretty much doing what I like. I draw a picture and input the materials, and ask Kunii-kun to finalize the technical aspects without getting into the finer details too much myself.

Kunii: Well, even when you do triple-collaborations like that, you never announce what you intend to release at the next 76 Summit, so ... [laughs]

Shitano: We don't make announcements because I don't want random strangers turning up. Fans who have always

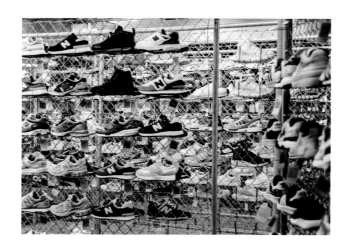

The unique space surrounded by wire mesh cages symbolizes Tokyo's street culture. Mita Sneakers uses wire mesh graphics of its signature patterns in branding. Hundreds of sneakers are displayed at the store, and its diverse lineup boasts one of the highest quality selections in Japan.

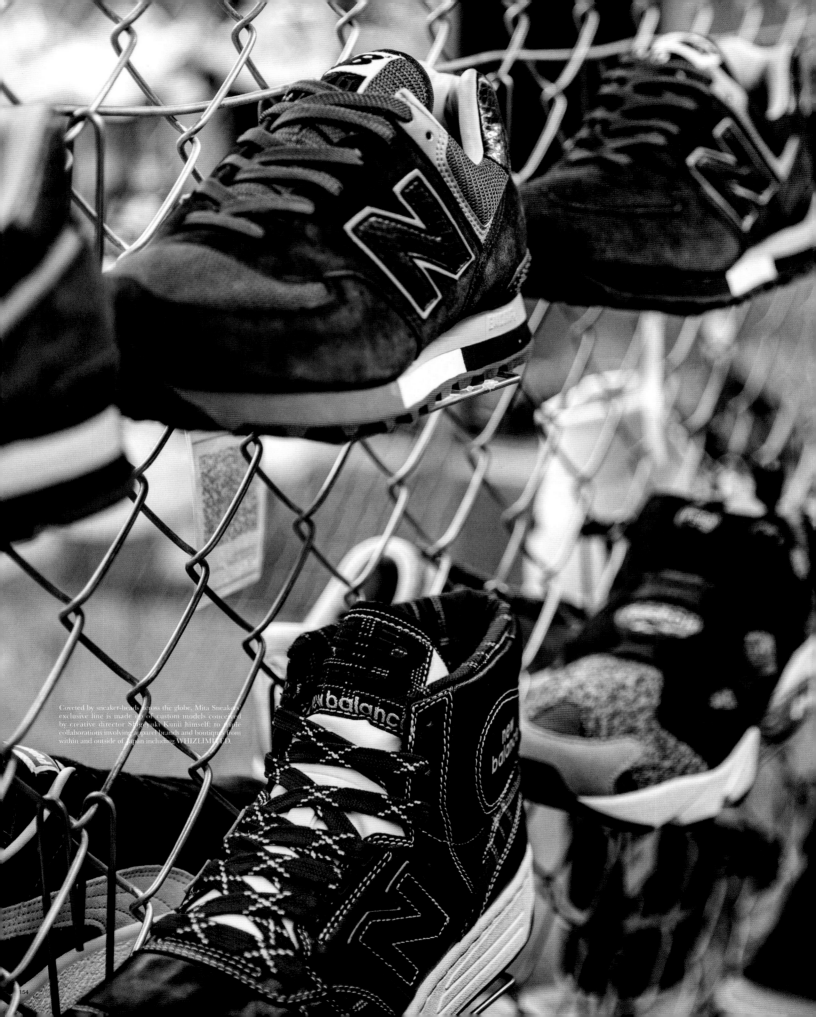

Coveted by sneaker-heads across the globe, Mita Sneakers' exclusive line is made up of custom models conceived by creative director Shigeyuki Kunii himself; to triple collaborations involving apparel brands and boutiques from within and outside of Japan including WHIZLIMITED.

supported the brand know that something special will come out on July 6th without us advertising it. That day is for regulars only because we want special items like that to only go to true fans of WHIZLIMITED. It's just phenomenal that we have customers who queue from the day before even though they have no idea what we will release. I can't thank them enough.

Kunii: In our collaborations with WHIZLIMITED, Shitano-kun concentrates entirely on the design while leaving a role for me as the shoe expert. I believe we have something which can be described as a true collaborative process, as opposed to simply pairing brand names with each other. I mean, "collaborations" are too often just money-making ventures where one brand borrows another brand's name, or they just license a popular character they can print onto a product. So, in comparison, I believe what we are doing is more meaningful. I'm always excited about what kind of designs Shitano-kun will come up with next. Sometimes, I will get an email from him with a new proposal that blows my mind, and I'm like, "Whoa that is really out there," and have to close my email to give myself a second.

Shitano: Well, I got you again recently, didn't I? I'm well aware that some of my ideas will be really difficult. But I think it's easier to just come out with everything you want to do as a starting point, then cut away as needed from there.

Kunii: Shitano-kun is always clear about the particulars he cannot compromise on, while giving me a free hand to execute everything else as I see fit, which is really helpful. He seems to have a clear idea about what he wants to achieve every time.

—What was the most memorable triple-collaboration of all time?

Kunii: Personally, the Puma Suede with red lamps on the heel that was unveiled on the runway at Tokyo Fashion Week.

Shitano: Ah, that was crazy [laughs]. It might be my favorite as well. At some point, I heard from Kunii-kun that Puma was making shoes that light up in the dark, and I immediately thought that they would be a perfect match for the theme of the upcoming exhibition and had to have them. There was barely enough time, but Kunii-kun miraculously got the shoes rushed into production.

Kunii: Originally, I was planning to use the light-up Puma suede as a base-model for cycling shoes and had already been in the process of getting them into production, but I felt that I simply couldn't hand the shoes over to Shitano-kun as they were. I knew what the runway show meant to him, and I wanted the shoes to be something really special. So, when I consulted with Puma's global team, they promptly replied that they knew of WHIZ and would be willing to help us out. In fact, the level of support they extended to us was phenomenal."

Shitano: I remember on the day of the show, we were checking the shoes backstage one by one, going, "This one lights up OK. This other one doesn't work." It was nuts.

Kunii: Because the shoes were rushed into production at our request, there were inevitable teething problems, like the wiring inside would sometimes break from impact. We both had to spend so much time checking the shoes that all the staff joked that we must be working for Puma.

Shitano: The knit Reebok Pump Fury is another memorable one. We always thought wearing mixed socks with Birkenstock or Teva sandals was cool and wanted to incorporate that look into the Pump Fury.

Kunii: At the time, flyknit, prime knit, and various knit material uppers began to appear in the sneaker industry, but we decided to go with a much older style of knit material. It was fun deliberately making something that went against the current.

Shitano: The UGG boots project was an interesting collaboration, too. In an oddball way.

Kunii: This started as a collaborative proposal from UGG, who approached me about making a bespoke sneaker model. Initially, I felt that it would be best to keep the sole as it was, and add a classic sheepskin upper. I didn't think Shitano-kun would be interested, but when I talked to him about getting involved, he said, "I'll give it a try." When he got back to me with his initial concept, I was blown away by this insane hybrid design that was beyond my wildest imagination. The shoe had mudguards in line with traditional sneaker design and distinctive detailing. If I had taken on the project on my own, I would have just stuck a sheepskin boot upper onto raised soles and called

Mita Sneakers created a Puma Suede model for WHIZLIMITED's SS2013 collection featuring red lamps in the heels which were supposed to light up in the dark. Due to teething problems owing to the last-minute production, each pair had to be checked on-site for loose wiring. Among the numerous triple collaborations by Puma, WHIZLIMITED and Mita Sneakers, a memorable model for all involved.

it a day, but when Shitano-kun had a go, he updated every detail of the model, while maintaining an overall sense of impeccable balance. It was the work of a true designer. I find our collaborations so gratifying because he always comes back with ideas that exceed my expectations by 120% or even 150%.

Shitano: This goes for clothing as well, but I would never want to be on the production end of something I designed. It must be so much work! [laughs]

Kunii: It was really difficult when I had to try putting gradation on the natural leather on a Puma Suede model. Even with the recent advances in inkjet printing, it was an impossible task and had to give up. Looking back though, there wasn't a single project with Shitano-kun that I can point at and say, "That one was a piece of cake."

Shitano: When I make sneakers, I always keep in mind what would go well with my clothing. I tend not to look at sneakers on their own, and I also choose different materials depending on my state of mind from time to time. I don't think about creating sneakers; I think about creating styles.

Kunii: From my perspective as a shoe maker, the sneakers you design are unique in their own right. Like, they're an embodiment of WHIZ's attitude.

Shitano: The Asics Gel Light V was another good one. It was linked with WHIZ's seasonal textiles, and each pair featured a unique original Afghan pattern.

Kunii: Generally speaking, most manufacturers prefer to make uniform products, which don't differ from unit to unit within the same production run, so we had to take a great deal of care to explain our motives in order to convince Asics put this shoe into production. This particular model

was released in 2015, during a period when Asics was still plagued with an image of being a brand worn by either junior high school kids or old people, especially in the eyes of people outside of Tokyo.

Shitano: One dealer for WHIZLIMITED even said to me, "You're doing an Asics model?! Are you sure that's a good idea?" But, when I got the sneakers on the cover of *Shoes Master* and they went on sale shortly afterwards, people snapped them up. A lot of our dealers outside Tokyo were like, "Damn, we should have stocked more!"

Kunii: I really felt the difference in the levels of enthusiasm in Tokyo and the rest of the country with that model. But besides that, working with WHIZ has meant that I got to be a part of runway shows, exhibitions in Paris, and so much else that I never would have been able to experience while simply running a sneaker shop in Ameyoko.

—What direction will the collaboration between WHIZLIMITED and Mita Sneakers take in the future?

Shitano: For the time being, our goal is to work with every single sneaker brand in the world. [Laughs]

Kunii: I feel that we could expand the scope of our collaborations outside sneakers too. I'd love to see a Birkenstock designed by Shitano-kun, for example. In that sense, the UGG collaboration was perhaps the first step in that direction. I want to expand into all kinds of footwear, not just limited to sneakers.

Shigeyuki Kunii, Creative Director at Mita Sneakers, who runs the long-established sneaker shop in Ueno, Tokyo. Working on original bespoke projects surprisingly inspired by classical eastern philosophical themes such as *Onko Chishin* ("learning from the past") and *Shinra Bansho* ("all things in the universe"), Kunii has been engaged in "triple-collaborations" as a bridge between manufacturers and creators. Since debuting as a salesperson for the Nike Air Total Max 95, his is a career spanning a quarter of a century. A genuine collaborator who continues to be at the forefront of the scene and has partnered with practically everyone in the scene, Tokyoites have anointed him worthy of the title "sneaker master."

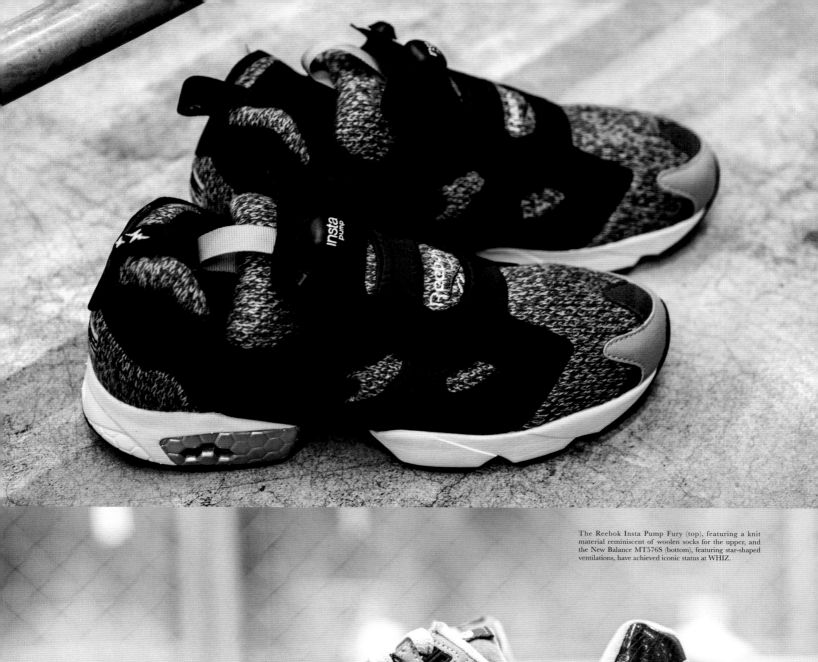

The Reebok Insta Pump Fury (top), featuring a knit material reminiscent of woolen socks for the upper, and the New Balance MT576S (bottom), featuring star-shaped ventilations, have achieved iconic status at WHIZ.

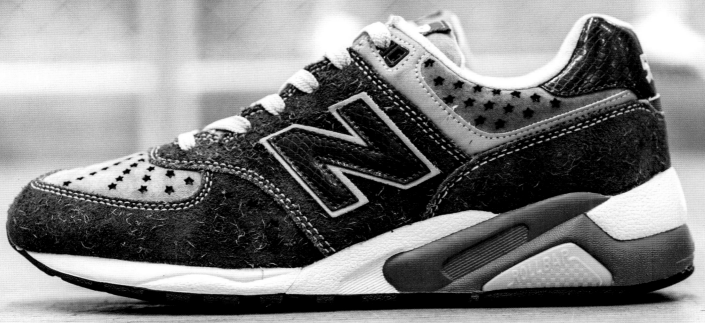

WHIZLIMITED and Mita Sneakers, brands that constantly seek out new details and strive to use the most innovative materials have collaborated at every opportunity. The masterful craft of Shigeyuki Kunii has made the materialization of the free-spirited ideas of designer Hiroaki Shitano possible time and again, bringing numerous innovations to the sneaker industry. Here, we see their collaborative work with the world's top sneaker brands over the years assembled in all their glory.

New Balance
WZ576 by WHIZLIMITED & Mita Sneakers

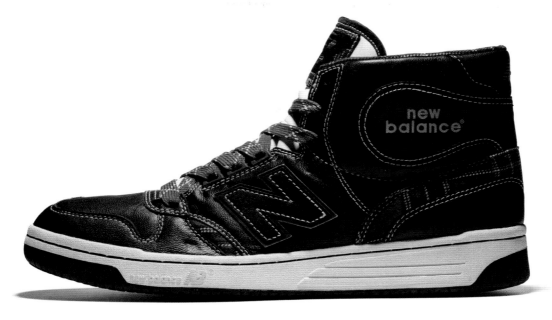

New Balance
P580 by WHIZLIMITED & Mita Sneakers

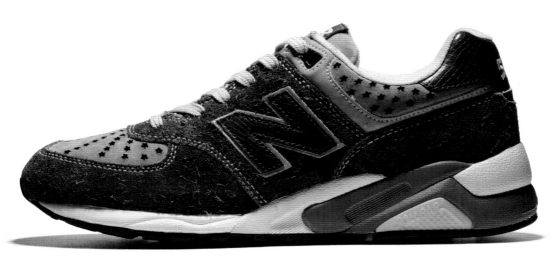

New Balance
MT576S by WHIZLIMITED & Mita Sneakers

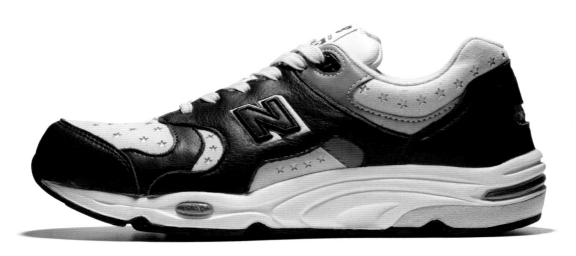

New Balance
CM1700 by WHIZLIMITED & Mita Sneakers

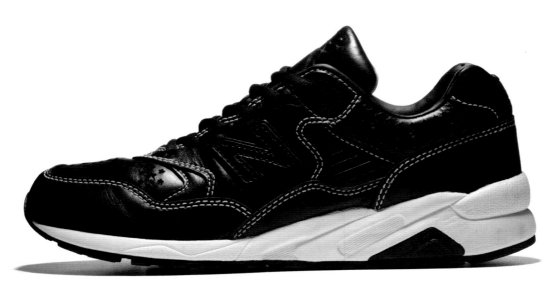

New Balance
MRT580 by WHIZLIMITED & Mita Sneakers

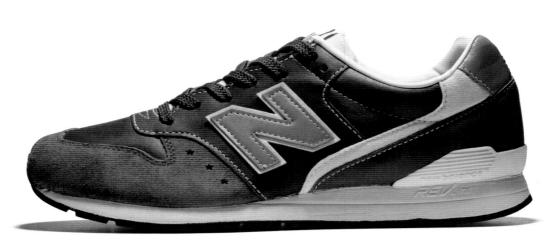

New Balance
MRL996 by WHIZLIMITED & Mita Sneakers

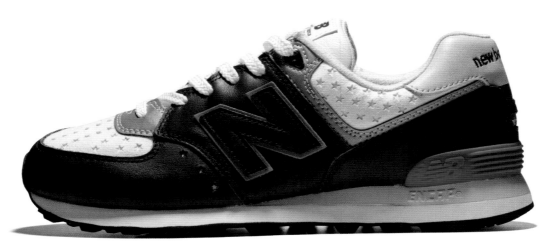

New Balance
ML574 "Iconic Collaboration" by WHIZLIMITED & Mita Sneakers

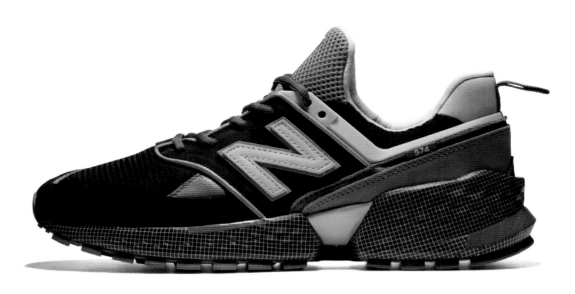

New Balance
MS574 V2 "Screen" by WHIZLIMITED & Mita Sneakers

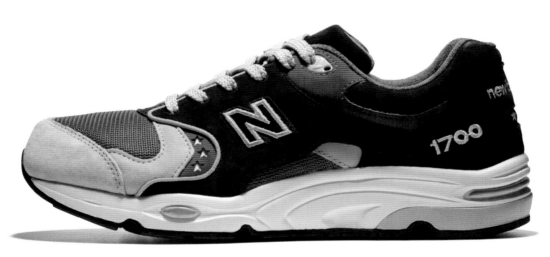

New Balance
CM1700 by WHIZLIMITED & Mita Sneakers

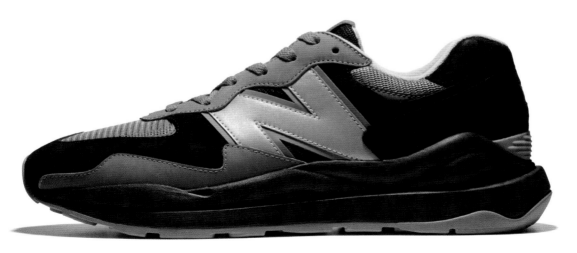

New Balance
M5740 "Neo" by WHIZLIMITED & Mita Sneakers

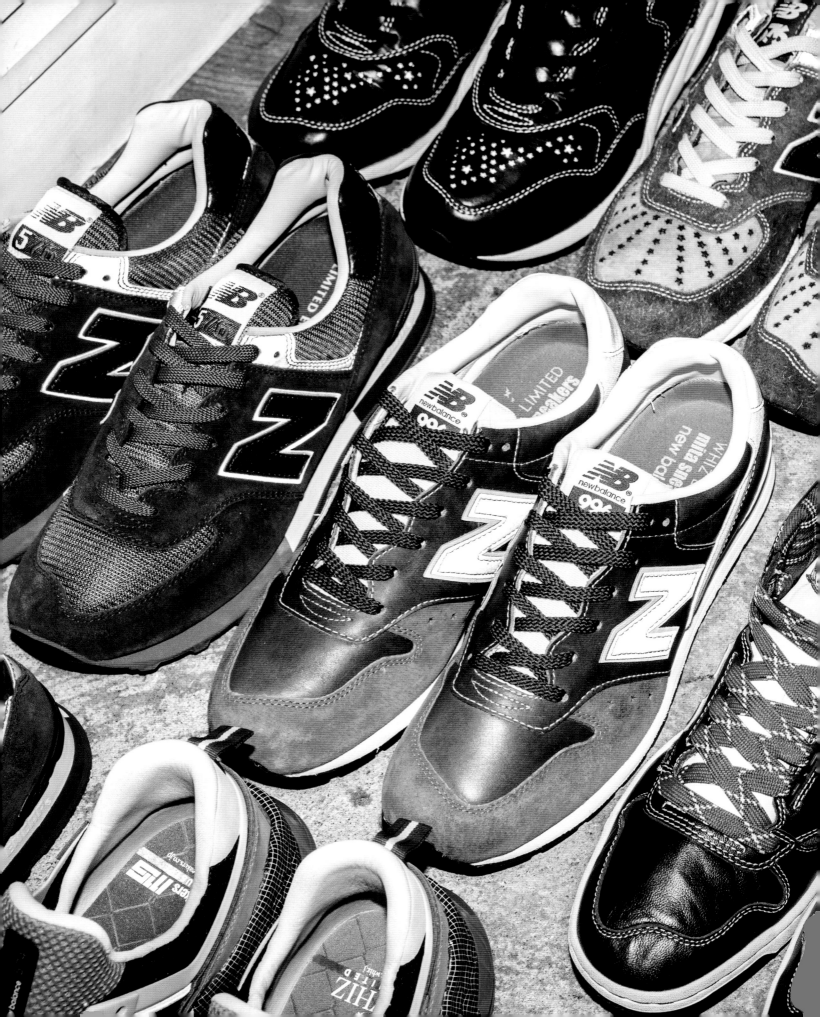

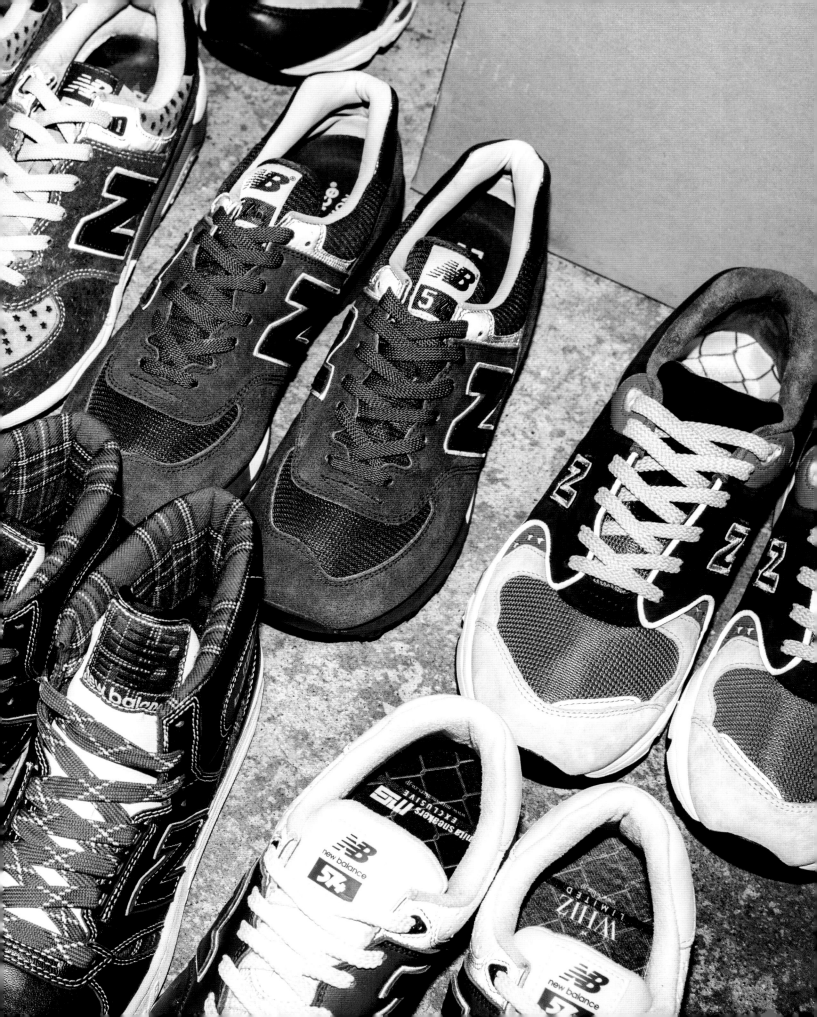

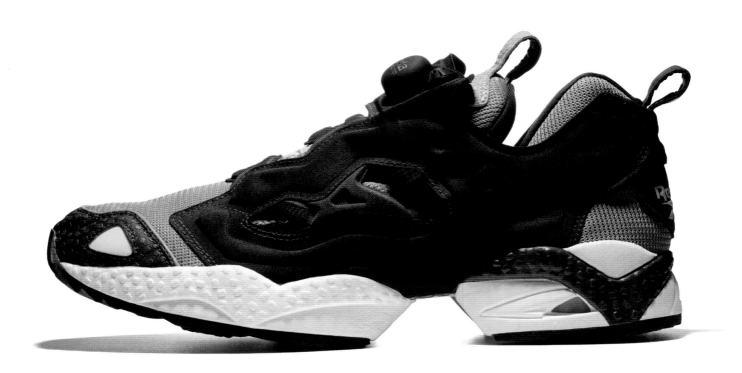

Reebok CLASSIC
Insta Pump Fury by WHIZLIMITED & Mita Sneakers

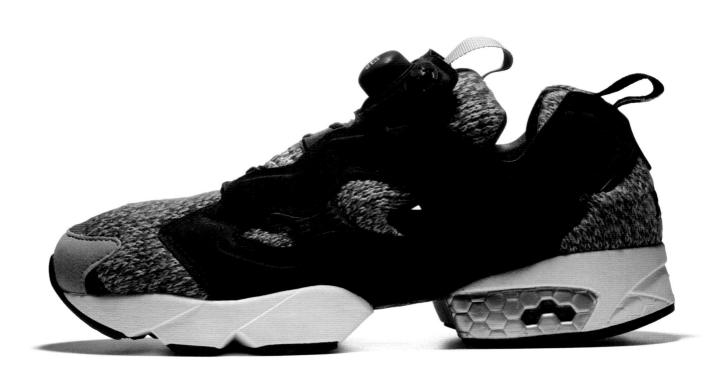

Reebok CLASSIC
Insta Pump Fury OG by WHIZLIMITED & Mita Sneakers

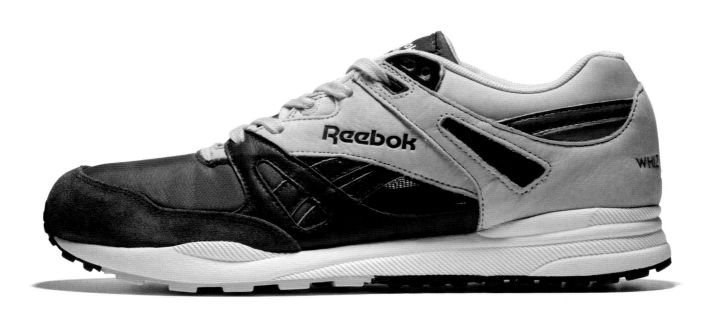

Reebok CLASSIC
Ventilator Affiliates by WHIZLIMITED & Mita Sneakers

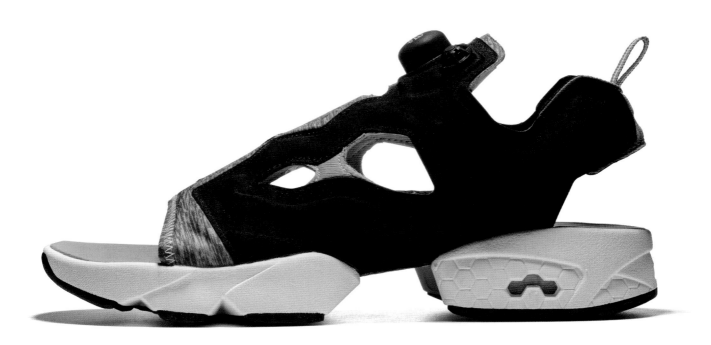

Reebok CLASSIC
Insta Pump Fury Sandal by WHIZLIMITED & Mita Sneakers

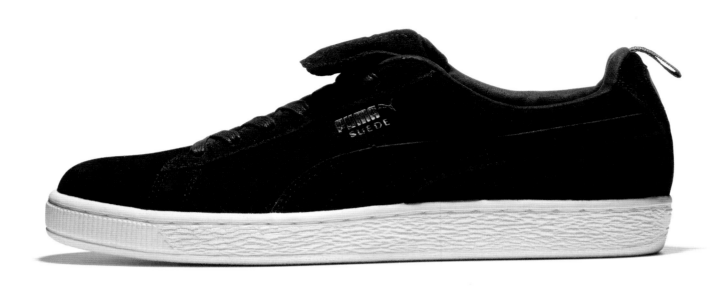

Puma
Suede Cycle Mita for WHIZLIMITED 2013SS "Off City" (Prototype)

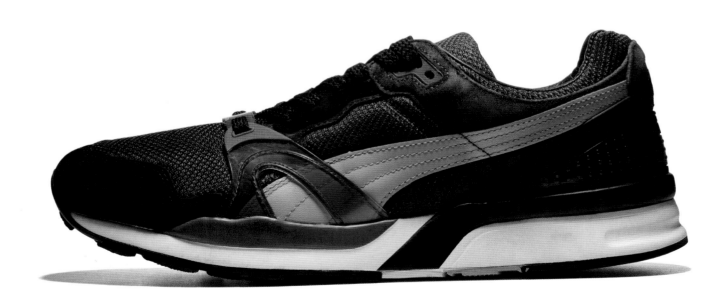

Puma
Trinomic XT2 by WHIZLIMITED & Mita Sneakers

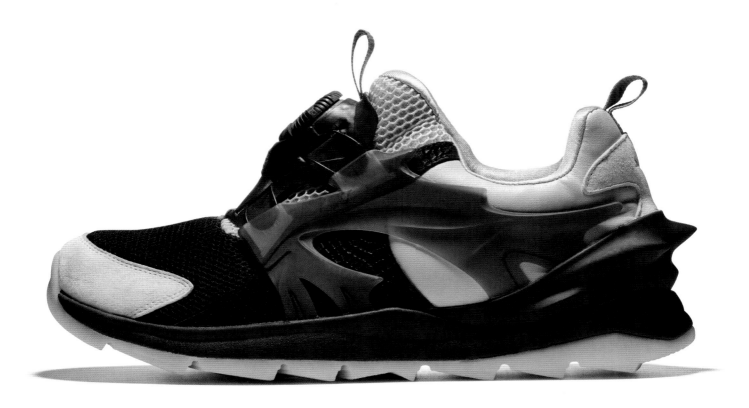

Puma
Disc Swift Tech WM by WHIZLIMITED & Mita Sneakers

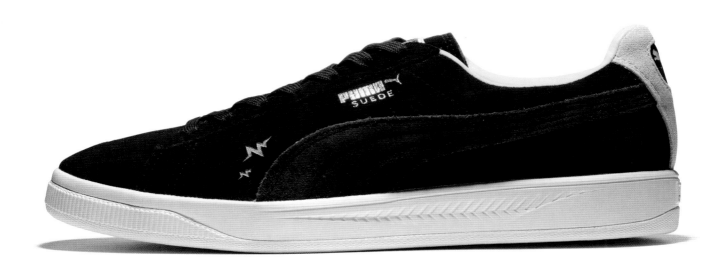

Puma
Suede Ignite WM by WHIZLIMITED & Mita Sneakers

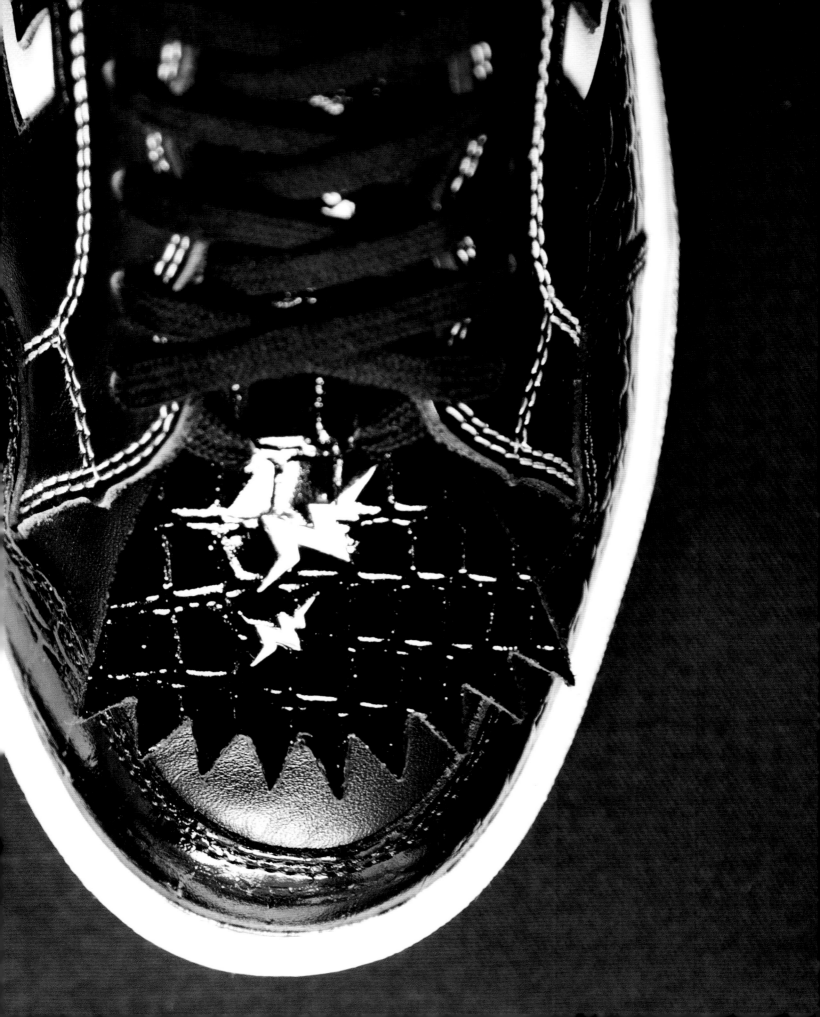

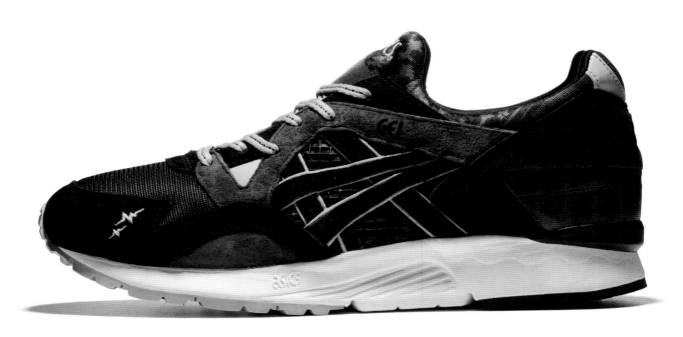

Asics
Gel-Lyte V 'Recognize' by WHIZLIMITED & Mita Sneakers

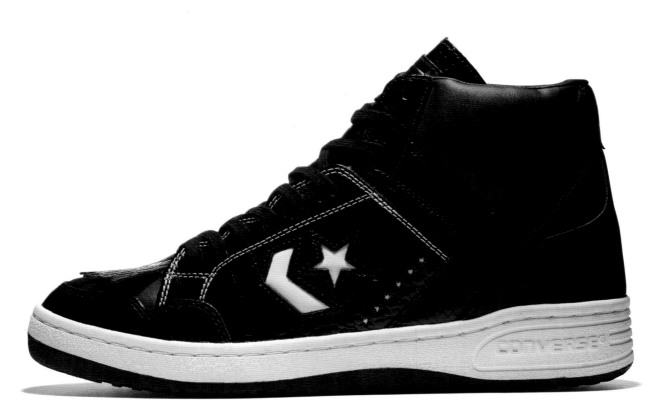

Converse
Weapon HI / MS WL by WHIZLIMITED & Mita Sneakers

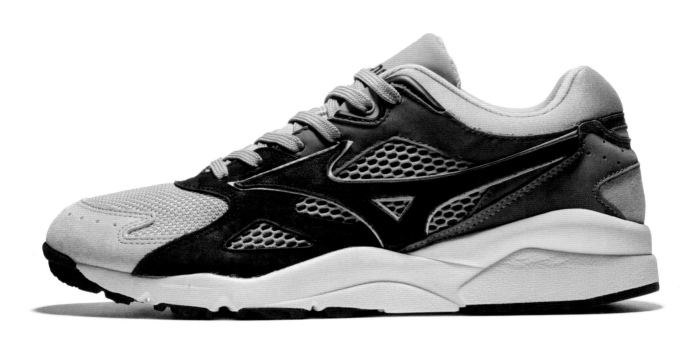

Mizuno
Sky Medal 'Greyscale' by WHIZLIMITED & Mita Sneakers

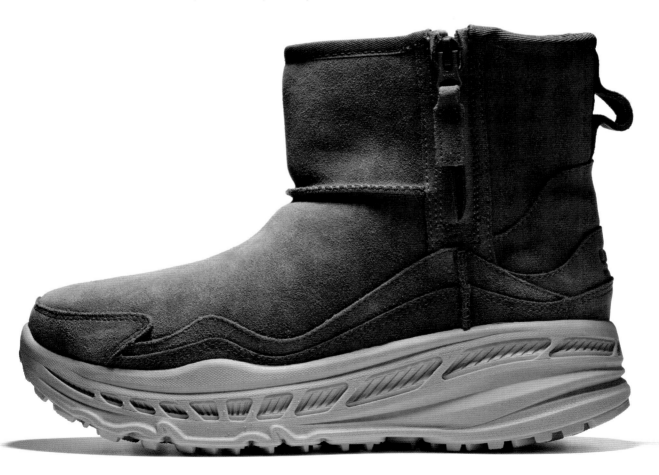

Ugg
M Mita x WHIZ Classic 805 by WHIZLIMITED & Mita Sneakers

IMITEDMITASNEAKERS

Felicity, a collaborative project between WHIZLIMITED and creative director Kazuki Kuraishi, produced an apparel line characterized by a distinctive embroidered star as well as a variety of classic sneakers in partnership with Adidas Originals.

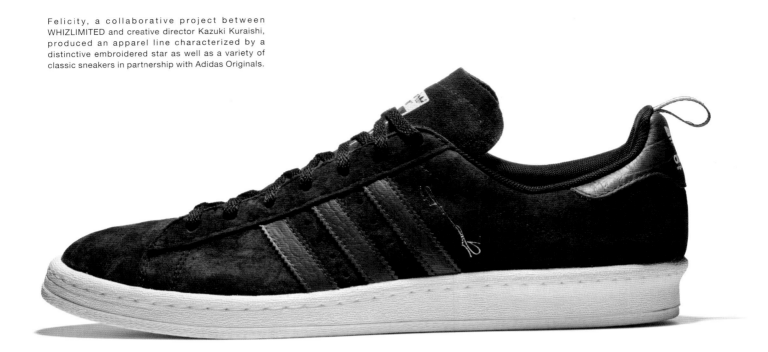

Adidas Originals by Originals
Campus 80s Felicity

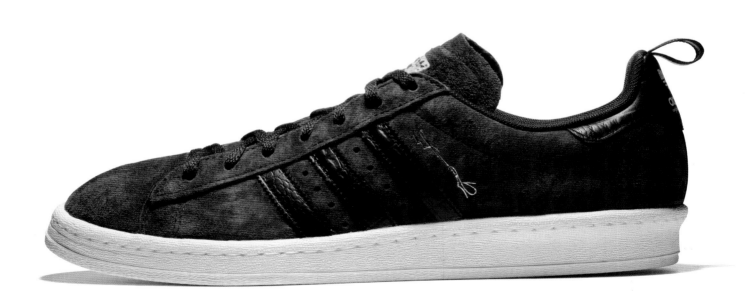

Adidas Originals by Originals
Campus 80s Felicity

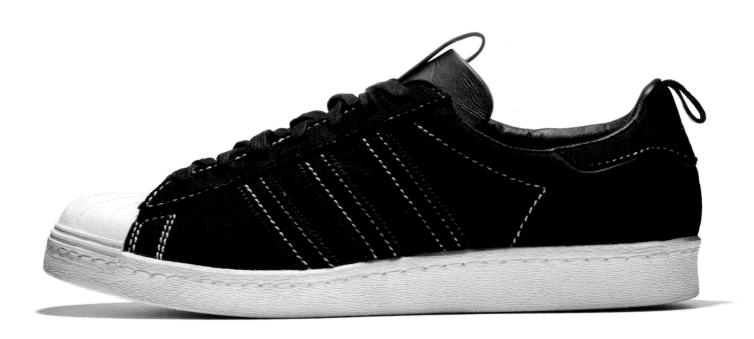

Adidas Originals by Originals
SS 80s Felicity

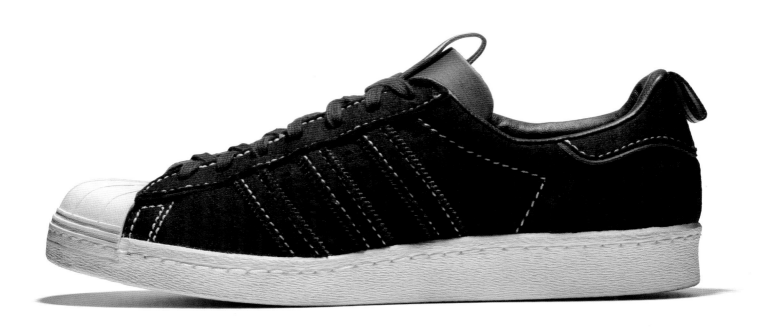

Adidas Originals by Originals
SS 80s Felicity

Adidas Originals by The Fourness
Rivalry Hi WHIZ Fourness

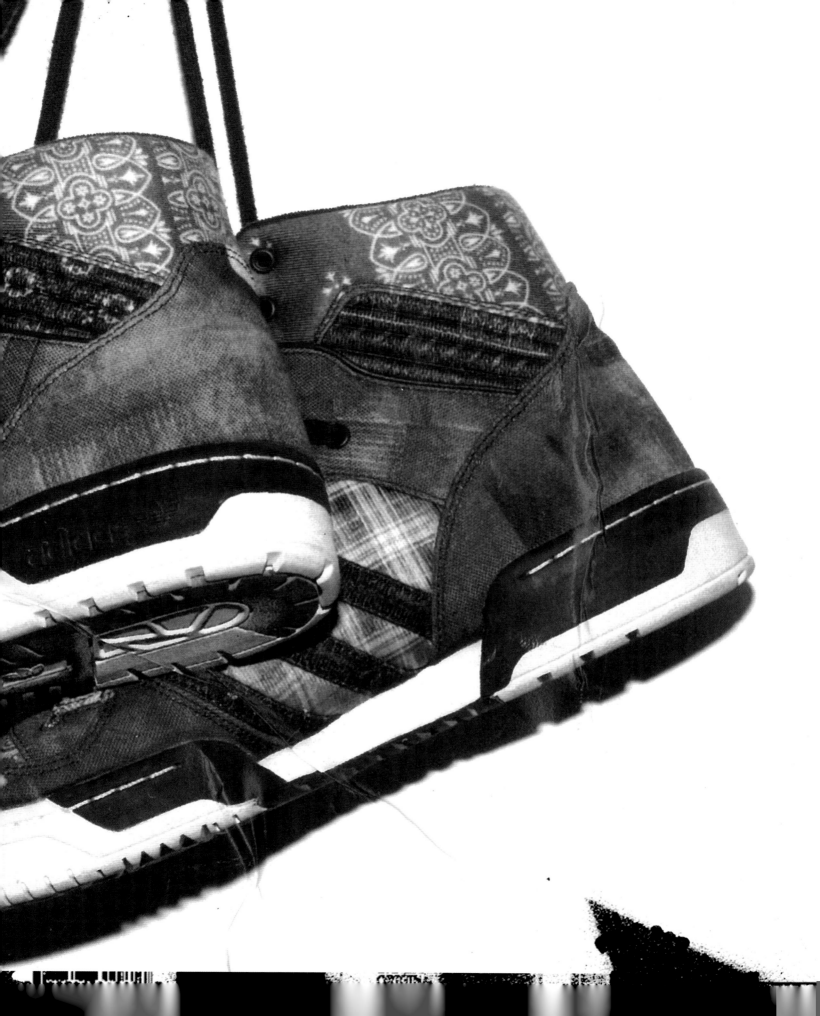

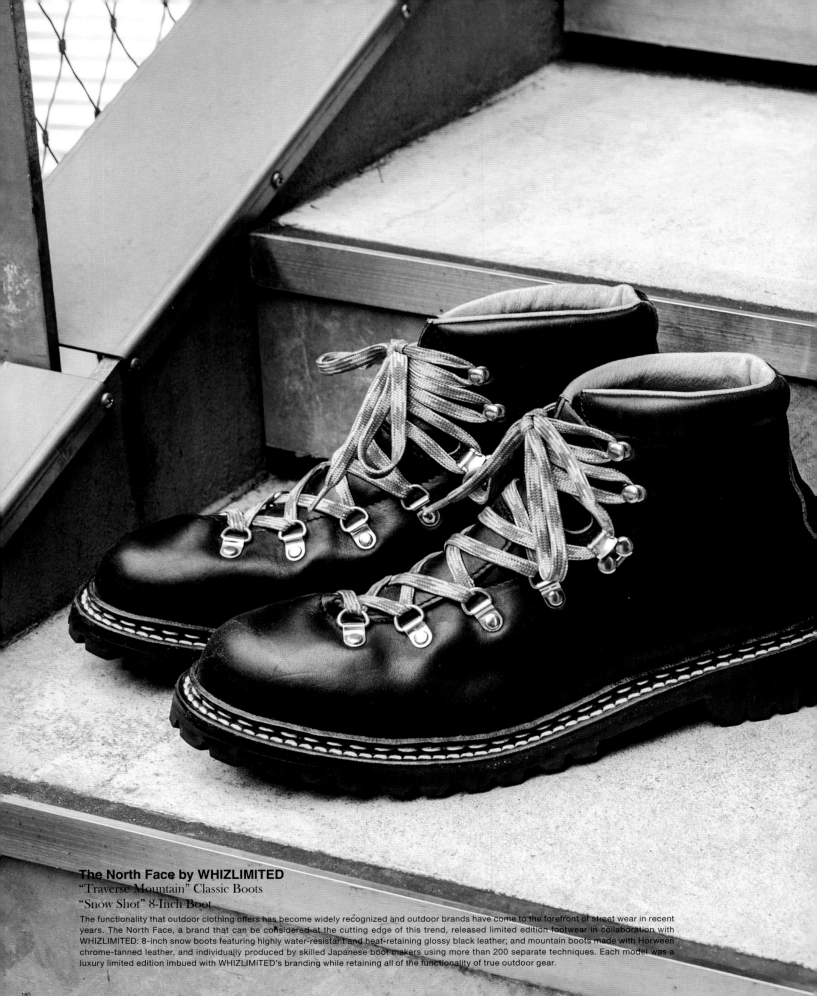

The North Face by WHIZLIMITED
"Traverse Mountain" Classic Boots
"Snow Shot" 8-Inch Boot

The functionality that outdoor clothing offers has become widely recognized and outdoor brands have come to the forefront of street wear in recent years. The North Face, a brand that can be considered at the cutting edge of this trend, released limited edition footwear in collaboration with WHIZLIMITED: 8-inch snow boots featuring highly water-resistant and heat-retaining glossy black leather; and mountain boots made with Horween chrome-tanned leather, and individually produced by skilled Japanese boot makers using more than 200 separate techniques. Each model was a luxury limited edition imbued with WHIZLIMITED's branding while retaining all of the functionality of true outdoor gear.

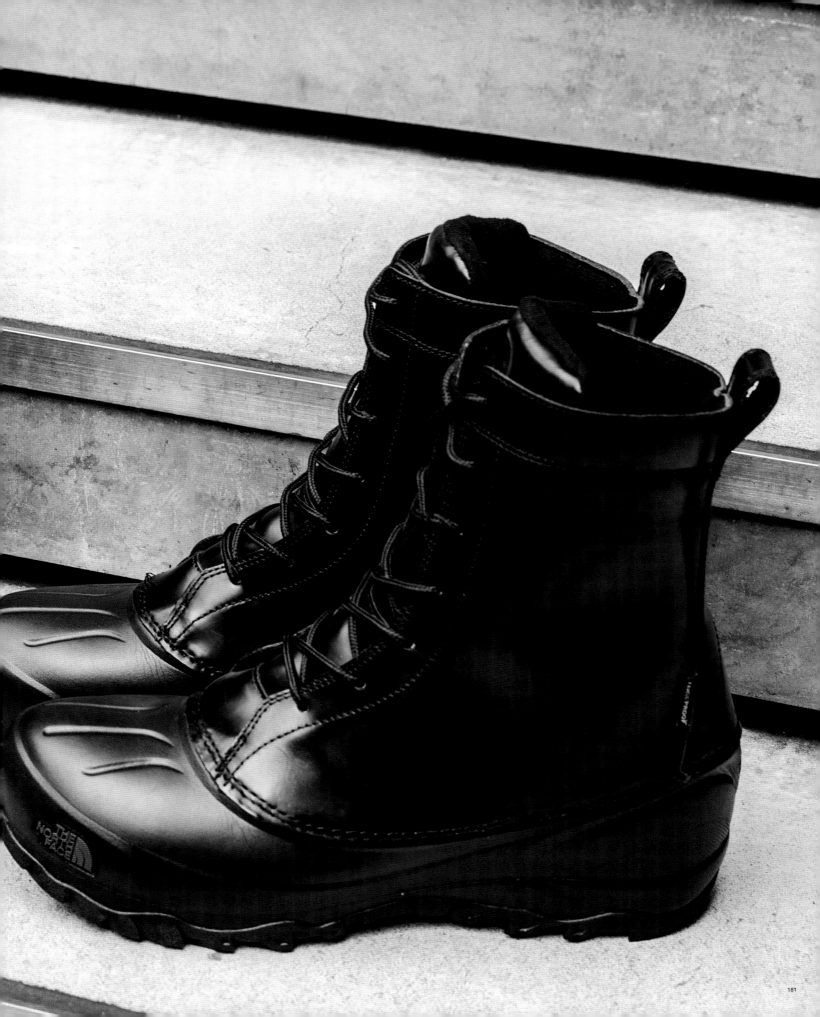

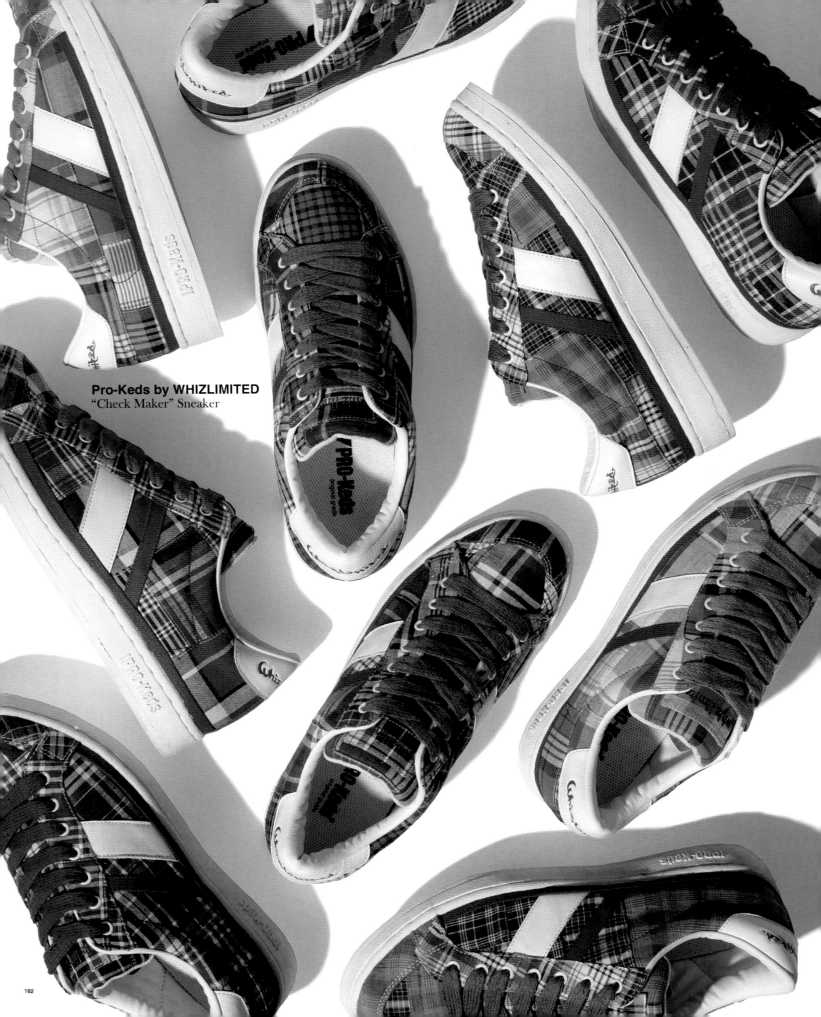

Pro-Keds by WHIZLIMITED
"Check Maker" Sneaker

182

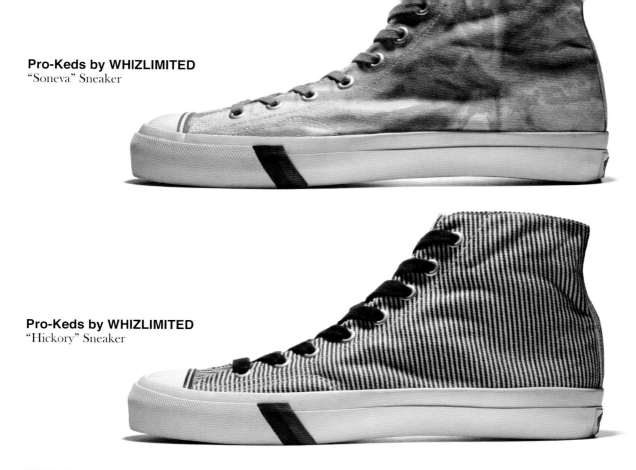

Pro-Keds by WHIZLIMITED
"Soneva" Sneaker

Pro-Keds by WHIZLIMITED
"Hickory" Sneaker

WHIZLIMITED partnered with Pro-Keds, a long-standing brand established in 1949 as a subsidiary of Keds to market its canvas basketball shoes, to release a range of custom sneakers over two seasons. The Check Maker was a low-top model featuring the Pro-Keds red and blue stripe, with uppers coming in a variety of five different patchwork shirt fabrics. The second collaboration came in the form of four high-top sneakers in tie-die, hickory, camouflage, and regimental stripes as part of the 2007SS collection themed "Resort, Work, Military, Formal".

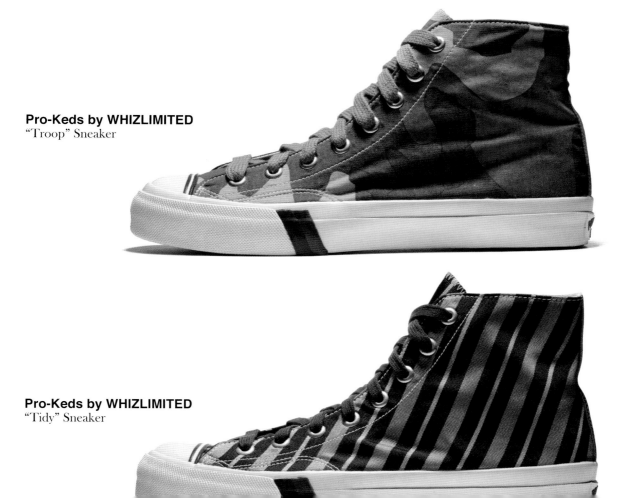

Pro-Keds by WHIZLIMITED
"Troop" Sneaker

Pro-Keds by WHIZLIMITED
"Tidy" Sneaker

183

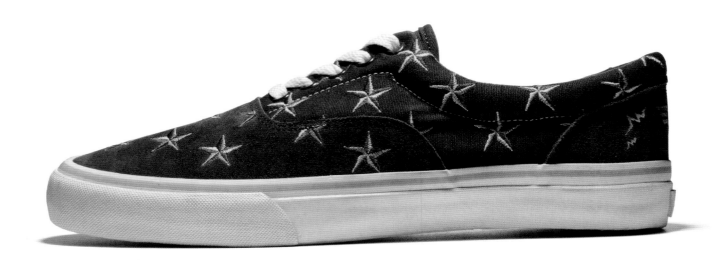

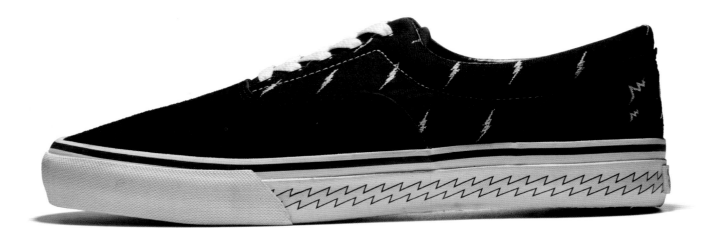

Airwalk x DC Comics
"Dude Wonder Woman"
"Dude Flash"

WHIZLIMITED engaged in a triple-collaboration with DC Comics and Airwalk, a skate shoe brand established in 1986. A high-top model featuring the "A" logo and a basic low-top, sold during Airwalk's early days, were adorned with motifs of popular characters from the DC Comics universe such as Wonder Woman and Flash, resulting in sneakers with a true oldskool legacy and a pop of color with comic-style graphics of the era.

TM&©DC Comics.

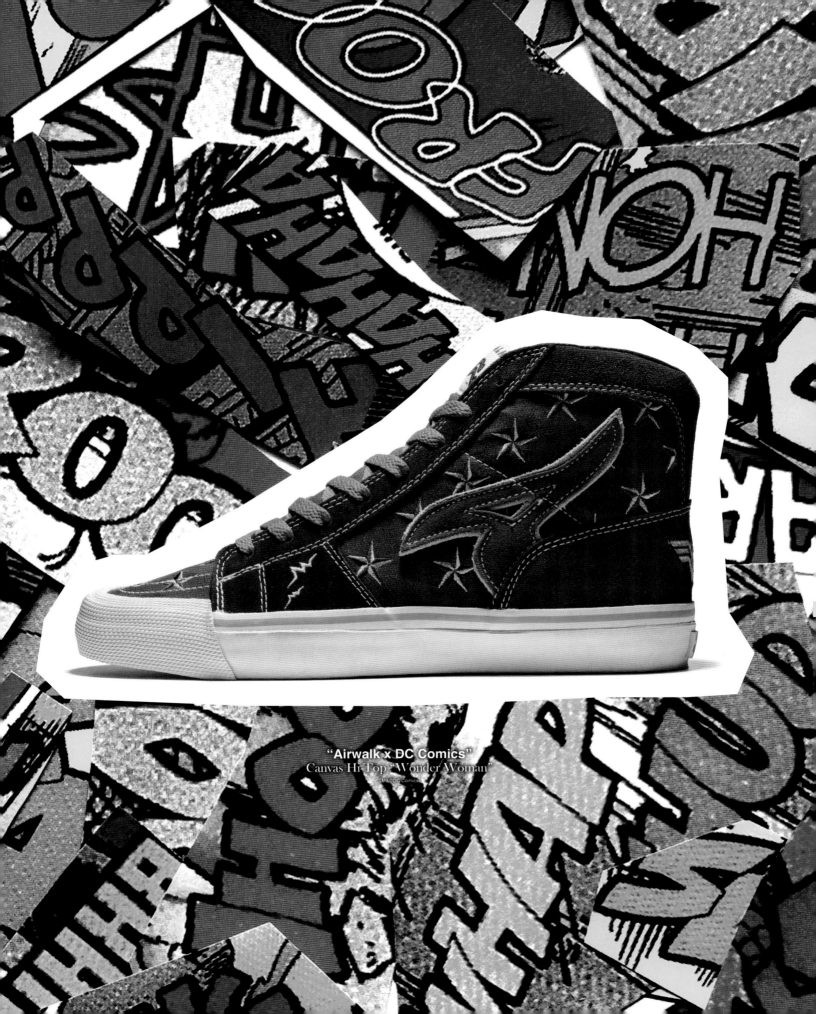

"Airwalk x DC Comics"
Canvas Hi-Top "Wonder Woman"
TM&©DC Comics

SCRAPBOOK

A collage of WHIZLIMITED in magazine media.

The following pages present a small portion of the WHIZLIMITED-related content published in Japanese and Chinese printed media, in publications with which WHIZLIMITED has built a close relationship since its inception. In Japanese streetwear magazines, the number of publications that featured WHIZLIMITED expanded as the brand grew, creating an environment that is more suitable for communicating the brand concept and its evolving nature. In Chinese streetwear publications, designer Hiroaki Shitano and his work is covered through serialized articles and brand-specific features.

Despite the proliferation of online resources, magazines and fashion-centric periodicals remain an important vehicle for transmitting streetwear trends in East Asia. Magazines were the first to document WHIZLIMITED's history and momentum, and continue to be a clear and vital means of tracking the latest information on the brand.

Size magazine's 8-year serialization project

WHIZLIMITED serialization in *Size*—mainland China's leading street culture magazine—began in May 2012. From runway reports of WHIZLIMITED to interviews with designer Hiroaki Shitano, the introduction of special collaborations, and coverage of special events, the wide range of content created for the magazine ultimately spanned 87 individual features. The role the publication and its editors played in creating and sustaining a loyal following for WHIZLIMITED in China cannot be overemphasized.

Design the Function

「機能をデザインする」アメカジを背景にベーシックなスタイルを独創的なディテールやギミックでアレンジ、その演出にもオリジナリティを追求してきたウィズだけに、機能とデザインの融和は最も重要なテーマのひとつだろう。常にユーザーの目線で使い手の機能性を検証し、常にクオリティの向上に努めてきた成果は、リバーシブル対応のダウンパーカやスノーボードウエアの最新作を見れば明らか。デザイナー下野宏明が創造するプロダクションは、生まれながらのリアルクローズであり、実践なきファッションアイテムなどいない。

03

01

03. テトラテックスなる3層構造の防水透湿素材を採用したウィズスス発のファストジャケット。インナーマスクを取り入れるなどオリジナリティを細部まで盛り込んだハイスペックモデル。ファストジャケット "FAST JK by WHIZ SNOW" ¥60,900

01. 艶やかな牛革をまとったムーブダウンジャケットのレザーバージョンモデル。プレミアムなリバーシブル仕様へとアップデイトした最新形態。リバーシブルレザーダウンジャケット "LEATHER MOVE DOWN JK" ¥99,750

04

02

04. ウール混紡のボアジャケットにコーデュロイを切り替え、本革のポケット開口やフロントボタンをきりげなくアレンジ、シンセレートおよびザーモトロン採用、コーデュロイボアジャケット "BORE JK" ¥37,800

02. シンメトリーなデザインに仕上げられたチェーン刺しゅうのツバメを配したベロア素材使用のスタジャンは、ゴージャスなバックスタイルを設定したソリッドな仕立てが魅力。スカジャン "SWALLOW SKA" ¥35,700

Update

「進化するプロダクション」アメカジを軸に独自のスタイルを確立してきたウィズのもの作りは、常に新たなエッセンスを取り入れながら着実に進化している。ヘビーアウターからカットソーに至る充実したラインナップのアパレル群に加えて、インデント柄の装小物やネイティブアメリカンをモチーフにした革製品、さらには裏ボア仕様のエンジニアブーツまで展開する'09秋冬コレクション。デザイナーの感性が息づくプロダクションに刮目すべし。

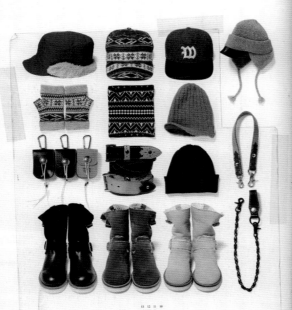

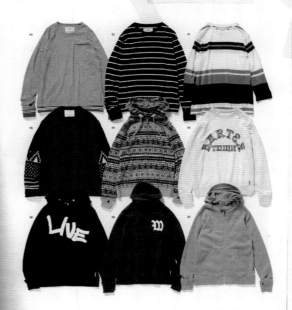

10. 耳当て付きビーニーに本革のブリムをアレンジしたコードアークティックキャップ "CORD ARCTIC CAP" ¥10,500。11. "W" ロゴの刺しゅうを織ったウールキャップは本革貼りのブリムを採用。キャップ "W WOOL CAP" ¥9,450。12. ノルディック柄が特徴のクライマーキャップは着こなしのアクセントに。キャップ "CLIMBER CAP" ¥8,400。13. ワイヤー内蔵のブリムに裏手の男塩とスタイリング自在なノースキャップ "NORTH CAP" ¥8,400。14. 編み地の違うニットをビビッドな配色で掛け合わせたアンゴラ混のムームニットシリーズより7分袖モデル。ニット "INDENT NECK" ¥7,875。16. 雪柄のニットを配したニットグローブはオープンフィンガー型。グローブ "CLIMBER GLOVE" ¥8,400。17. 本革を編んで切り替えたウォレットコード、ブレスやトリコ天共通のドッグタグ付きに。ウォレットコード "CREST CORD" ¥10,500。18. 表情豊かなニットを折り返したアラビニー "RUSTLE CAP" ¥7,350。19. ネイティブアメリカンの伝統工芸を丁寧にアレンジしたウォレット、本革のベルトループにフックを採用し、ベルトループにカラビナを手付らくしたベルト "CREST BELT" ¥24,150。20. 9分袖のサドルレザーを手編い仕上げたポーチ "PORCH" ¥16,800。21. スナップボタンを付け込んだ本革のループにメタルのチェーンをブラックとゴールドなど全3色展開。ウォレットチェーン "WALLET CHAIN" ¥15,750。22〜24. 牛革にスノーボタンを前後で切り替え、アンクルのたるみとつま先のボリュームを演出、裏ボア仕様のエンジニアブーツ "ENGINEER BOOTS" 各 ¥50,400

01. ランダムな幅と配色が個性的にデザインされた7分袖のボーダーカットソー "DROP 7/S" ¥11,550。02. リバーシブル仕様の襟リブを採用したボーダーカットソー "LIST L/S" ¥12,600。03. 両袖と裾両サイドの袋ポケットの間口に切り替えたロングスリーブフル "LIGHT L/S" ¥12,600。04. 今季のタイトルロゴ "BARTER TOWN" をプリントしたビンテージテイストのスウェット "BARTER CREW" ¥23,100。06. フェイスマスク付のフードとユニークなギミックを大胆に採用した総柄プリントのクライマーパーカ "CLIMBER PARK A" ¥23,100。06. ビッグウールのスタンドカラーのフードを採用した最新型フルジップウェット "INDENT KNIT V" ¥18,900。07. ネックロゴ刺繍でチームにバイポ含ひきのフード、新解釈のフルジップスウェット "BRIM PARKA" ¥21,000。08. オーバーマークフードを一体化したロブパーカは、見頃のたるみを採用したボリュームパーカ "ROB PARKA" ¥18,900。09. 躍動的なタギングのリブパーカは、緯の配のアレンジ自在のスナップボタン付き。パーカ "LIVE PARKA" ¥18,900

Whiz Limited

2009 A/W "Barter Town"

ウィズ '09 秋冬コレクション "バータータウン"

― ブランド設立以来、変わることのないスタイルで東京のストリートウエア市場に一時代を築いてきたウィズ、9年目のコレクション。―
異国の文化が行き交う交易の街 "バータータウン" と題した最新コレクションの全貌をここに公開する。

PHOTO : TOSHIAKI SHIGA S-336　TEXT : NOBUKAZU KISHI EXCLUSIVE　DESIGN : MO'DESIGN INC.
㈱LUMP TOKYO　☎ 03-5785-2644　http://www.whiz.jp

Concept

「バータータウン」 かつて行商人が異国の特産品を持ち寄って物々交換した古き良き時代の "交易都市"。これをシーズンコンセプトに掲げたウィズリミテッドは、まさにその言葉どおり、洋の東西を問わず世界各地の民族的なエッセンスがひとつのブランドの下に凝縮されて複合的なコレクションを形成する。エスニックな編み柄のニットシリーズ、オリエンタルな刺しゅう工芸のスカジャン、ネイティブアメリカンの伝統的なレザーアクセサリーなど…地域や時代を超越したアパレルデザインが交流するミックスカルチャーこそウィズの真髄なり。

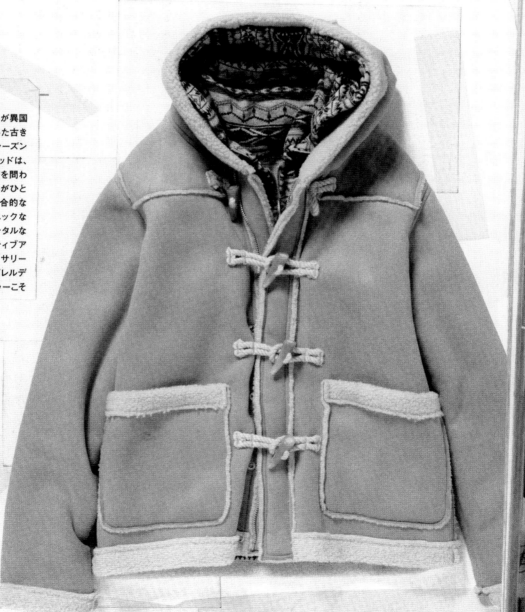

羊革の柔らかな色艶と肉厚な質感に裏毛の処理まで巧みに表現したフェイクムートン製、ショート丈のダッフルコートは、象牙を模した乳白色のトグルにもこだわりを見せる。贅沢かつコストパフォーマンスを極めた今季のエポックメイキング也。フェイクムートンジャケット "BANDIT JK" ¥44,100。インナー着用のパーカ "CLIMBER PARKA" ¥23,100

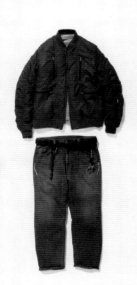

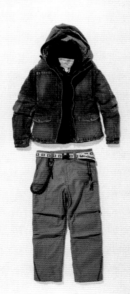

whiz limited
2006 AUTUMN／WINTER EXHIBITION
PHOTO : TOSHIAKI SHIGA (S-336)　TEXT : NOBUKAZUKISHI(EXCLUSIVE)
(有)LUMP ☎03-5785-2844

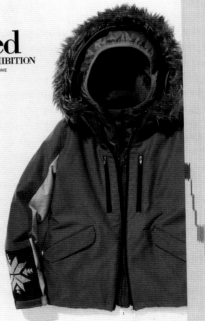

whiz limited 06秋冬コレクション
"SATISFUNCTION"
〜充ち満ちた機能とデザイン〜

今季06秋冬エキシビションにて whiz limited が打ち出したオリジナルコンセプト「SATISFUNCTION（サティスファンクション）」とは、言うまでもなく"saturation（＝満足）"と"function（＝機能）"から成る結語だが、その意図するところはじつに明確だ。近年のアパレル市場ではハイテク素材を使用したアイテムも多くなく、大手カジュアルブランドの影響からさらにマスな存在へと拡大の一途を辿る。特にスポーツウエアやアウトドア用に犬の地で開発された吸水速乾ボディのTシャツはサラッとしたUの地で洗濯すればスグ乾くとあって早々に市民権を得たようだが、あくまで whiz limited が標榜するのは現代の都市生活に適したテクニカルなアパレルラインであり、そこには機能的である以上にストリートウエアとしての矜持がデザインされていなければならない。故に先進マテリアルを採用することで、自然の恵みから人体を保護する防水・防風・断熱性、快適な着心地を提供する透湿・保温性、また長期間の使用を促す耐久性や衛生面をケアする防汚性などテクニカルなアドバンテージを獲得した上で、それらを独自のアイデアで組み合わせたり切り替えたり、既存のスタイルに縛られない whiz limited のクリエイションが展開される。アウターシェルとインナーダウンの多様なレイヤーシステム然り、よりハードコアな止水ファスナーのアレンジ然り、ときには機能性を逸脱したユニークなリブの切り替え然り。ここに whiz limited 06秋冬エキシビションの全貌を公開し、彼らが創造したストリートリアルな機能とは…そのビジョンを明らかにしたい。

OUTER. FLICK JK_ミリタリーアウターの王道"MA-1"をモチーフにバーティカルな止水ファスナーやリップストラップの切り替えなどオリジナルなスタイルを施したフリックジャケット。表地は耐久撥水性に優れたH2OFF_ブラックをベースにビビッドな配色メルトンシリーズならではのサーモトロン製。裏地はシンサレート、裏地はサーモトロン製、オリーブ、ブラウン、ネイビー、ブラックの全6色展開。10月上旬発売予定。¥31,500 **INNER.** WAFFLE L/S_カラー分け切り替えのボーダーワッフルのコットンジー、コットン100%、全4色展開。¥12,600 **BOTTOM.** WD BRAID PANTS_Felicityライン、ベーシックなスタイルのデニムパンツに農事ビーズの飾り紐をアレンジしたwhizデニムの最新モデル。ポケットおよびベルトループに各種フック付きで、ウォッシュのバリエーションはブルーデニム3、ブラックの全5色展開。¥31,500 BORDER PATCH_冬場のレイヤーに重宝なコットン・ワッフル製のボーダーパッチ、グレー、ブラック、オリーブ、ネイビー、レッドターコイズ、ブルーレッドの全6色展開。¥10,500 **ACCESSORY.** FRATERNITY BELT_フラタニティシリーズよりテープカラーがランダムのOGIベルト、全3色展開。¥6,825 CLIMB HOLDER (F)_連結設計やIDパス内蔵、オリジナルカラビナ付きでコードカラーはランダム、全3色展開。¥5,250

OUTER. STAND DENIM JK_スタンドカラーに内蔵されたフードおよびリブを軽くオンスデニムで切り替えたデニムジャケット。フロントにはサイドジップポケットやフラップポケットを採用する。インナーダウン取り付け可能なレイヤーシステム対応。ブルーおよびブラックデニムの全4色展開。10月中発売予定。¥47,250 **INNER.** FURNISH JK_リバーシブルダウンジャケット、ダルファイン使用、全4色展開。10月下旬発売予定。¥37,800 SUMMIT L/S_薬心地の良さを追求したカットソー、コット80%、カシミア20%、全4色展開。¥15,750 **BOTTOM.** SHUT 6P PANTS_ボトムのサイドジップやマチのカーゴジポケットやミリタリーのディテールを無数にアレンジした6ポケットのニューモデル。ほかにウエストアジャスター、シークレットポケット、各種フック付き、ベージュ、オリーブ、ネイビー、ブラックの全4色展開。10月中旬発売予定。¥22,050 **ACCESSORY.** FRATERNITY BELT_フラタニティシリーズよりテープカラーがランダムのOGIベルト、全3色展開。¥6,825 CLIMB CORD (F)_カラビナおよびパス付きのウォレットコード、こちらもコードの色はランダム、全3色展開。¥8,400

Equipment
アイデンティティを主張するwhiz limited発パーソナルエキップメント12選

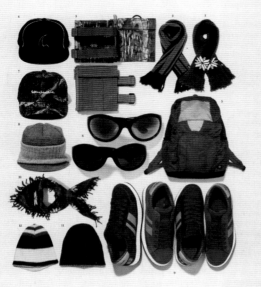

1. CREST MUFF_whizオリジナルの徽章を雪柄に見立てたウインター小物の変春ニットマフラー、11月中旬発売予定、全4色展開。¥10,500 **2.** MELT MUFF_ブラックをベースにビビッドな配色メルトンシリーズならではのニットマフラー、11月上旬発売予定、全4色展開。¥10,500 **3.** MULTI CASE_マチに使えるセパレート型ケースにストラップを通せばスノーボード用のパスケースに早変わり、全56バイピング仕様、各¥7,350 **4.** Lave CAP_それぞれ"Whiz"と"Limited"の頭文字を搭載した新型ワンポイントキャップ、こちら5ラインナップ、全6色展開。¥7,350 **5.** ONE WAY PACK_中綿入リリブ素材を使用したミラーレンズ&ラインナップ、10月中旬発売予定、全6色展開。各¥13,650 **6.** WHIZ SHADE_ラウンドシェイプのゴーグル状スノーボードサングラス。全3色展開、各¥13,650 **7.** FUNCTION CAP_リアルなツバ迷彩柄をベースに今季のメイングラフィックをプリントしたニューモデル。全6色展開、¥7,350 **8.** ROLL CAP_ロールタイプのツバを上げて良し、下げて良しのリバースにも機能的なニットキャップ、こんなところも機能的というスケートモデルのベーシックキャップ、全3色展開。¥7,350 **9.** PRO KEDS_スニーカー創始国の老舗プロケッズとwhiz limitedが共同企画にミラーレンズをラインナップ。全6色展開。¥13,650 **10.** CREST STOLE_フリンジ&ツバにもあしらったニットのビッグマフラー、グレーレッド、ネイビーチャコール、全色展開。¥8,400 **11.** ERECT CAP_グレールッド、ネイビーチャコールをカレンジのリバーシブルニットキャップ、全5色展開。¥7,350 **12.** MELT CAP_ホワイトベースにトリコロールの彩配色を見せるメルトンシリーズならではのボーダーニットキャップ、全4色展開。¥7,350

Comfort
whiz limitedが創造するフォルムとカラーのコンフォートウエア9選

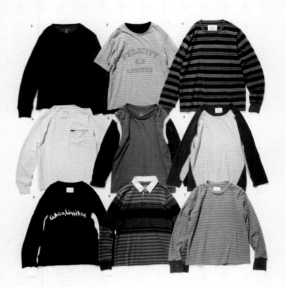

1. CORAL KNIT_Felicityライン、パープル、オレンジ、ターコイズをベースにビビッドなボーダーを揃えるストレッチコットンニット、全3色展開。¥12,600 **2.** MAD L/S_Felicityライン、ユーズド加工を施した同色プリントTシャツのレイヤーとソリッドなロングスリーブのリバーシブル仕様。全6色展開、¥15,750 **3.** FLOW L/S_ボディに無地の両面から裏地が覗けるクラフト感覚のカットソー、計算された凹凸感を加えて、針地の凹凸感を利用し表地すると出るコット8分袖カットソー、全6色展開。¥13,650 **4.** FUNCTION HEADS_8/S_針地やツバメロ素材違いの異なるコットンを曲線的な切り替えより組み合わせた8分袖コットンニット、全6色展開。¥12,600 **5.** SUMMIT_8/S_アームホールを大胆にリブよせしたストレッチコットンニット、薄い地の良いのスタイプ、薬心地の良い8分袖カットソー、全6色展開。¥15,750 **6.** FRICTION ZIP KNIT_ナイロン製のジップポケットおよびリブをあしらったストレッチコット&リブのクルーネックニット、全6色展開。¥12,600 **7.** WAFFLE L/S_ボーダー柄のコット&ワッフル地にハイコントラストな襟リブが揃える、左裾に刺しゅうロゴ、ブルーレッドほか全色展開。¥12,600 **8.** MELT POLO_マルチスト&ライン変更構成に定評&whizならではの最新メルトンシリーズのロングスリーブポロ、全6色展開。¥15,750 **9.** CLAW SWEAT_首回りと袖の下にシェイプの効いた切り替えリブをデザインしたクロウシリーズよりクルーネックのスウェット、全5色展開。¥15,750

2 | RESORT

WHIZ LIMITED
The Operating Manual Spring 07

whiz limited '07 コレクションの手引き

ストリートウエアの可能性を模索すべく、これまで独自のスタイルやシステムの創造に邁進してきた whiz limited が、今季は新たに3つのカテゴリーに体系化したアパレルラインを発表する。これは、フォーマル、リゾート、アーミー、ワークからなる07年度スプリングコレクションの全貌を記したユーザーズマニュアルである。

photograph : Toshiaki Shiga [S-330] composition : Nobukazu Kishi Exclusive special thanks to Hiroaki Shitano and Akinobu Nakajima [Lump co.,ltd.]

1 | FORMAL

R

F

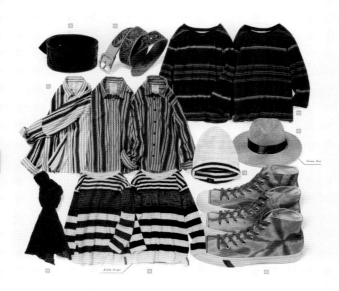

Straw Hat

Aloha Stripe

Leaf Belt

2	RESORT	オレンジ、サックス、グレーを基調に展開する3つのストライプからハイビスカスモチーフのオリジナルのアロハ柄まで、リゾートな気分をパターンや配色でグラフィカルに表現した whiz limited 発クルーズライン。

01_GILL'L'S SHIRTS リゾートシリーズがフィーチャーするインパクトある配色のストライプを纏ったコットンシャツ。￥17850
02_CLAM S/S リゾートウエアのリラックスした空気感を纏ったオーバルなボディ。8分袖のコットンソー、バーガンディ、ブルー、グリーン、チャコールの全4色展開。各￥12600
03_TUSH S/S ハイビスカスのモチーフがWHIZの文字に読み込まれたグラフィックをフロント柄のダブルボーダー。8分袖のコットンソー。ネイビー、グレー系の全3色展開。各￥12600
04_STOLE リゾートなウールやレーヨン100%の素材感がポイント。エレガントなスタイルを演出するストール。ホワイト、レッド、オリーブ、ネイビー、ブラックの全5色展開。￥5250
05_LEAF BELT モーゼンマミといい刻印加工をしたトロピカルなリーフを表現したレザーベルト。すべてハンドメイドというリアルワーク仕立て。全3色展開。￥8200
06_LEAF HAND 細くリーフ柄のカービングセンをフィーチャーしたリストバンド。細かきさカタチをデザインする購入特典のエンルスを兼ね立たえる。全3色展開。￥23200
07_SUT RING ワークシリーズの必須アイテム。大胆さを加味したストローハット。リボンを合わせたトラディショナルなデザイン。グレー、ベージュ、ネイビー、ブラックの全2色展開。￥12500
08_KIRI CAP ソリッドの表面に向かやかなボーダー柄を組み合わせたリバーシブルのニットキャップ。ホワイト、バーガンディ、ネイビー、チャコール、ブラックの全3色展開。￥7350
09_SONEVA SNEAKER コットンキャンバス製のベーシックなハイトップにて上質感のあるタイダイ柄をフィーチャーしたブロガース限定モデル。全3色展開。各￥12600

本製品に掲載された商品に関するお問い合わせは LUMP まで

item	material	size	color	delivery	price	detail
01_TIDY JK	Wool 70%, Polyester 30%	M, L, XL	Heather Grey, Navy, Charcoal, Black	Feb.	¥32600	
01_TIDY SHIRTS	Cotton 100%	M, L, XL	Wine Black, White Stripe Black, Blue Navy Burgundy Burgundy	Feb.	¥21800	
02_TIDY PANTS	Wool 70%, Polyester 30%	M, L	Heather Grey, Navy, Charcoal, Black	Feb.	¥24150	
02_TIDY PATTERN PANTS	Wool 70%, Polyester 30%	M, L	Tender Grey Stripe, Navy Pink, Charcoal Stripe, Black Stripe	Mar.	¥25150	
01_TIE	Polyester 100%	Free	Burgandy Stripe, Blue Stripe, Green Stripe, Black Stripe, Black Solid	Feb.	¥4200	
02.03_TIE BELT	Polyester 100%	Free	Burgandy Stripe, Blue Stripe, Green Stripe, Black Stripe, Black Solid	Mar.	¥7350	
04.01_TIDY CHAIN	Brass 100%	Free	Silver, Gold, Black	Feb.	¥10500	

4 | WORK

4 | WORK

Reversible System

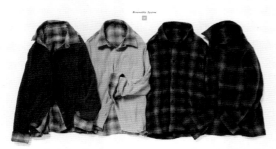

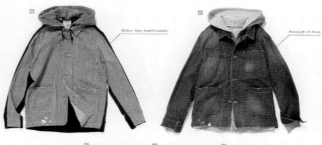

Hickory Sewar Hood(Detachable)

Heavy/Light On Denim

W

W

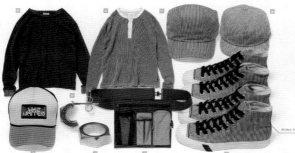

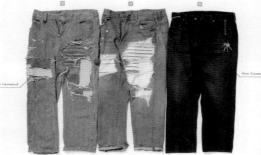

Hickory Stripe

Repair Customized

Paint Customized

4	WORK	インディゴに染まるデニムウエアをはじめ、ヒッコリーストライプやフランネルの素材感にフォーカスしたアイテム群を展開するワークシリーズ。古き良き時代のアメカジを独自の視点で再構築した whiz limited の真骨頂。

01_OPERATION L/S SHIRTS 柔らかな肌合いのフランネルを変えたリバーシブルシャツ。表地はチェック、当地ソリッドの6色合わせ付き合わせ。各￥11000
02_HICKORY HENLEY ヒッコリーストライプを纏ったナチュラルなボディへのスウェット。ヘンリーネックの口元はナチュラルソーのなミ色展開。￥15750
03_INDIGO CREW ワーカー軍を意としてインディゴで染めれたナチュラーのスウェット。ヘビーウエイガラーのの2色展開。￥16800
04_PAINTER BAG ペイントワーカーのクローブッシュに感覚可能なうちのメカ付にメッシュツクルックデザイン。バージューはほかな1色展開。￥8400
05_PAINTER MESH CAP フロントバミに新しのパッチをアレンジしたワークテイスのサイドメッシュキャップ。ブラウン色ほか全2色展開。
06_HICKORY CAP つばを元にワイヤーを加減したヒッコリーストライプを纏ったニットキャップ。レッド、グレー、ネイビー、ブラックの全3色展開。￥7350
07_HICKORY PAINT CAP ブラックチアップを纏ったヒッコリーストライプを纏ったワークキャップ。全1色展開。￥7350
08_NUT RING ワークシリーズのでは大胆なモチーフに演してしたナンツリング。サイズは17、19号。シルバー、ゴールド、ブラックの全3色展開。￥7350
09_NUT PIERCE ハートとナチにをモチーフにオレンジしたワークシ星のセルザー。キャッツをチガンを登場。フリーサイズ。￥4200
10_HICKORY SNEAKER ネイビーおよびブラックのヒッコリーストライプをアッパーにまとったワークシリーズのハイトップ。ブロガース限定モデル。各￥12600

本製品に掲載された商品に関するお問い合わせは LUMP 03/5793-2644 まで

item	material	size	color	delivery	price	detail
01_PAINTER JK	Cotton 100%	M, L, XL	Lt. Blue, Mid Blue, Dk. Blue	Feb.	¥19900	
01_HICKORY PARKA	Cotton 100%	M, L, XL	Green, Navy, Black	Feb.	¥18900	
02_PAINTER HICKORY JK	Cotton 100%	M, L, XL	Navy, Black	Feb.	¥23600	
02_PAINT DENIM PANTS	Cotton 100%	S, M, L	Lt. Blue, Mid Blue, Dk. Blue	Mar.	¥15500	
03_DECORATE DENIM PANTS	Cotton 100%	S, M, L	Lt. Blue, Mid Blue, Dk. Blue	Mar.	¥18900	
04_DECORATE HICKORY PANTS	Cotton 100%	S, M, L	Navy, Black		¥23600	

streetwear

ISSN 1860-9996 | D € 5,00 | USA $ 10,00 | UK £ 6,00 | SKR 70 | NKR 85
E, F, I € 9,00 | A, B, L, NL € 6,00 | CHF 10 | CNY 100 | HKD 80 | JPY 1400

INTERNATIONAL STYLES today

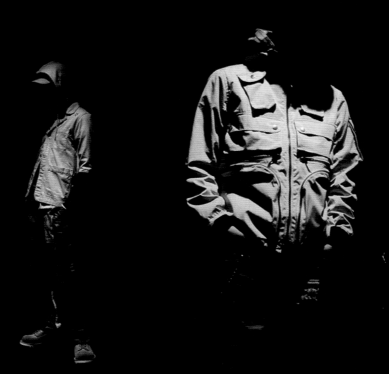

**STW2D No. 31 I | 2010: JANUARY, FEBRUARY, MARCH | "SYNOBSIS" - WHIZ
DENHAM | CIVILIST | JUSE | LOZZA | ONE TRICK PONY | PRICINCT5 | VAEL**

WHIZ LIMITED
SYNOPSIS

I t was that day when i had some time to fly thru time and space. Chillin' on my couch, the laptop was heating up my legs, a good amount of sound in my ears, time to visit some sites, after getting bored of the usual suspects, all of a sudden I remembered my good friends from Headquarter store in Mexico and Vancouver. As the people behind have this specific taste to rout out some of the freshest stuff around, I came across the very tasty imagery of the Whiz limited Brand.

"THEM AMONG FRIENDS"

"I AM STILL NO.1 HEAVY USER OF WHIZ"

Hey, how's life in Tokyo?
I was born and grew up in Tokyo. So it's a normal life for me.

I could read you started your Brand with hand printed shirts. When was this and what was the aim behind it?
I started printing T-Shirts by hand in 1996, these just to wear them among friends.

How was the reaction of the people surrounding you?
More and more friends and other people surrounding us found out about my T-shirts just because we wore them and gradually other people started to buy my T-shirts, thankfully.

What have you done before that time? How did you get into the fashion world?
I was in high school studying before that. After graduation, I learned how to use a Mac by myself and bought a hand-made T-Shirts printer. That's my start.

From hand made t-shirt design towards a full line is a big step, how did you reached this goal?
After several T-shirts design's I tried to produce some caps and baseball jackets etc..
But since i turned 21 years old, I also had a job and worked for a fashion store called „FAMOUZ" in Harajyuku, this as a regular shop boy. And when I turned 24 years old in the year 2000, I finally started my own brand „Whiz" formally with all my savings from that job.

On your way to a full line you got more and more professional. When was the biggest turning point?
From 2000 to now, I have continued my Brand „Whiz" without changing the Brand's image and stance. On top of that, it also did not change that I am still No.1 heavy user of „Whiz".
Although I think a turning point was in Fall/Winter 2003 collection, specifically in points of products quality and the numbers increasing.

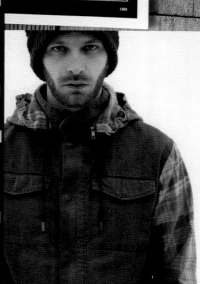

Tokyo is known for a high class street outlook, how do you see your part in it?
My part is to believe in myself and i will continue to produce items with that style all my own.

For spring summer 2010 you release a new line, what is part of the line and what is your favorite piece?
My favorite item is made of a new original textile. I took apart used clothing to diverse pieces and custom designed them with inkjet on the textile.

The sneakers are gone?
I think sneakers and boots are the style and will always be. I developed a collaboration sneaker with New Balance which is coming in April this year.

What is trend in your description? What comes next?
I always release items in my timing. So I don't know next trend.

What sort of stores are you looking for to sell your products?
A store which understands my brand as well.

What is a dream of yours?
I just wish i can continue things and do what I like.

Any last words you like to ad?
Please check www.whiz in

fig. 03
JET JK¥29400.
TRANS HOOD¥18900

fig. 01
Ink-jet Print Clothes

今季のWHIZを象徴する要素として"インクジェットプリント"が挙げられる。解像度の高い転写技術を駆使して新しくも摩訶不思議な表情を完成させた。裏地が付けられたM-65タイプのジャケットは袖と取り外し可能なフード部分にインクジェットの生地を使用。これは古着の褪せたフランネルをパッチワークにした後、他の生地に転写プリントしたもの。さらに縫製後に洗いをかけることで身頃と袖のアタリ感が自然に馴染んでいる。パンツもコットンツイルの生地にデニムの刺し子を転写プリント。見た目はつぎはぎだらけのジーンズだが、デニムではないというギミック。上下ともに生地感と着心地のアンバランスを楽しめる、WHIZらしい"遊び"の効いた仕上がりといえよう。

fig. 02
Ink-jet Shirts

古着のバンダナを集めてパッチワーク仕様にしたものを転写。それをコットン生地にプリントした長袖シャツ。新品では絶対にできない古着の褪せた雰囲気を見事に再現している。ソフトな素材感もポイント。

fig. 03

fig. 01
TRANS JK¥39900. JET PANTS¥28350.
TWIST KNIT CAP¥7350.
BALL WALLET CHAIN¥10500.
WL KEY CASE¥12600

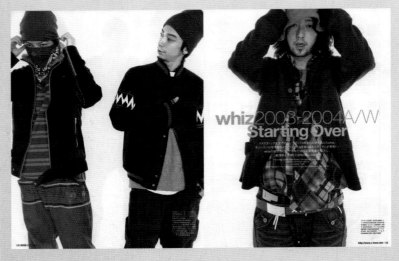

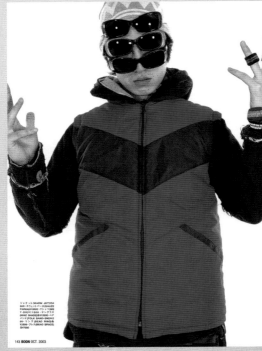

whiz2003-2004A/W
Starting Over

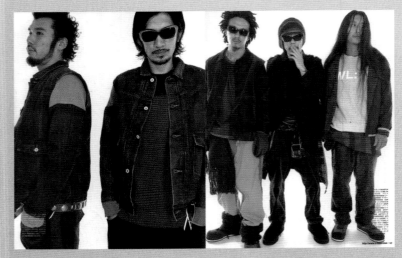

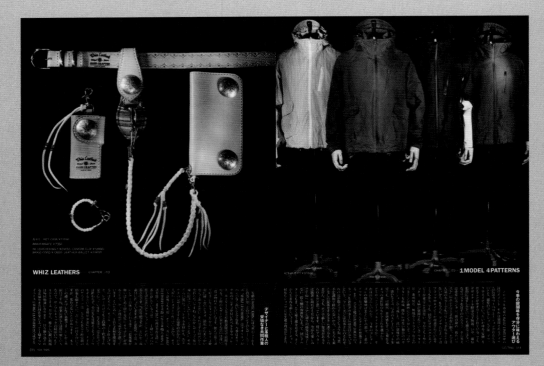

WHIZ LEATHERS

1 MODEL 4 PATTERNS

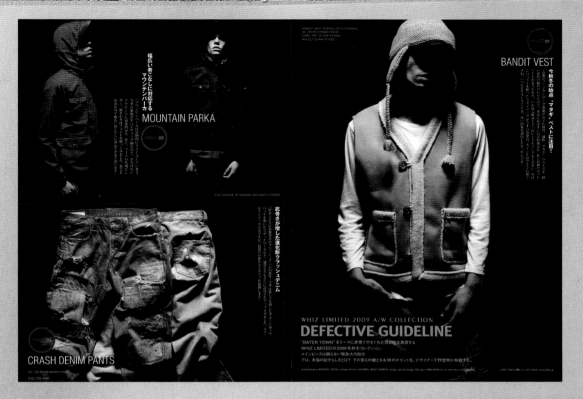

MOUNTAIN PARKA

BANDIT VEST

幅広い着こなしに対応する
マウンテンパーカ

今秋冬の始点、「マタギ ベスト」に注目！

CRASH DENIM PANTS

武骨さが増した進化形クラッシュデニム

WHIZ LIMITED 2009 A/W COLLECTION
DEFECTIVE GUIDELINE

"BATER TOWN" をテーマに武骨でやさぐれた雰囲気を表現する
WHIZ LIMITED の2009年秋冬コレクション。
メインピースは勝らない等身大の自分。
では、本当の自分らしさとは？ その答えとなる妙のポイントを、デザイナー下野宏明が解答する。

Hedge

Photo : Go TANABE
Design : Masaru YOKOYAMA
Edit. Hiroaki KAGIYAMA (EAGe)
Text : Yuichi YAMASHINA (EAGe)

本格的なクライマーに向けてハイスペックなウェアを展開する
アメリカの名門アウトドアブランド〈Marmot〉。
今秋冬シーズンより〈whiz〉の下野宏明をデザイナーに迎え、
ハイエンドなカジュアルライン〈Marmot by whiz〉を立ち上げた。
今回のHedgeでは、日々研究を集めて開発された
ハイクオリティなスペックと下野氏の豊かなアイデアが融合した、
革新的なアウトドアウェアの全貌に迫る。

Marmot by whiz
PICTORIAL BOOK

TAILORED JACKET

PEA COAT

SOUVENIR JACKET

ENGINEER BOOTS

PATTERN SHIRTS

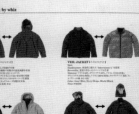

PICTORIAL BOOK
Marmot by whiz

全10型で構成された
〈Marmot by whiz〉の1stコレクション。
多様性をテーマにデザインされた
ハイクオリティなアイテムを一挙に紹介。

VEIL JACKET

TRENCH COAT

UNIONHOOD JACKET

MIST JACKET

UNION JACKET

Bullet Vest

TWIN JACKET

GLITTER JACKET

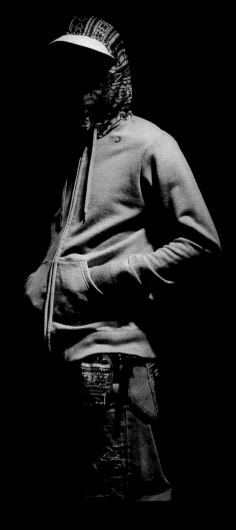

「 2000年にINDIVIDUAL CLOTHINGをコンセプトに
始まったWHIZ LIMITED、東京ストリートが最盛期を
迎えおびただしいブランドが乱立する中24歳の僕は一人
ブランドを立ち上げた。毎日作った洋服のすべてを背負
える限界であろうどでかいリュックに詰め込み毎日原宿
に足を運んだあの時から10年。歳月は経ちブランドの成
長と共に増えるサポートしてくれる仲間達。そしてこのブ
ランドのすべてと言っても過言ではないThe Tribe Of
Whizと言われる日本全国のWHIZKIDS。ここ東京から
発信されるリアルな情報を海を超えたこれから出会える
であろう友人達に送る今回のスペシャルコンテンツ。現在
もたった5人で運営される会社からみんなと改めて自分達
の歩んだ10年という歳月を振り返ってみる事にする。」

Hiroaki Shitano

"WHIZ-LIMITED是我在2000年的时候以INDIVISUAL
CLOTHING为理念开始的品牌。当时东京的街头文化正处
在最鼎盛的时期，各种各样的品牌不断涌现，那时24岁的
我一个人创立了这个品牌。回想10年前，也就是品牌创立之
初，我坚持每天用超大的背包背着每天做好的衣服送到原
宿……时光流逝，现在我的品牌在很多朋友的支持下日
益成长，因此，我可以毫不夸张地说，WHIZ-LIMITED已
超越了品牌本身的含义。日本全国范围内喜欢WHIZ的朋友
"WHIZKIDS"已经组成了名为"The Tribe of Whiz"的
部落。现在由我亲自编辑的特别内容，已经从东京发给所有
在海外那将与我和WHIZ-LIMITED成为朋友的人。WHIZ-
LIMITED现在依然只有5个人运营全部事务，借着品牌成立
10周年的这个机会，同时也是借着这次特别内容的机会，我
想与大家一起回顾一下我们10年来一起走过的足迹

下 野 宏 明

Ready for the
WHIZ
next
DECADE

十 年，感 谢
—— WHIZ-LIMITED主理人下野宏明亲自编辑，
打造品牌10周年特别策划

创立于2000年的里原宿品牌WHIZ-LIMITED在2010年迎来了品牌成立10周
年的庆典，而我们也决定在2011年开始时为大家奉上WHIZ-LIMITED品牌10周
年的回顾特辑，这一次，我们邀请到WHIZ-LIMITED品牌的主理人下野宏明本人
亲自主笔，以编辑的身份为我们制作了大家现在看到的这个关于品牌10周年历
史和品牌10周年限定联名产品的特辑。其中更包括了下野宏明本人10年间的心
路历程及其对里原宿文化的理解和看法。下野宏明本人也表示，在这个栏目中出
现的许多内容，都是在过去10年中从未对外界提及过的。他相信大家通过这个栏
目，一定会对WHIZ-LIMITED这个品牌有一个深刻的理解。不容错过的独家精彩
内容，《SIZE潮流生活》为你奉上！

■ text/editor Hiroaki Shitano c/s editor Johnney translation Rico Hyottokuki
photo Hiroaki Shitano Raymond design Cindy

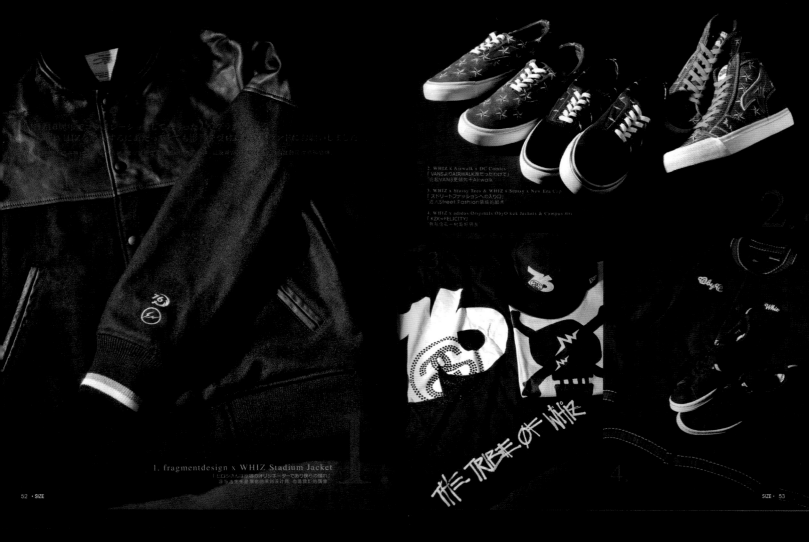

2. WHIZ x Airwalk x DC Comics
「VANSよりAIRWALK派だったわけで」
比較VANS更傾向于Airwalk

3. WHIZ x Stussy Tees & WHIZ x Stussy x New Era Cap
「ストリートファッションへの入り口」
近入Street Fashion領域的起点

4. WHIZ x adidas Originals ObyO kzk Jackets & Campus 80s
「KZK×FELICITY」
共生生名一何裂桥明友

1. fragmentdesign x WHIZ Stadium Jacket
「エロシさんは京都のオリジネーターであり僕らの憧れ」
当年是先辈是原宿的潮的设计师 也是我们的偶像

THE TRIBE OF WHIZ

where you and indivisual clothing meet... step by step/season concept... 2000-2010 whiz-limited retrospect...

Feb 2005 - Feb 2007

Feb 2007 - Jan 2008

BIOGRAPHY

2000 A/W	MOVE	何戦可能（無事可追）
2001 S/S	We Have Ideal Zones	正しい方向へ（自由）
2001 A/W	THE EDGE	攻撃こそすべて（反骨精神）
2002 S/S	ROOM	あるべき場所（普遍的原点）
2002 A/W	MAKE BELIEVE	反抗心（反骨）
2003 S/S	adapt	けがれない戦い（自身の純粋）
2003 A/W	Which way am I from / Where am I heading at?	迷えないように（希望意志）
2004 S/S	PURSUIT	迷える願い（持続希望志思）
2004 A/W	Ruler	生涯（生活）
2005 S/S	Last Supper	反復循環境
2005 A/W	TRANSPECZ	プルとハイブ（両面性）
2006 S/S	NOWORNEVER	今こそすべて（環境保存）
2006 A/W	SATISFUNCTION	自己防衛（自我保衛・武装反抗）
2007 S/S	COLORS	自由とギャ（不義平等）
2007 A/W	BORDER	地球に若ちゃん（死界限）
2008 S/S	MINOR THREAT	矛盾抵触（少数精革）
2008 A/W	MIGRATION	大地のめぐみ（大地是我信仰）
2009 S/S	THE CHOICE IS YOURS	現代社（民意飲居信）
2009 A/W	BARTER TOWN	経済の時代（最悪的不況）
2010 S/S	WORKING CLASS HERO	引アプリも信（矛盾衣実居化文化）
2010 A/W	CURTAIN CALL	決議・謝幕衣幕

The decade of
WHIZ-LIMITED
2000-2010
RETROSPECTIVE

whiz.tv

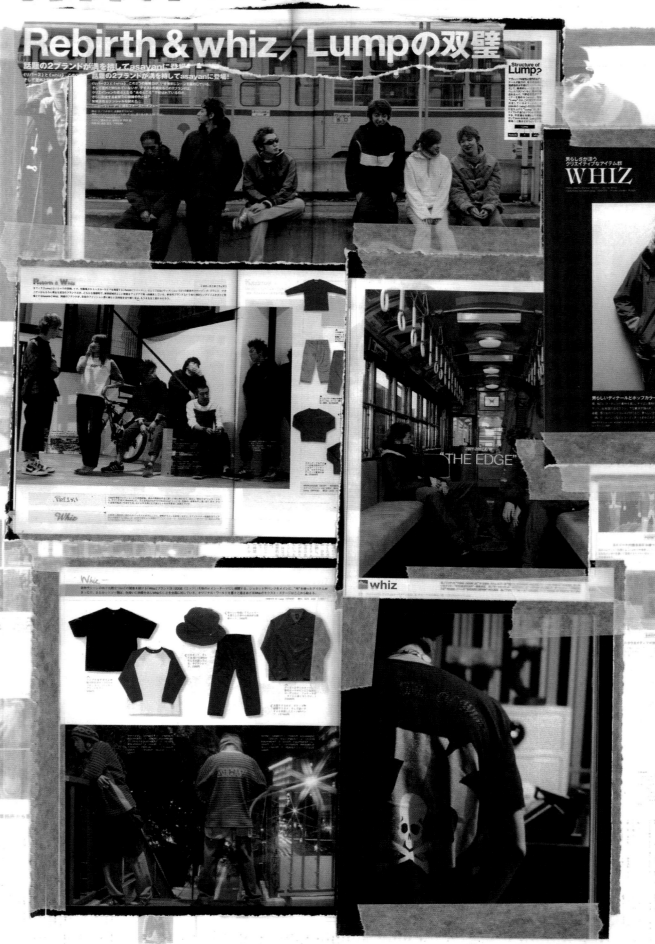

Rebirth & whiz／Lumpの双璧

話題の2ブランドが清を持してasayanに登場！

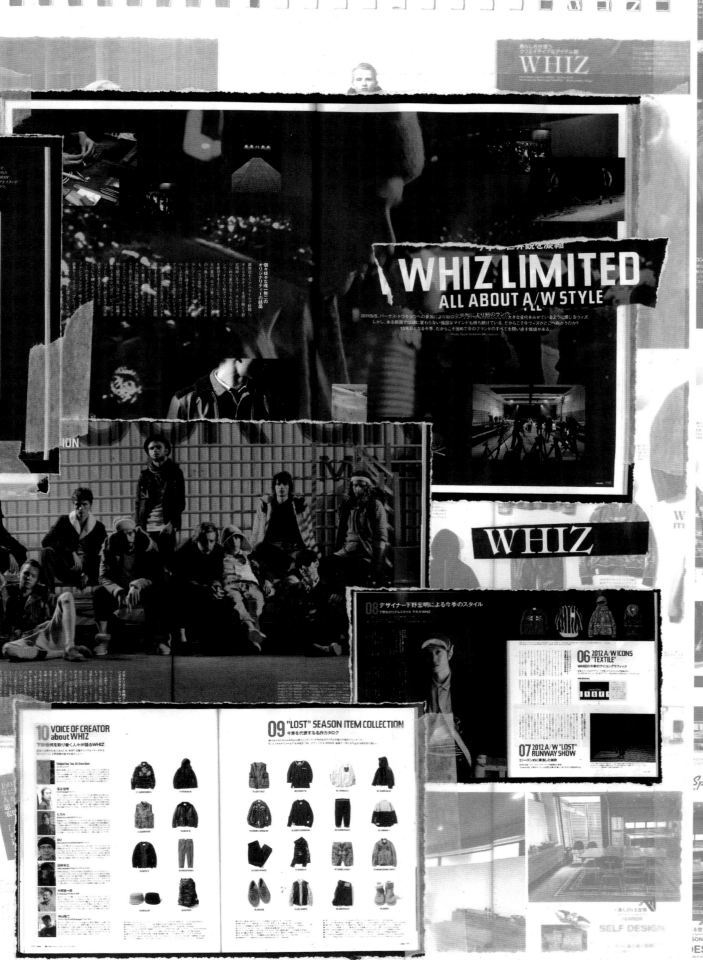

WHIZ LIMITED
ALL ABOUT A/W STYLE

WHIZ

WHIZ
ITEM PREVIEW

08 デザイナー下野宏明による今季のスタイル

06 2012 A/W ICONS "TEXTILE"

07 2012 A/W "LOST" RUNWAY SHOW

10 VOICE OF CREATOR about WHIZ

09 "LOST" SEASON ITEM COLLECTION

SELF DESIGN

Space

1

201

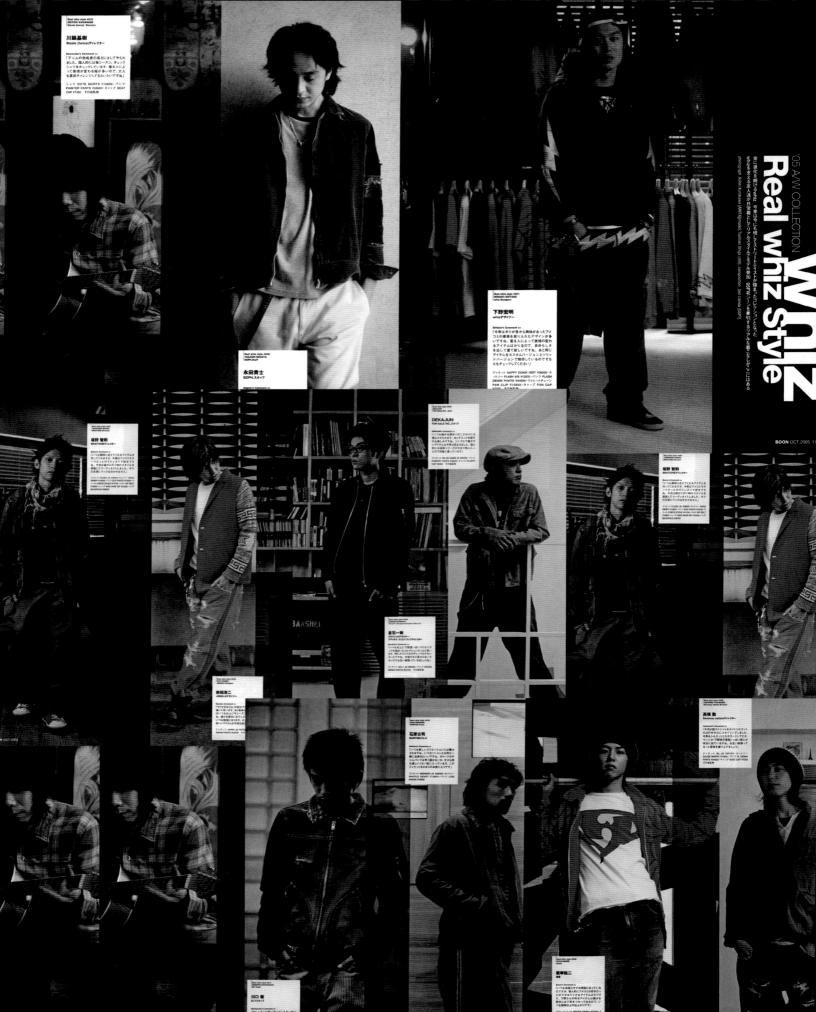

'05 A/W COLLECTION

Whiz
Real whiz style

常に進化し続ける"whiz"。今年は今にも熱いストリートテイストが倍っしまたフレッシュになった
whizを支える友人達が自由な着こなしよりリアルスタイルを伝授。'05FWシーンを牽引するリアルな着こなしはここにある

photograph: Kohei Kurihara [AMP/Ajimoto], Tetsuya Shiga [uni], composition: Gen Uchida [IGAT]

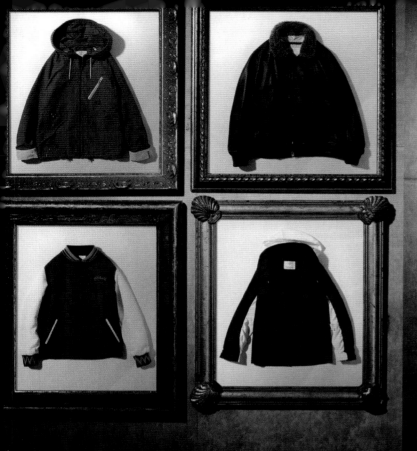

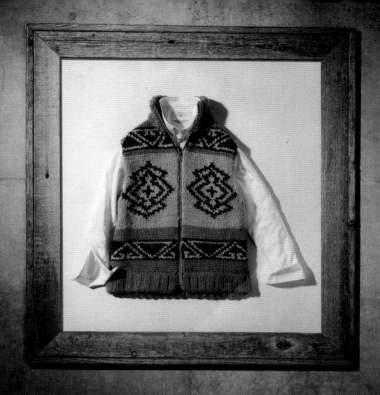

WHIZ LIMITED
"MIGRATION"
2008 A/W EXHIBITION START HERE NOW !!!

ストリートカルチャーの聖地、東京からリアルクローズを発信する whiz limited 発
2008 年秋冬コレクション〜 MIGRATION 〜。ネイティブアメリカンの伝統的な様式に独自の解釈を加えた
パターンがコンセプトを、そしてディテールの独創性がアイデンティティを主張する作品群。
奇しくも本誌発売日と同じ 8 月 23 日より全国のディーラーにて発売開始、
解禁第一報となる誌上ギャラリーで最新ワードローブを展示した。

01. NATION VEST オウナンセーターというネイティブな柄のモチーフが定番だが、伝統的な丸編みの三つ編にアレンジ。ローゲージのデックリした編み地に1サイズ上な感
何学模様を編み込んだ whiz オリジナルのニットベスト。レイヤードで着回しの幅のバリューなアイテム。ベージュ、ネイビーブラックの3色展開。¥27300 QUILT B.D SHIRTS、ベストの
ナーンの特々なキルティングに関かれたギャッチ。プラコットとポケットにカードデザイン。キルティングカウント。¥17358
02. PRIME JK 上質なスーツのような厚手の勢力的マットナイドルを使ったウール。さり気ない whiz 調のロゴプリント。さて数の Gヨ ラインで多いのオクシードベネルの切り替えとディ
ディギ仕様のハンドウォーマーなビックマフラー。洗練されたエクストリアに、抜群な手の調えなれそにもトレラングなどに最心地も気持ちきをもブレミアな表長ジャケット。¥157500 03.
PLANT JK コットンツイルでしたてたコート丈のモーピーコート。両柄の内掛にわりとストレス地を地地、同素肌でジップを限の内掛にワードを装着する。トコットなスタイルにエグネス
フなな偲じくもしたまったエモス音が。whiz の広告用。¥52800 04. FIELD JK カクマジックジャケットに絶対なコントラストのこもコット、ナイロン混地のフィールドジャケット。

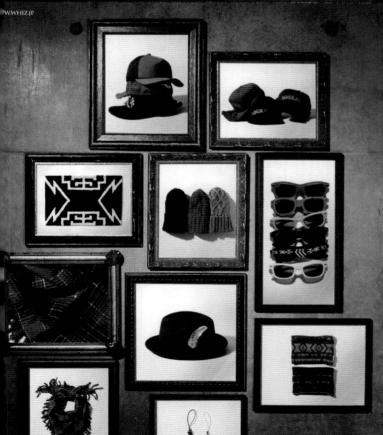

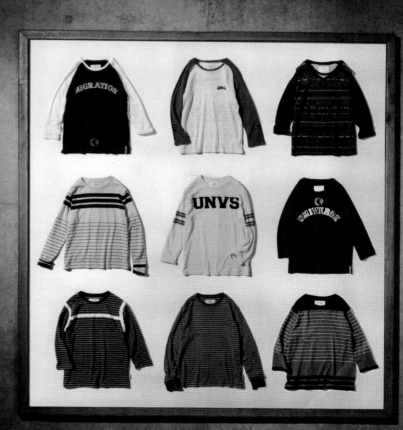

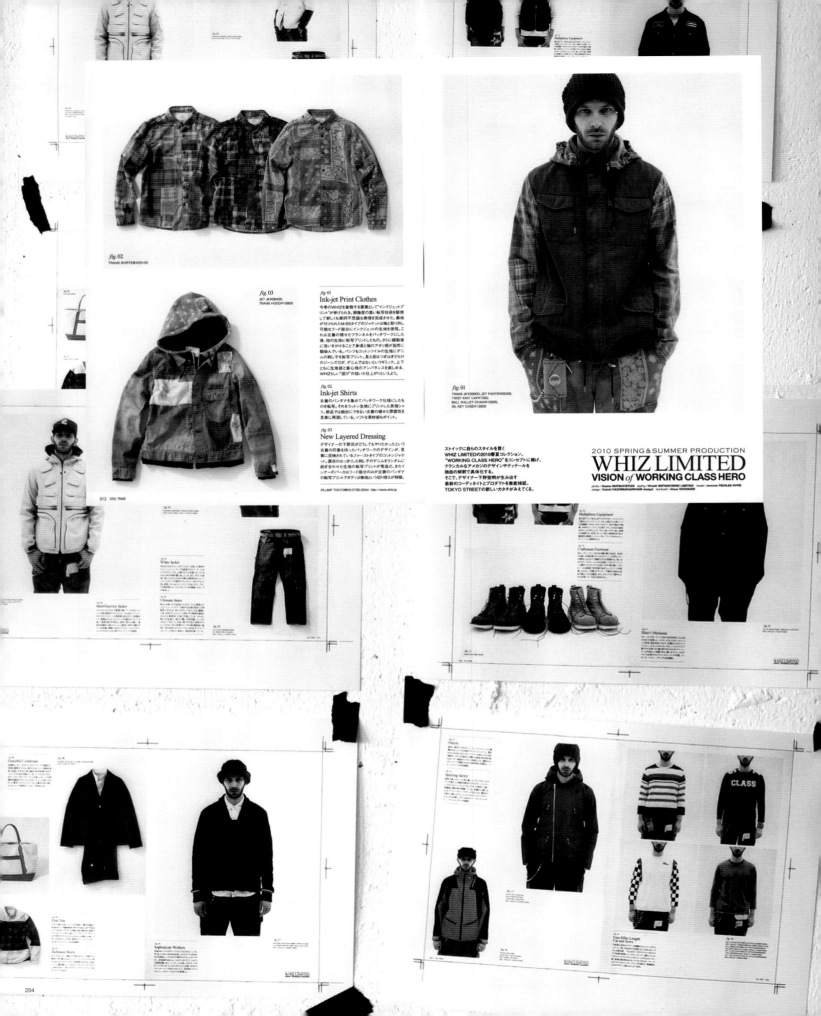

fig.02
TRANS SHIRTS各¥23100

fig.03
JET JKY29400.
TRANS HOODY18900

fig.01
Ink-jet Print Clothes

今季のWHIZを象徴する要素として"インクジェットプリント"が挙げられる。解像度の高い転写技術を駆使して新しくも摩訶不思議な表情を完成させた。裏地が付けられたM-65タイプのフードジャケットは袖を取り外し可能なフード部分にインクジェットの生地を使用。これは古着の褪せたフランネルをパッチワークにした後、他の生地に転写プリントしたもの。さらに縫製後に洗いをかけることで身頃と袖のアタリが自然に馴染んでいる。パンツもコットンツイルの生地にデニムの刺繍チを転写プリント。見た目はつぱははだけだけのジーンズだが、デニムではないというギミック。上下ともに生地感と着心地のアンバランスを楽しめる、WHIZらしい"遊び"の効いた仕上がりといえよう。

fig.02
Ink-jet Shirts

古着のバンダナを集めてパッチワーク仕様にしたものを転写。それをコットン生地にプリントした長袖シャツ。新品では絶対にできない古着の褪せた景図柄を見事に再現している。ソフトな素材感もポイント。

fig.03
New Layered Dressing

デザイナーの下野氏がどうしてもやりたかったという古着の印象を持ったパッチワークのデザインが、見事に反映されているファーストタイプのコットンジャケット。褪色のはっきりした粗いデニムとのデニムをランダムに結ぎ合わせた生地の転写プリントが秀逸だ。またインナーのパーカはフード部分のみが古着のバンダナの転写プリントでボディは無地のいうり替えが特徴。

SILUMP TOKYO■03-5785-2644 http://www.whiz.jp

013 COOL TRANS

fig.01
TRANS JKY39900.JET PANTSY26350.
TWIST KNIT CAPY7350.
BALL WALLET CHAIN¥10500.
WL KEY CASE¥12600

ストイックに自らのスタイルを貫く
WHIZ LIMITEDの2010春夏コレクション。
"WORKING CLASS HERO"をコンセプトに掲げ、
クラシカルなアメカジのデザインやディテールを
独自の解釈で具体化する。
そこで、デザイナー下野宣明が生み出す
最新のコーディネートとプロダクトを徹底検証。
TOKYO STREETの新しいカタチがみえてくる。

2010 SPRING & SUMMER PRODUCTION
WHIZ LIMITED
VISION of WORKING CLASS HERO

photo / Osamu MATSUO(STUH) styling / Hiroaki SHITANO(WHIZ LIMITED) model / Jeremie PEXILES HYPE)
design / Kaichi HACHMAN(ARKHAM design) text&edit / Atsuo WATANABE

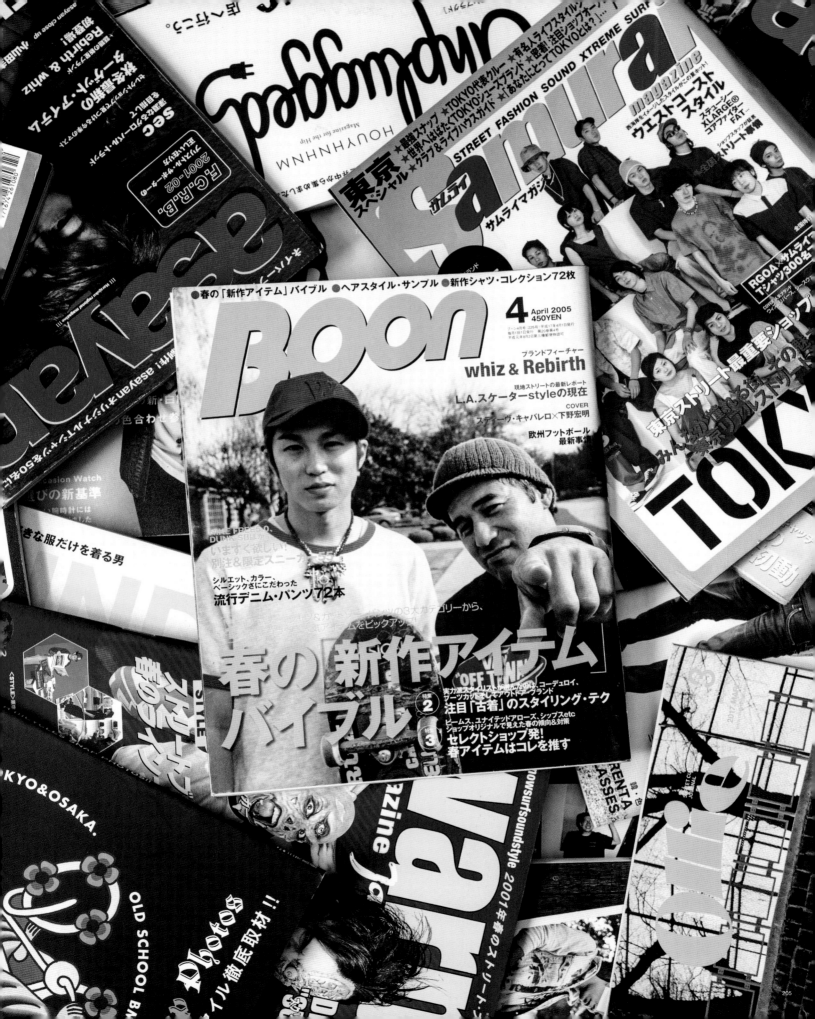

What 76 signifies.

In a tribute to the generation born in 1976,
a graphic monument to celebrate a brand established on July 6th.

WHIZLIMITED designer Hiroaki Shitano was born in 1976. Tsutomu Takahashi, with whom Shitano established the precursor of WHIZLIMITED, and Tomonori Banno, with whom Shitano would go on to create and work on yet another brand, were also born in 1976. Since they could not find other creators from the same generation in Harajuku at the time, they decided to call themselves the "76 generation" and began producing iconic graphics.

Later, when they established WHIZ, they took the same magic number and decided July 6th to be their anniversary, which led to the creation of the "76 summit." The historical legacy that WHIZLIMITED has inherited has become an everlasting motif that represents the brand, appearing in collaborations with various partners. Here, we present you some of the most notable pieces from the archives of the "76 Tee."

The First 76 Tee by WHIZ

The graphic of a pink star layered over a blue-gray number takes full advantage of its vivid silkscreen print. This original 76 Tee was made for 2000AW, WHIZ's very first collection. There were also black and gray versions in addition to the pictured version.

Stüssy

Mastermind Japan

Mastermind Japan / Stüssy

M&M Custom Performance

Detroit Tigers / Majestics

Tohoku Rakuten Golden Eagles

Porter

Fragment Design

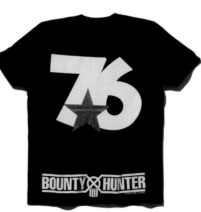

Bounty Hunter

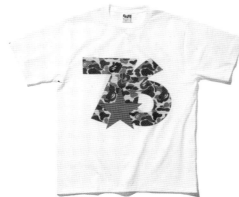

A Bathing Ape

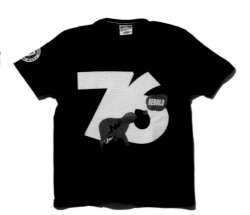

Tar

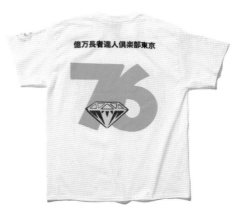

Billionaire Boys Club

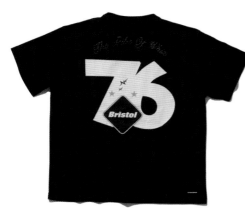

F.C. Real Bristol

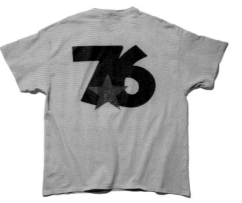

Tower Records

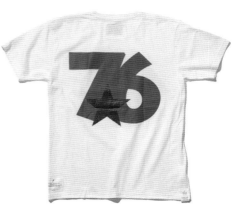

76 Summit

New Era

Landscape Products

Winiche & Co.

Fragment Design

Produced in collaboration with Fragment Design, the 76 Tee is fringed with a cross bandana pattern along the inside of the sleeves and down the sides of the body. It features the number 76 printed in a reflective material and a rhinestone Fragment Design logo on the front. The detailed masterpiece also combines ECG heartbeats with the transparent number printed on the back lining.

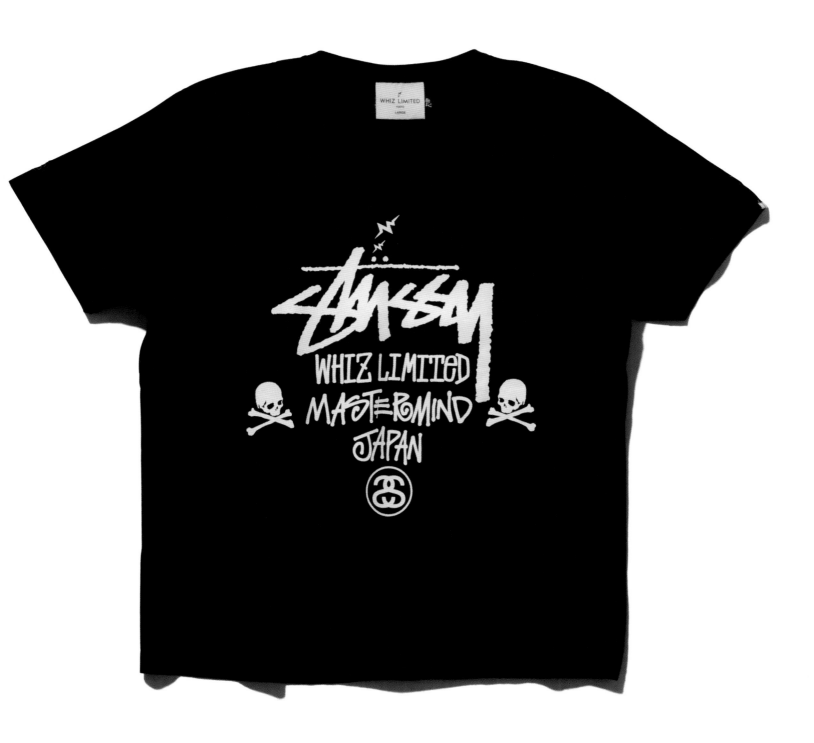

Mastermind Japan / Stüssy

A triple collaboration 76 Tee with Stüssy, a brand responsible for establishing the foundation of authentic American clothes against the background of Southern California surf culture, and Mastermind Japan. The front displays the three brand names in Stüssy's proprietary font while the back mixes the number 76 with the Mastermind Japan skull and crossbones.

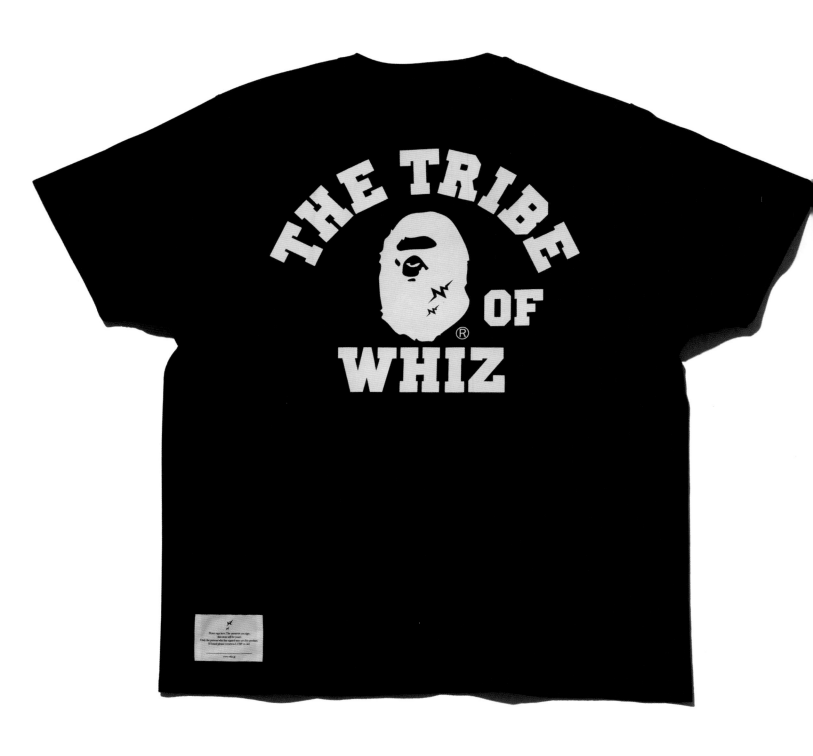

A Bathing Ape

Collaboration 76 Tee with A Bathing Ape® features a Bape® logo surrounded by collegiate-style The Tribe of WHIZ logo. The front is printed with a Bape® "camo" number adorned with a red star.

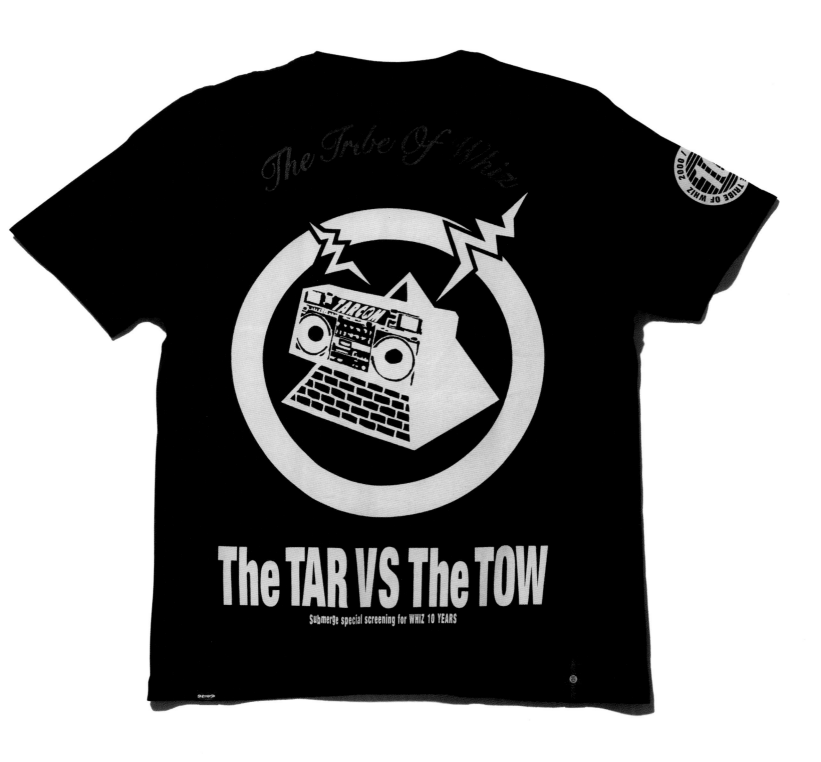

Tar

76 Tee made in conjunction with Tar, a brand that transmits an authentic view of Ura-Harajuku culture from its shop in the snowy country of Niigata prefecture. The back features an embroidered arch logo of the Tribe of Whiz. A commemorative item that celebrates the tenth anniversary of WHIZLIMITED.

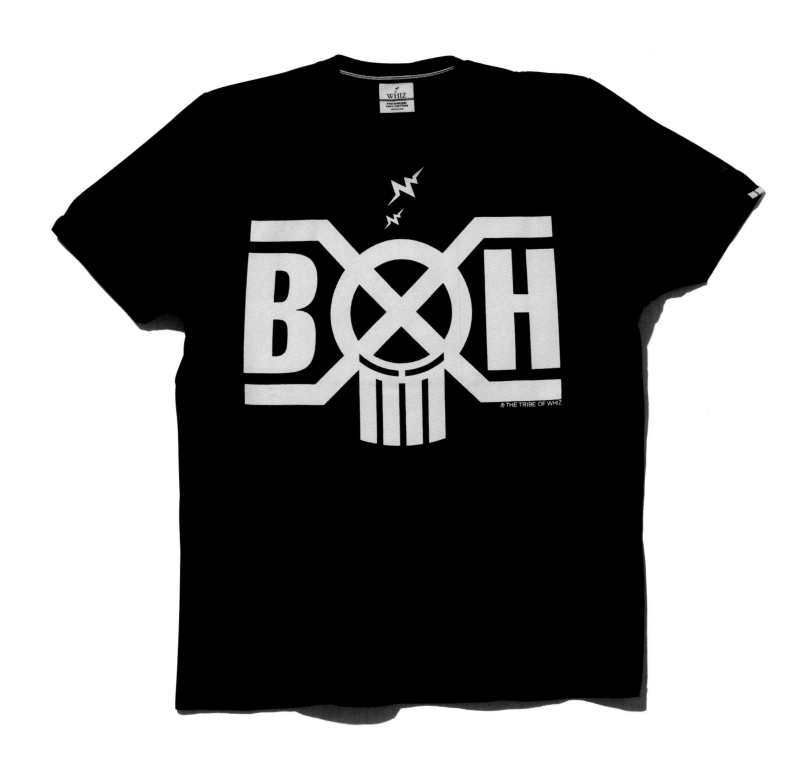

Bounty Hunter

A 76 Tee made in collaboration with Bounty Hunter, a label that represents Tokyo's punk rock culture. The front features the iconic Bounty Hunter logo crowned with WHIZLIMITED's ECG heartbeats while the back hem was adorned with basic Bounty Hunter logo.

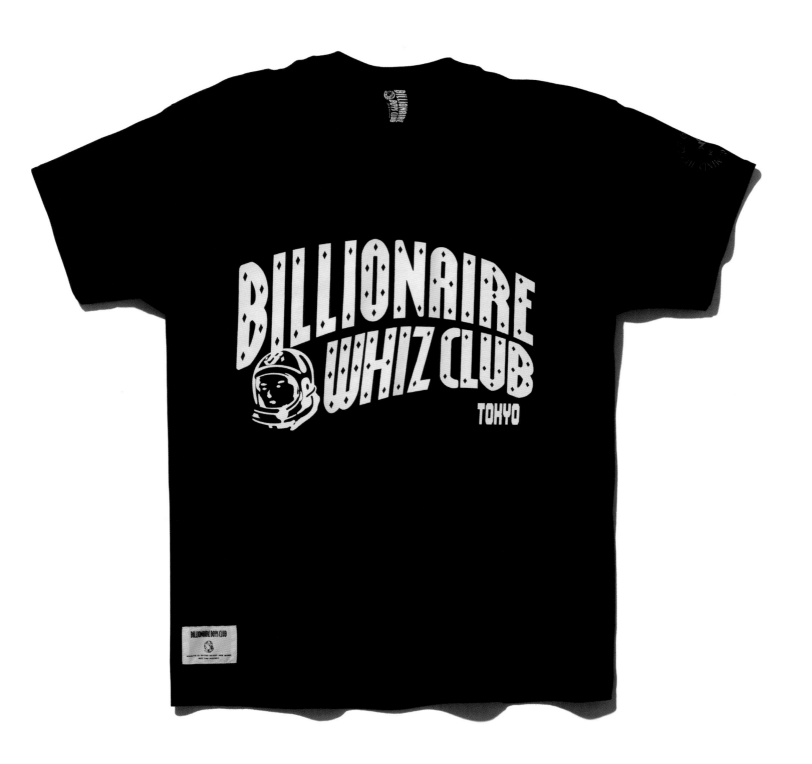

Billionaire Boys Club

Billionaire WHIZ Club logo design reimagines Billionaire Boys Club, established by Pharrell Williams and NIGO®. The back of this edition features a round, brilliant-cut diamond pattern superimposed on the number 76.

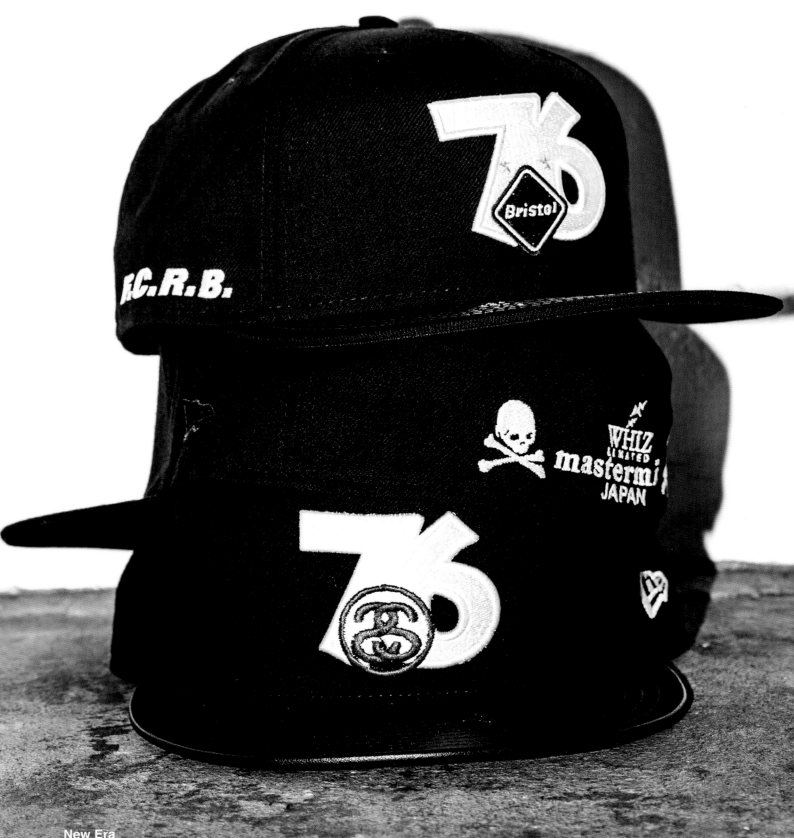

New Era
F.C. Real Bristol / Mastermind Japan / Stüssy
WHIZLIMITED's triple collaboration collection with F.C.R.B., Mastermind Japan, and Stüssy is based on the staple of baseball caps, 59FIFTY. Includes a 76 logo featuring a club team emblem, a stacked original skull logo, and a mixed logo combining traditional SS-Link and crown. The collection weaves together the unique branding and creativity of the three brands.

Stüssy

Stüssy

Stüssy

Stüssy / Mastermind Japan

Stüssy / Mastermind Japan

Mastermind Japan

Facetasm

Tohoku Rakuten Golden Eagles

Yomiuri Giants

F.C. Real Bristol

Mita Sneakers

Mita Sneakers

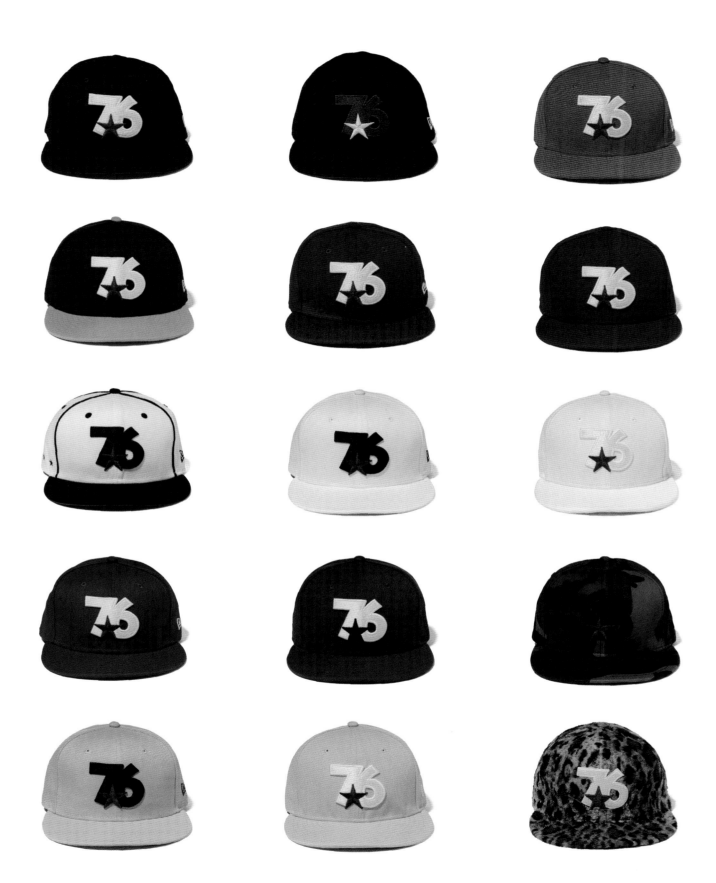

7 Stars Design

7 Stars Design

7 Stars Design

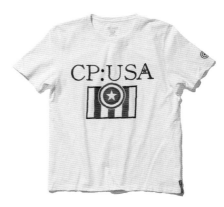

Marvel

©MARVEL

Marvel

©MARVEL

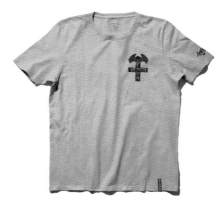

Marvel

©MARVEL

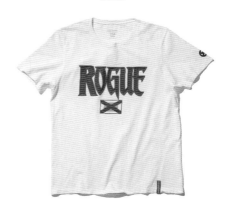

Marvel

©MARVEL

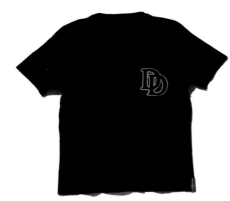

Star Wars

© & ™Lucasfilm Ltd.

Star Wars

© & ™Lucasfilm Ltd.

Famouz

Keith Haring

©Keith Haring Foundation.www.haring.com. Licensed by Artestar, New York.

Freedom-Project

©2006 FREEDOM COMMITTEE

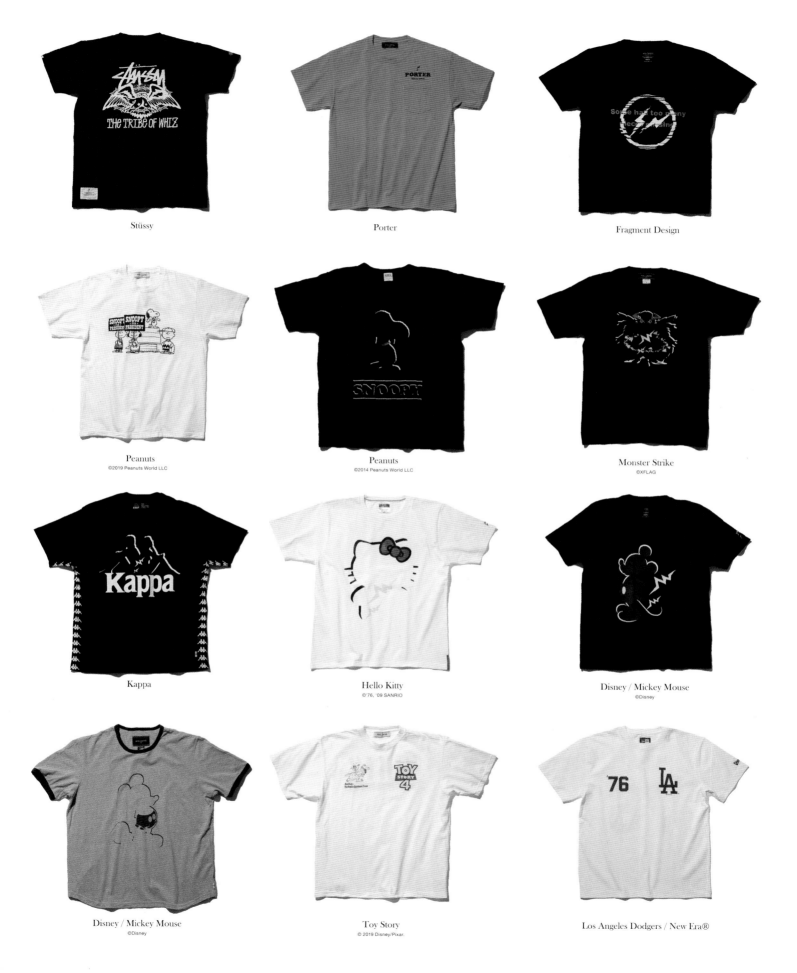

Stüssy

Porter

Fragment Design

Peanuts
©2019 Peanuts World LLC

Peanuts
©2014 Peanuts World LLC

Monster Strike
©XFLAG

Kappa

Hello Kitty
©'76, '09 SANRIO

Disney / Mickey Mouse
©Disney

Disney / Mickey Mouse
©Disney

Toy Story
© 2019 Disney/Pixar.

Los Angeles Dodgers / New Era®

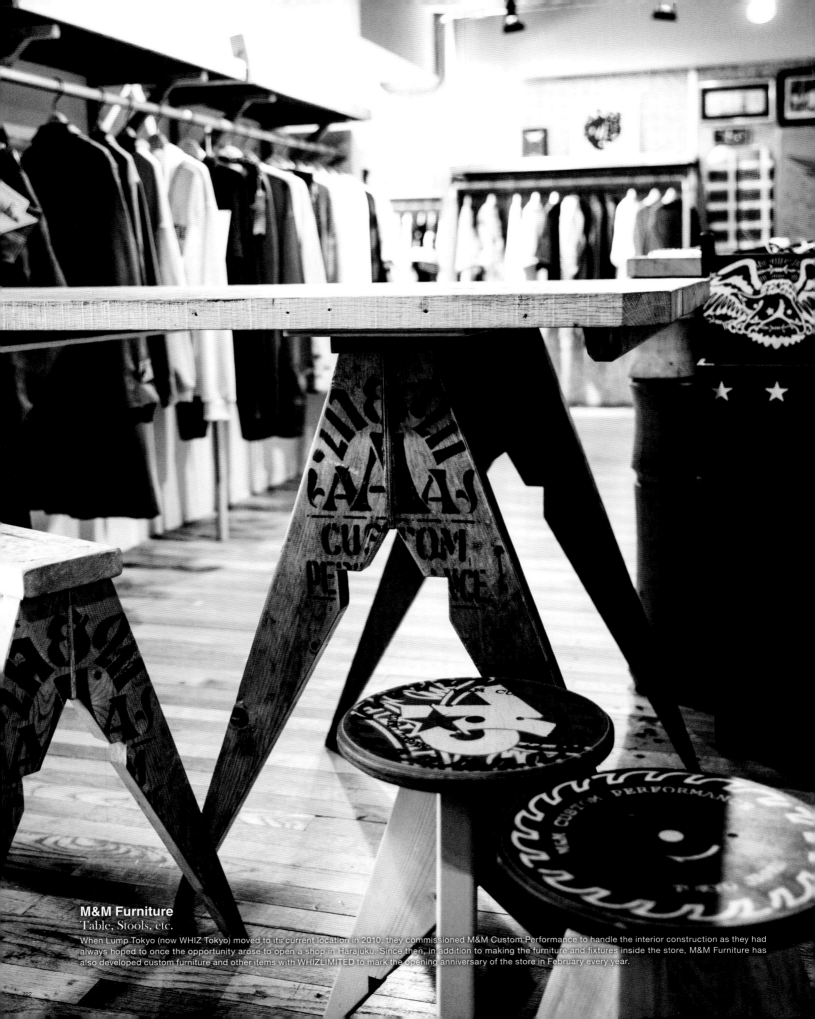

M&M Furniture
Table, Stools, etc.
When Lump Tokyo (now WHIZ Tokyo) moved to its current location in 2010, they commissioned M&M Custom Performance to handle the interior construction as they had always hoped to once the opportunity arose to open a shop in Harajuku. Since then, in addition to making the furniture and fixtures inside the store, M&M Furniture has also developed custom furniture and other items with WHIZLIMITED to mark the opening anniversary of the store in February every year.

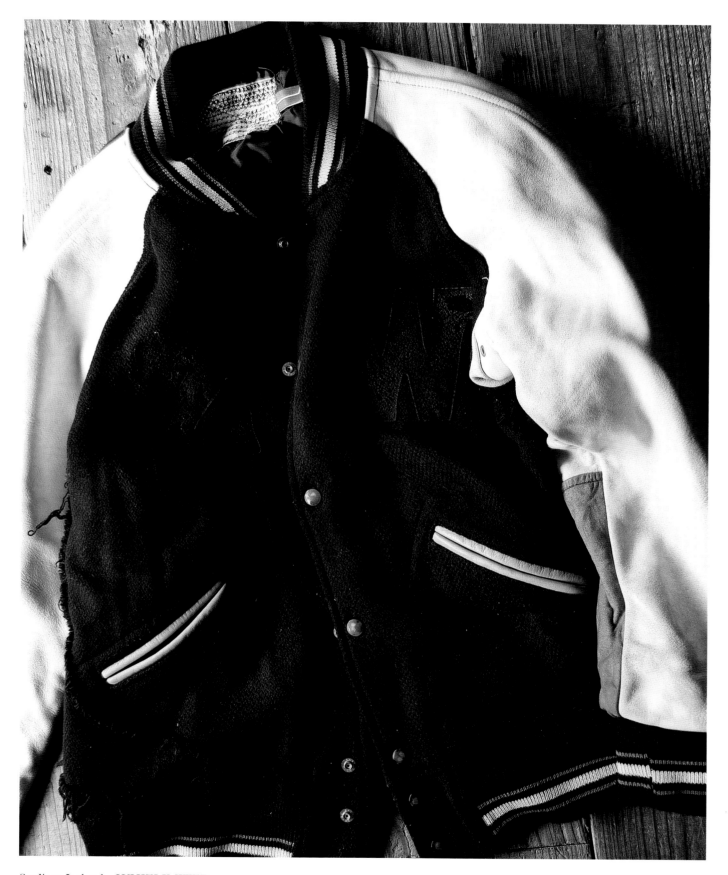

Stadium Jacket by WHIZLIMITED

WHIZLIMITED releases its limited-edition stadium jacket at the beginning of each year. Each jacket is individually numbered from 00 to 76, with 76 being permanently reserved for the designer himself. Pictured above is the stadium jacket made in collaboration with Rebirth whose elaborate aging process was one of the defining features of this item. The oldest existing model in this series is from the Rookey for Household era before WHIZ and was sold in person by the designer circa 1998.

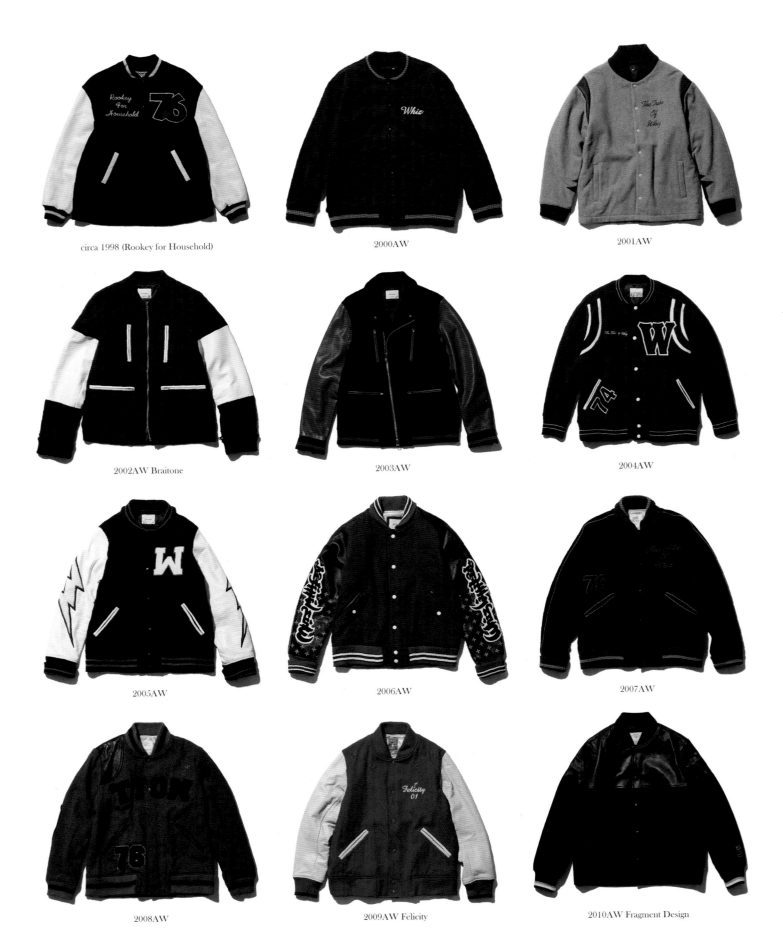

circa 1998 (Rookey for Household)

2000AW

2001AW

2002AW Braitone

2003AW

2004AW

2005AW

2006AW

2007AW

2008AW

2009AW Felicity

2010AW Fragment Design

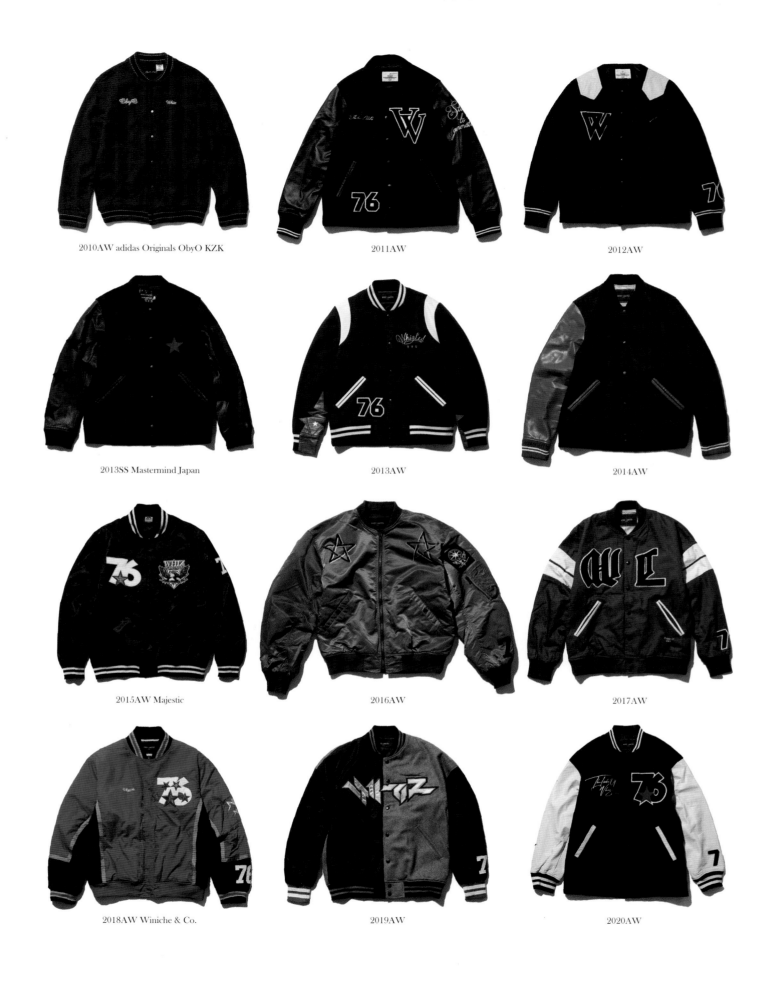

2010AW adidas Originals ObyO KZK

2011AW

2012AW

2013SS Mastermind Japan

2013AW

2014AW

2015AW Majestic

2016AW

2017AW

2018AW Winiche & Co.

2019AW

2020AW

Medicom Toy
Be@rbrick 100% / 400%

Ever since Medicom Toy, one of the most iconic toy makers from Japan, introduced Be@rbricks in 2001, their popularity has shown no sign of abating. Their compact shape, measuring around 70 mm (100% version), acts as a canvas for the unique vision of each brand and lends itself to a variety of collaborations. WHIZLIMITED has also produced many iterations—matte, luminescent, metallic coat, and all-over tartan—with its own painting and logo design to fit the theme of each collection and custom-ordered a variety of 100% and 400% Be@rbricks.

NO MORE ANDY'S HOME !

I WANNA GO TO THE LADY'S HOME !

SecretBase

Secretbase
Skull Head Pinstripe / Toy Figures in WHIZLIMITED Gear, etc.

Over the last few years, Secretbase, renowned for their American-style PVC toy figures using elaborate Japanese craftsmanship, has been making custom WHIZLIMITED items to be sold on their July 6th anniversary. Yet each year, even Shitano doesn't know what's being created until the last moment. This is a thrill that he gets to freely enjoy because of his utmost trust in Secretbase's molding technology. Among the acclaimed pieces are a pinstripe skull head and figurines clothed in fabrics sourced from WHIZLIMITED's own collections, as well as custom order character figures.

FREEDOM PROJECT

Freedom-Project
Space Puff Jacket

Freedom-Project was a promotional campaign by Nissin Cup Noodles that ran from 2006 to 2008. WHIZLIMITED, bringing its expertise as an apparel manufacturer, created a white shell puff jacket based on the one worn by the protagonist Takeru in the OVA film series for which Katsuhiro Otomo served as character designer. The limited-edition jacket embodies the essential details of a spacesuit and imagines a life in a city on the moon.

©2006 FREEDOM COMMITTEE

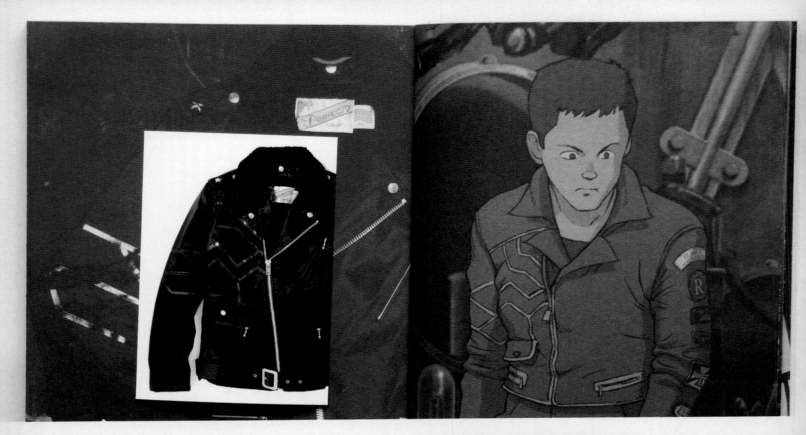
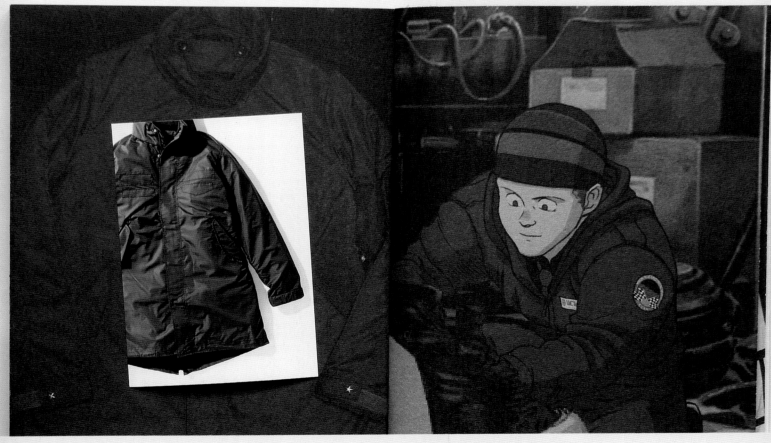

Landscape Products
Incense Chamber

A tree-shaped incense holder designed in such a way that when incense is placed inside the trunk, smoke drifts from gaps between the vertically stacked triangular cones to resemble pollen emanating from a cedar tree. Created in collaboration with Landscape Products.

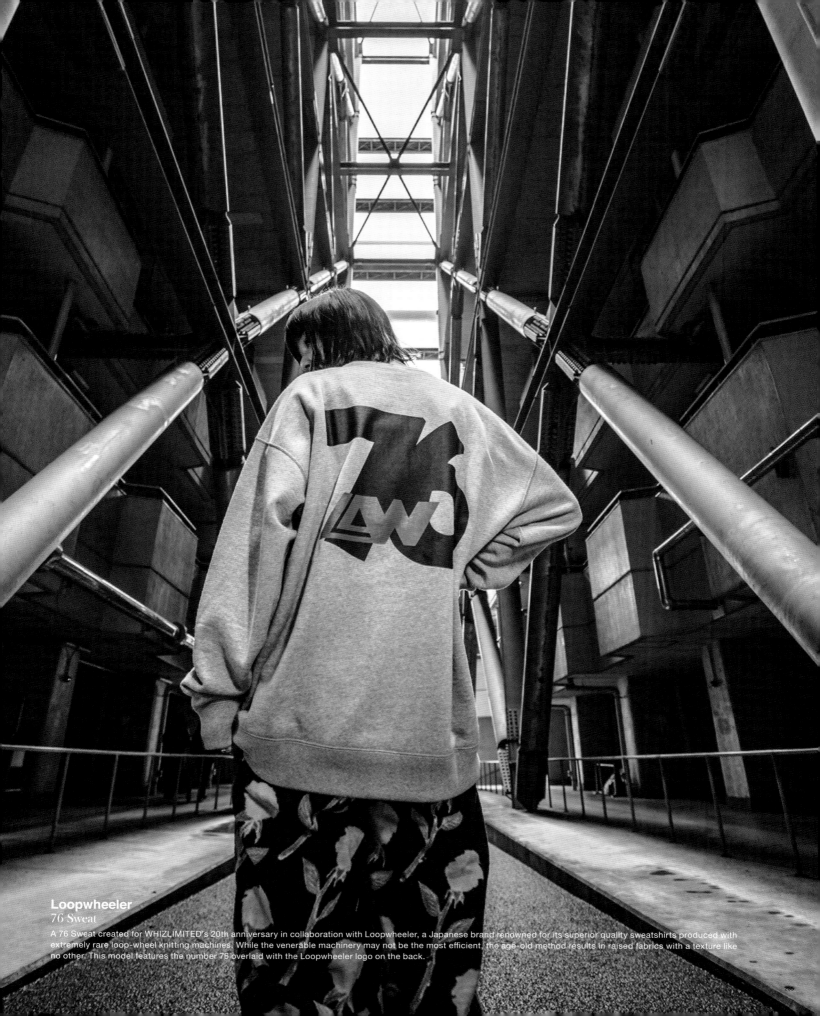

Loopwheeler
76 Sweat

A 76 Sweat created for WHIZLIMITED's 20th anniversary in collaboration with Loopwheeler, a Japanese brand renowned for its superior quality sweatshirts produced with extremely rare loop-wheel knitting machines. While the venerable machinery may not be the most efficient, the age-old method results in raised fabrics with a texture like no other. This model features the number 76 overlaid with the Loopwheeler logo on the back.

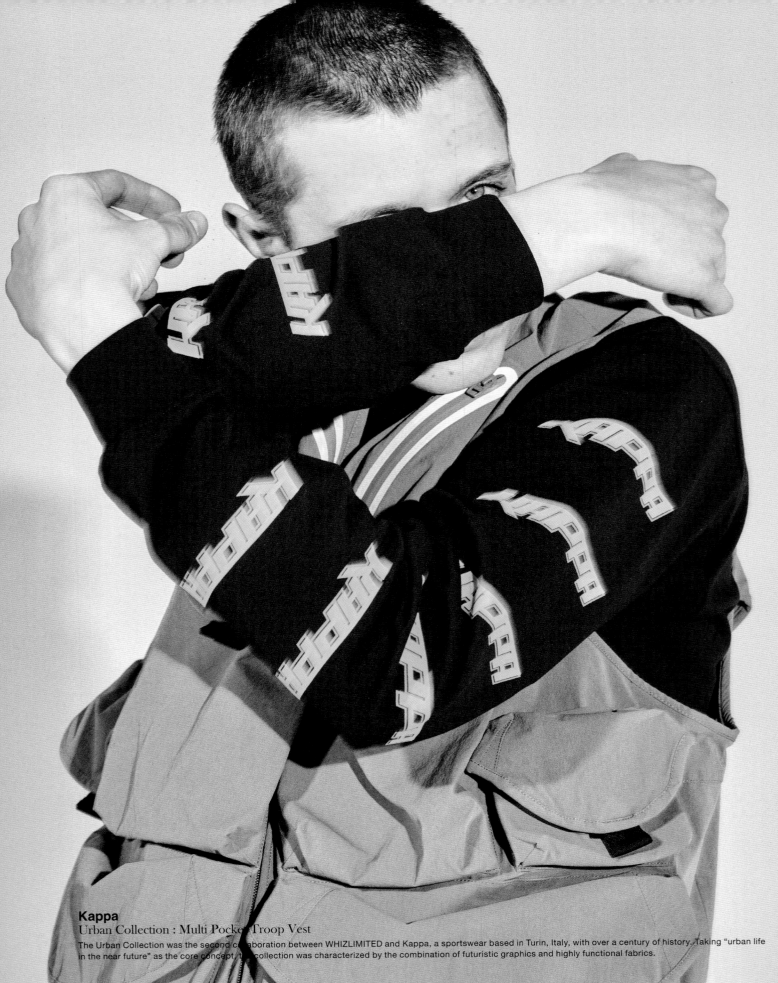

Kappa
Urban Collection : Multi Pocket Troop Vest
The Urban Collection was the second collaboration between WHIZLIMITED and Kappa, a sportswear based in Turin, Italy, with over a century of history. Taking "urban life in the near future" as the core concept, the collection was characterized by the combination of futuristic graphics and highly functional fabrics.

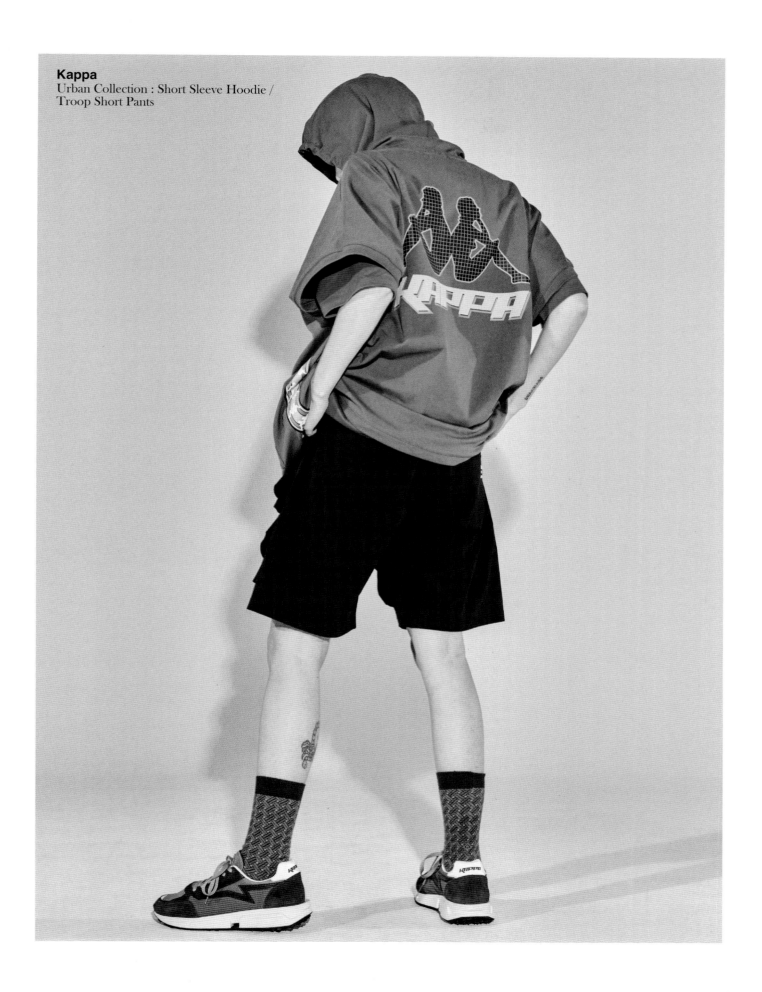

Kappa
Urban Collection : Short Sleeve Hoodie /
Troop Short Pants

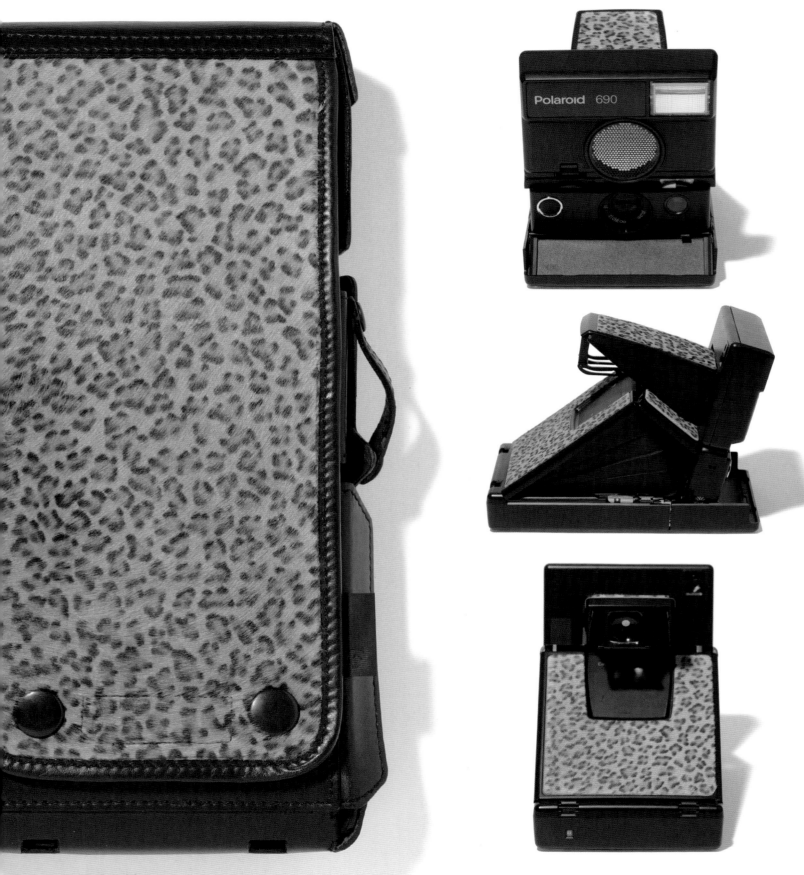

Polaroid
SX-70 MOD with Leopard Camera Case

The polaroid instant film camera features a mechanical accordion structure and a modified SX-70 casing done up in a leopard print textile. The designer, an SX-70 user himself, created a leopard print camera case for this WHIZLIMITED collaboration product.

F.C. Real Bristol
Team Jacket / Team Pants / 76 TEE / New Era® 76 Cap

Beginning with custom jersey top and pants for F.C. Real Bristol, a fantasy football club managed by Soph., the capsule collection also features the 76 Tee and New Era® baseball caps produced in collaboration with WHIZLIMITED. The Soph. embroidery has been rearranged with WHIZ, and the collaboration logo, with its diamond-shaped emblem and ECG heartbeats at the top, celebrates the twentieth anniversary of the brand. The fantasy-world collaboration garnered a passionate following from trend-conscious football players, gym trainers, and joggers alike.

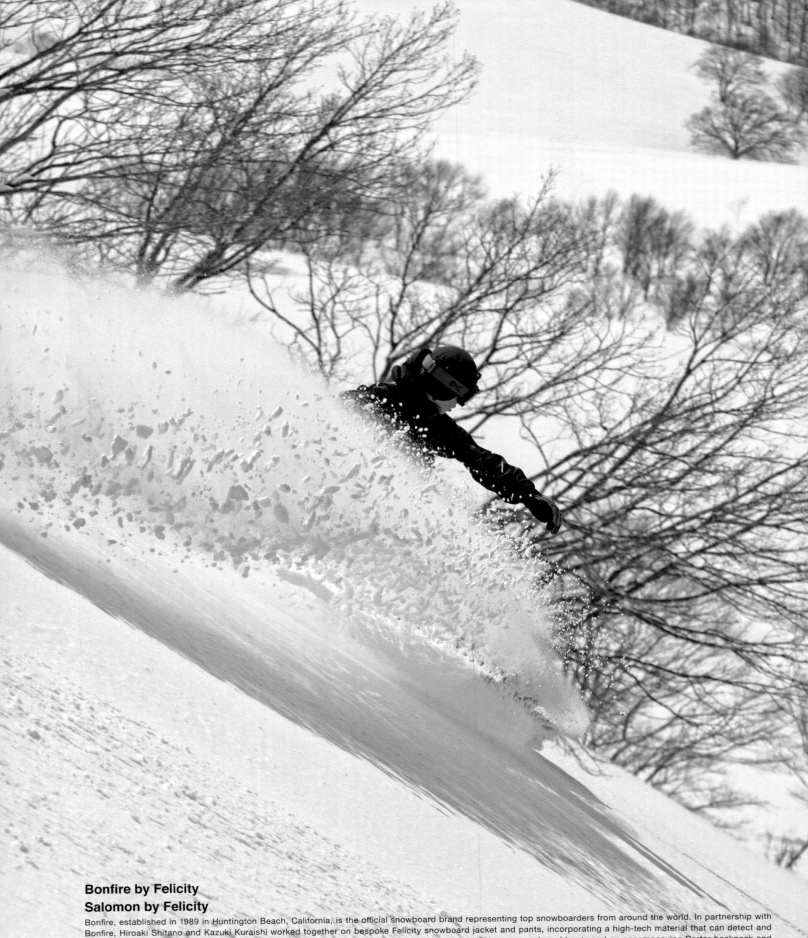

Bonfire by Felicity
Salomon by Felicity

Bonfire, established in 1989 in Huntington Beach, California, is the official snowboard brand representing top snowboarders from around the world. In partnership with Bonfire, Hiroaki Shitano and Kazuki Kuraishi worked together on bespoke Felicity snowboard jacket and pants, incorporating a high-tech material that can detect and regulate the internal temperature of clothing. The 2012 Winter capsule collection also included Salomon snowboard boots and an accompanying Porter backpack and card case specially ordered and perfected by Felicity.

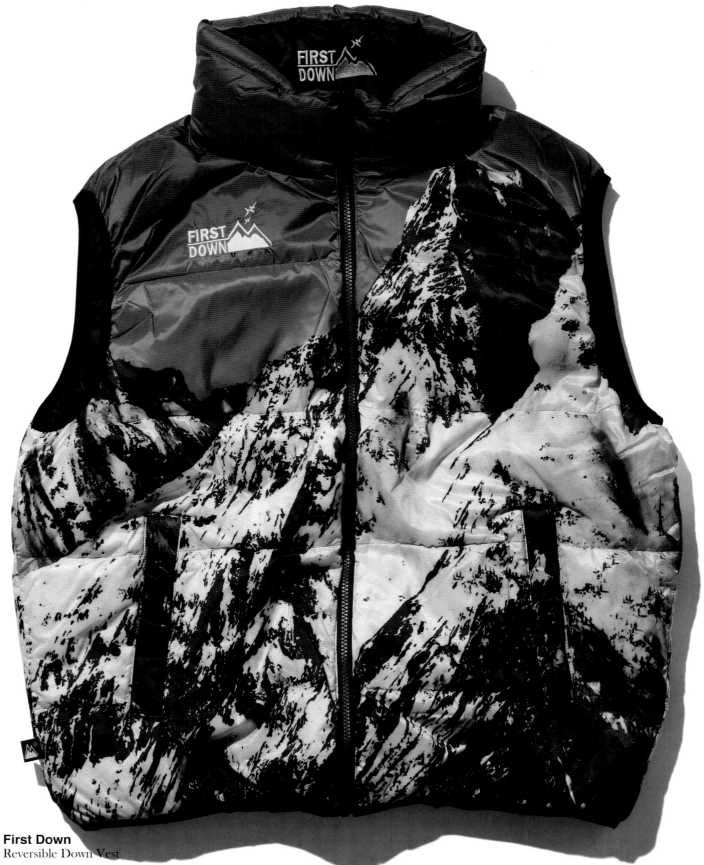

First Down
Reversible Down Vest

First Down, launched in New York in 1983, is a brand beloved by international icons from Notorious B.I.G. to Michael Jackson. Its instantly recognizable brand logo depicts the lines of a mountain ridge. WHIZLIMITED's custom down vest, with its ECG heartbeats logo reverberating from the mountain peaks, is printed with a dynamic silver mountain on the front and back of the body. The reversible vest reworks the snowcapped mountain print that made First Down's jacket into a top-selling masterpiece in the brand's history.

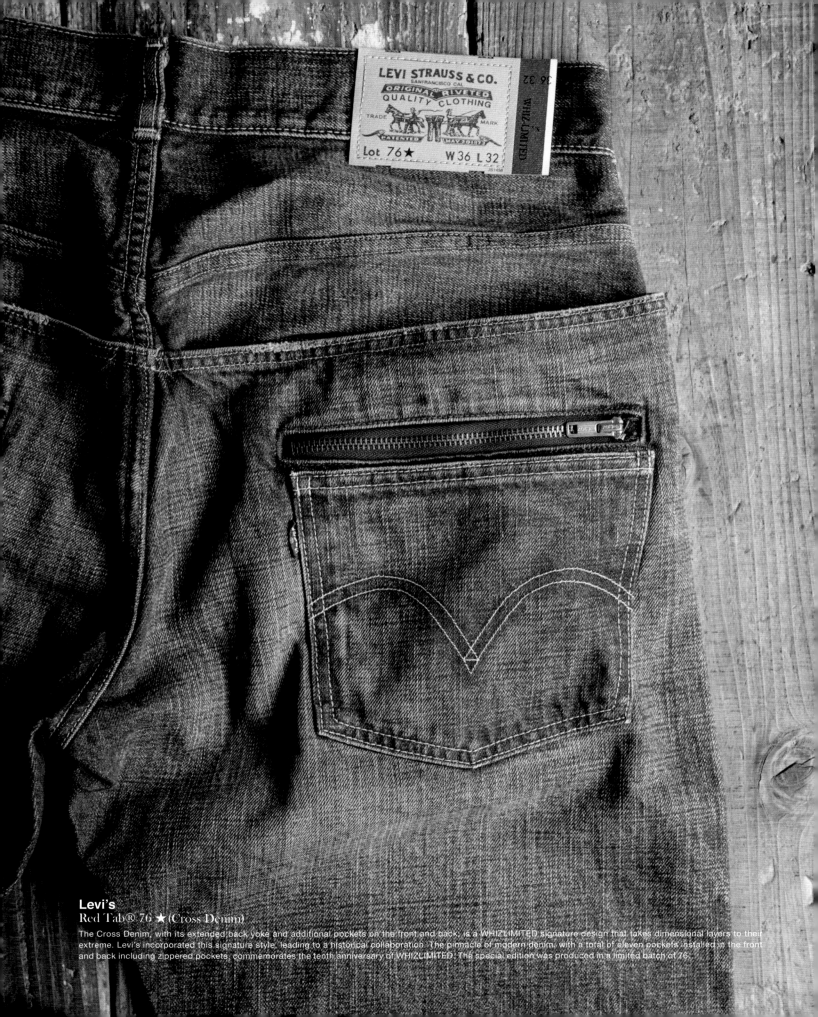

Levi's
Red Tab® 76 ★ (Cross Denim)

The Cross Denim, with its extended back yoke and additional pockets on the front and back, is a WHIZLIMITED signature design that takes dimensional layers to their extreme. Levi's incorporated this signature style, leading to a historical collaboration. The pinnacle of modern denim, with a total of eleven pockets installed in the front and back including zippered pockets, commemorates the tenth anniversary of WHIZLIMITED. The special edition was produced in a limited batch of 76.

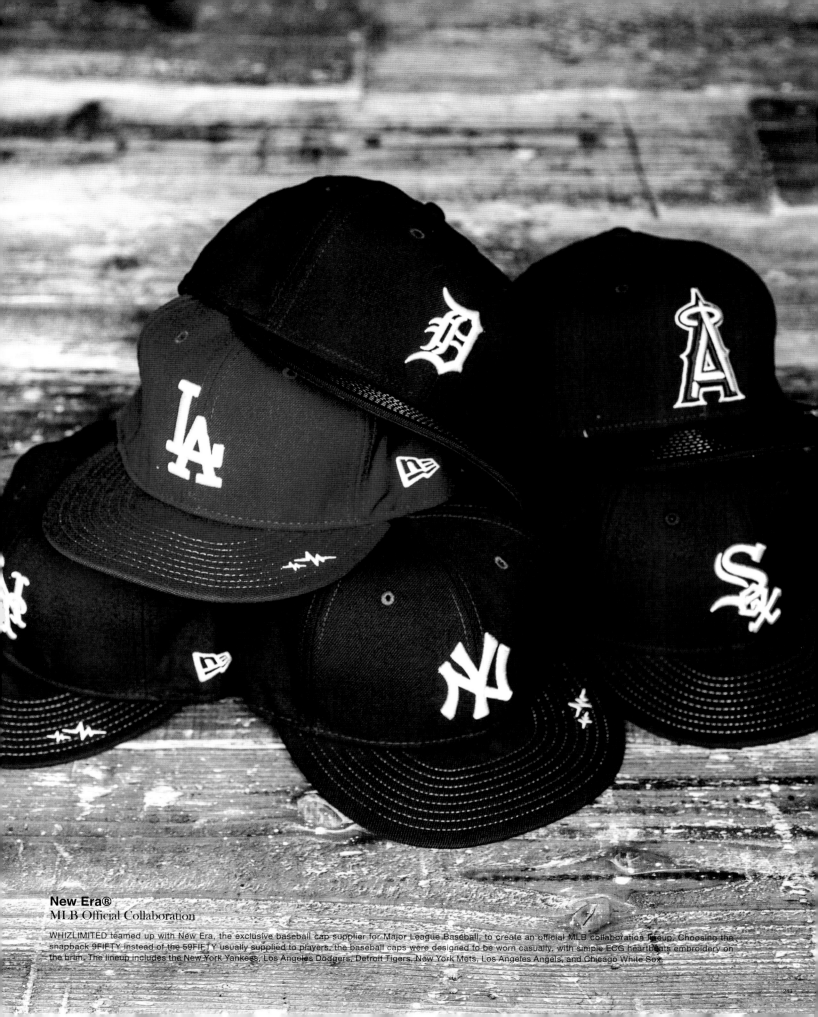

New Era®
MLB Official Collaboration

WHIZLIMITED teamed up with New Era, the exclusive baseball cap supplier for Major League Baseball, to create an official MLB collaboration lineup. Choosing the snapback 9FIFTY instead of the 59FIFTY usually supplied to players, the baseball caps were designed to be worn casually, with simple ECG heartbeats embroidery on the brim. The lineup includes the New York Yankees, Los Angeles Dodgers, Detroit Tigers, New York Mets, Los Angeles Angels, and Chicago White Sox.

Casio "G-Shock"
DW6900FS for WHIZLIMITED

Seiko "Wired"
WW Type4 WHIZLIMITED Edition

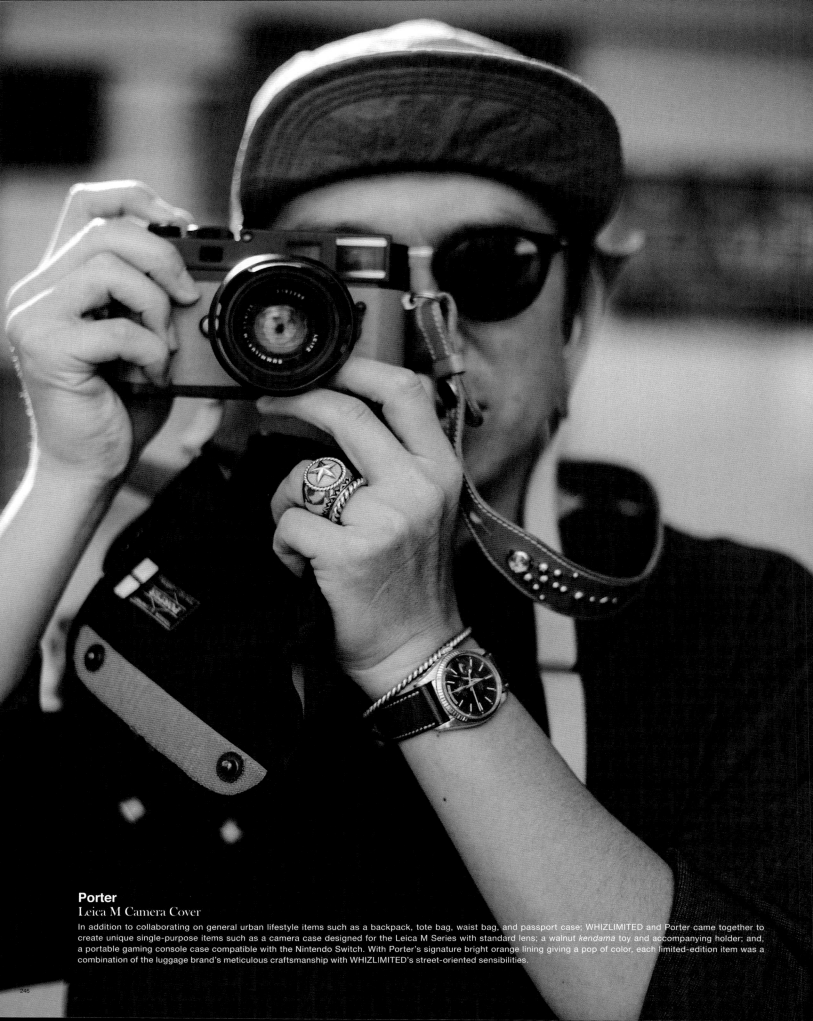

Porter
Leica M Camera Cover

In addition to collaborating on general urban lifestyle items such as a backpack, tote bag, waist bag, and passport case; WHIZLIMITED and Porter came together to create unique single-purpose items such as a camera case designed for the Leica M Series with standard lens; a walnut *kendama* toy and accompanying holder; and, a portable gaming console case compatible with the Nintendo Switch. With Porter's signature bright orange lining giving a pop of color, each limited-edition item was a combination of the luggage brand's meticulous craftsmanship with WHIZLIMITED's street-oriented sensibilities.

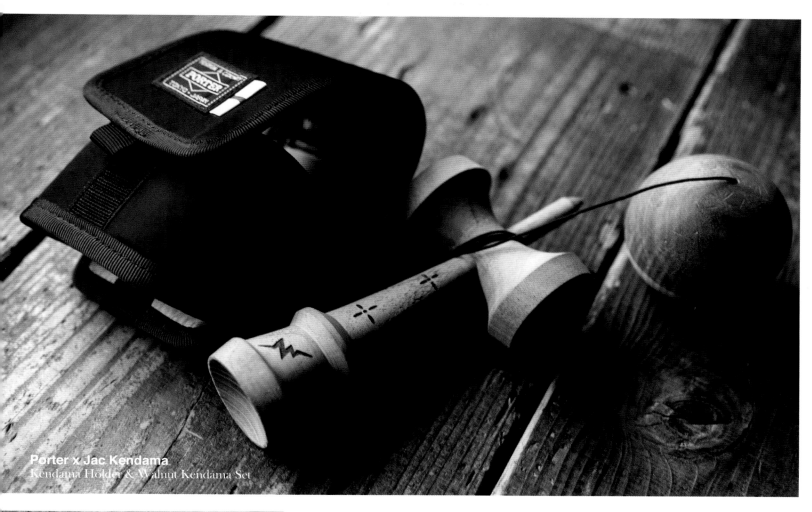

Porter x Jac Kendama
Kendama Holder & Walnut Kendama Set

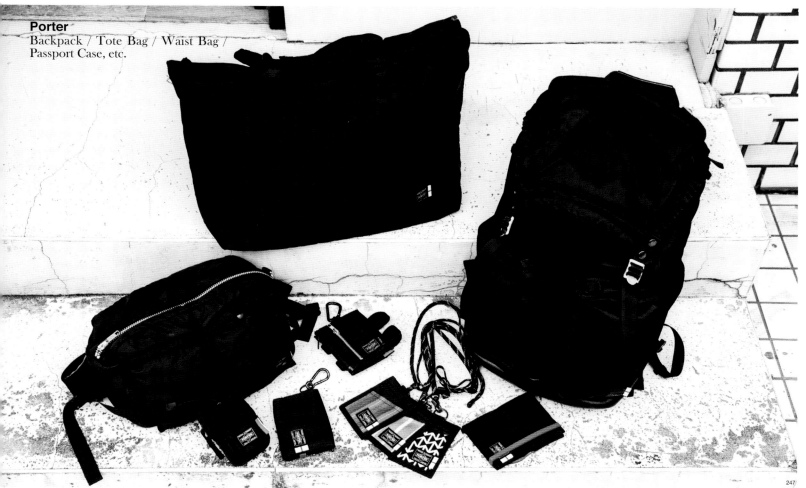

Porter
Backpack / Tote Bag / Waist Bag /
Passport Case, etc.

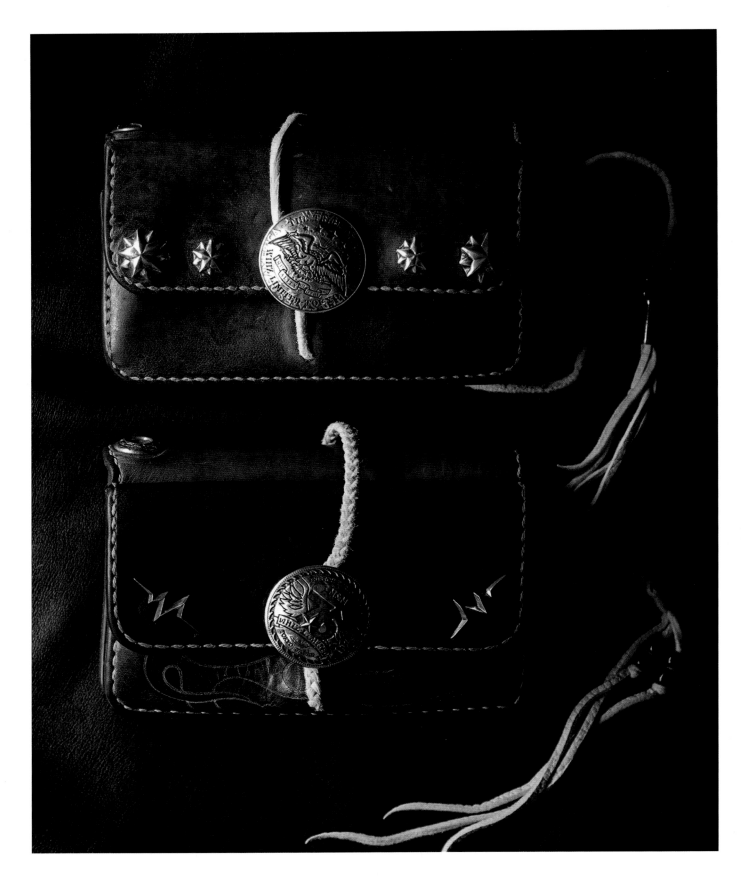

Jam Home Made / M&M Custom Performance
Whiz Leathers Wallet

Whiz Leathers Wallet is known for its thick, painstakingly tanned leather and robust yarn stitching. The silver conchos were all produced in-house by Jam Home Made, incorporating design elements from all three brands. The wallet pictured at the bottom was created in collaboration with M&M and features laser-etched fire pattens and eagle motif.

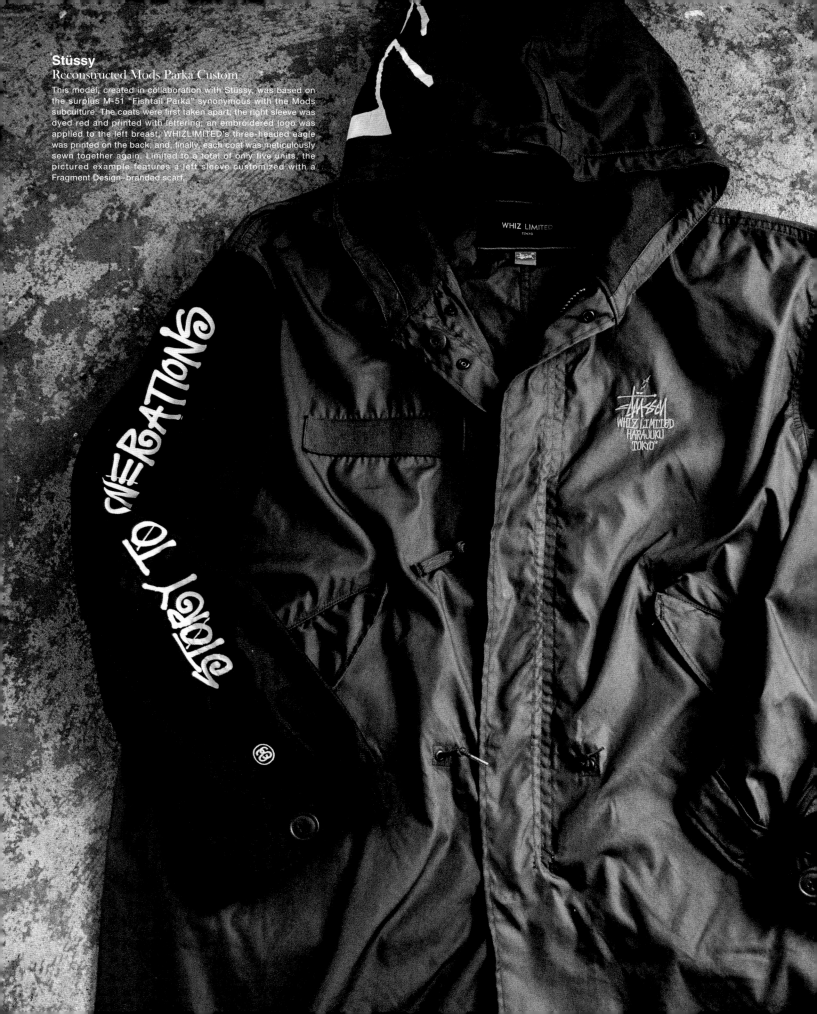

Stüssy
Reconstructed Mods Parka Custom

This model, created in collaboration with Stüssy, was based on the surplus M-51 "Fishtail Parka" synonymous with the Mods subculture. The coats were first taken apart; the right sleeve was dyed red and printed with lettering; an embroidered logo was applied to the left breast; WHIZLIMITED's three-headed eagle was printed on the back; and, finally, each coat was meticulously sewn together again. Limited to a total of only five units, the pictured example features a left sleeve customized with a Fragment Design–branded scarf.

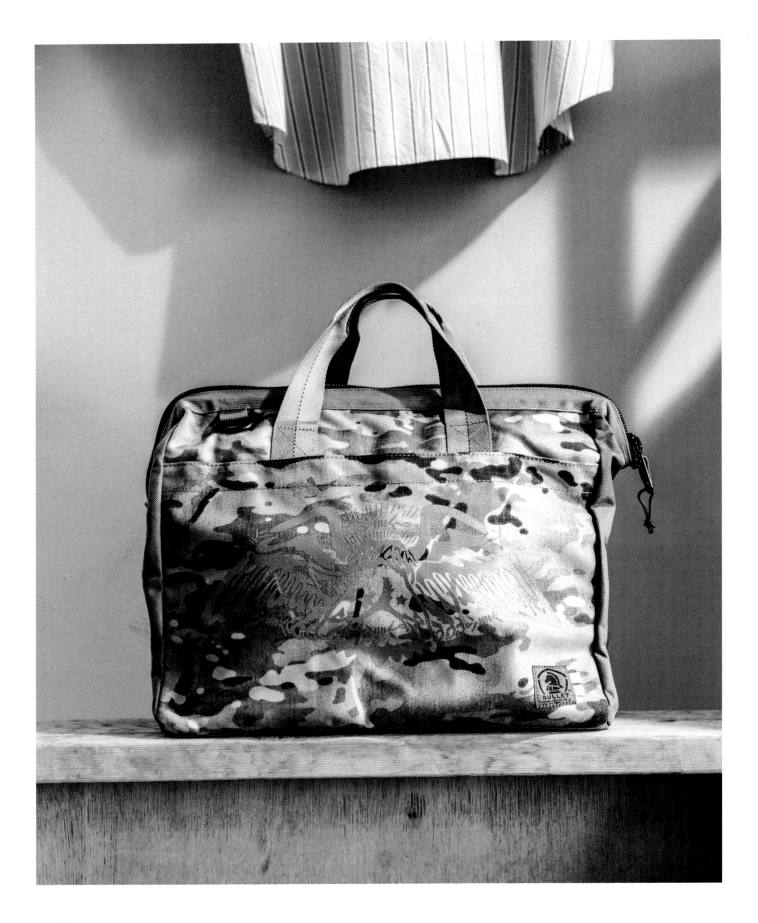

Bullet
Shoes Bag for Shoes Master 15th Anniversary (Novelty)

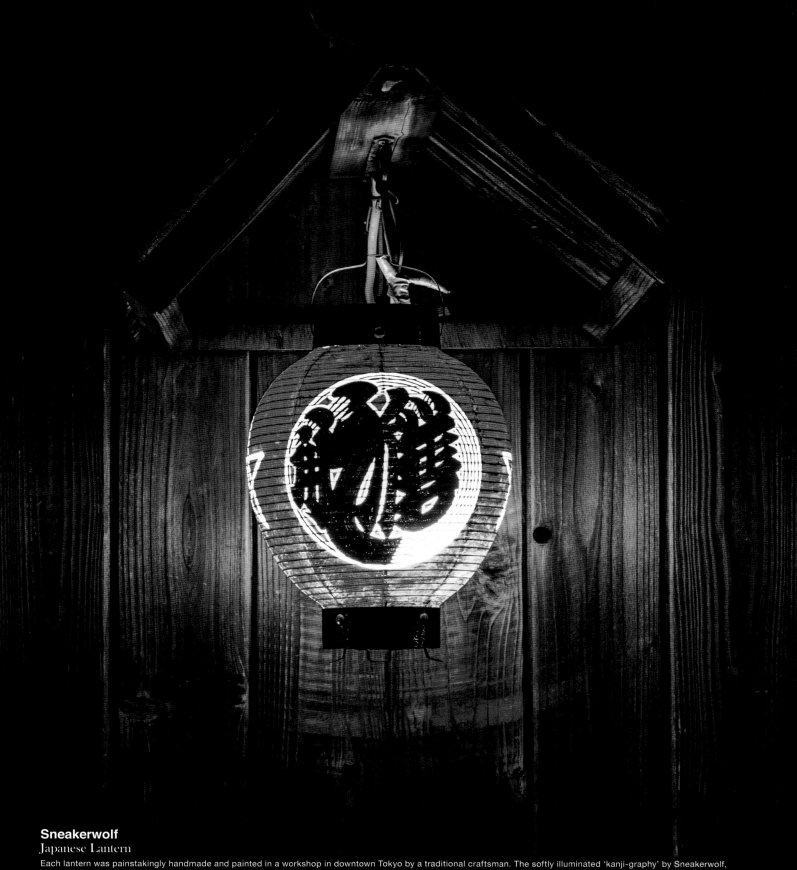

Sneakerwolf
Japanese Lantern
Each lantern was painstakingly handmade and painted in a workshop in downtown Tokyo by a traditional craftsman. The softly illuminated 'kanji-graphy' by Sneakerwolf, which at first glance appear to be stylized random kanji characters, is constructed out of the letters in "WHIZLIMITED". Feeling a special kinship with Sneakerwolf's blending of Western and Eastern cultures, WHIZLIMITED collaborated with the designer at every opportunity. In fact, during the early years of Lump Tokyo, Shitano became such an ardent fan of Sneakerwolf that he held an in-store exhibition of Sneakerwolf's pieces.

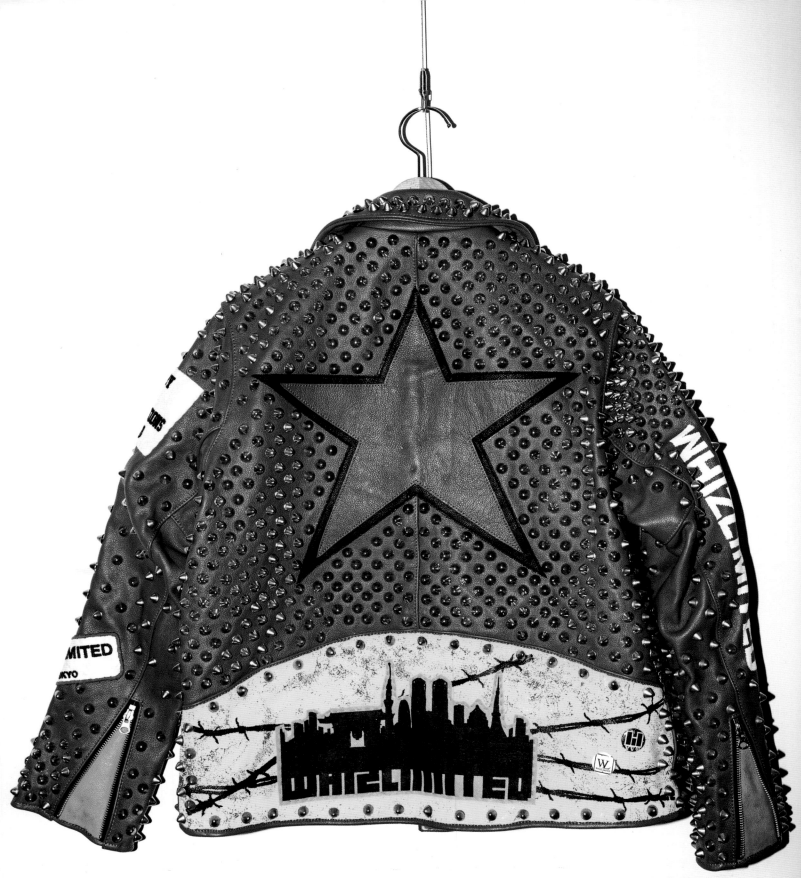

Vanson
Custom Studded Leather Jacket
Produced by Kenny (Creature From The Living / Madtoyz)
Customized by Shiga-Chan (A.F.P.)

WHIZLIMITED has specially ordered many motorcycle jackets—with a single star emblazoned on the back—from the Boston-based company Vanson, known for their traditional leatherwear. This customized version has been decorated with studs, paint, tin badges, and hand-embroidered felt patches. Going beyond the issue of wearability, the ultimate evolution of this jacket was elevated into a personal art piece by WHIZLIMITED. When it comes to customization, there is no final destination.

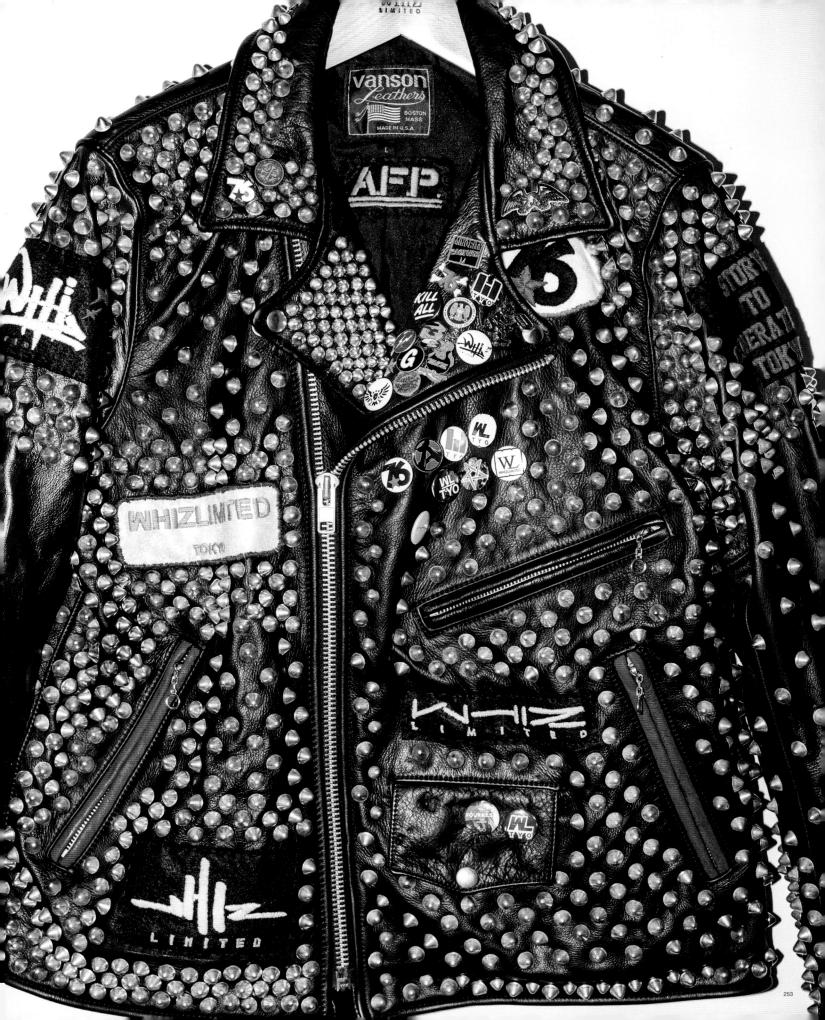

253

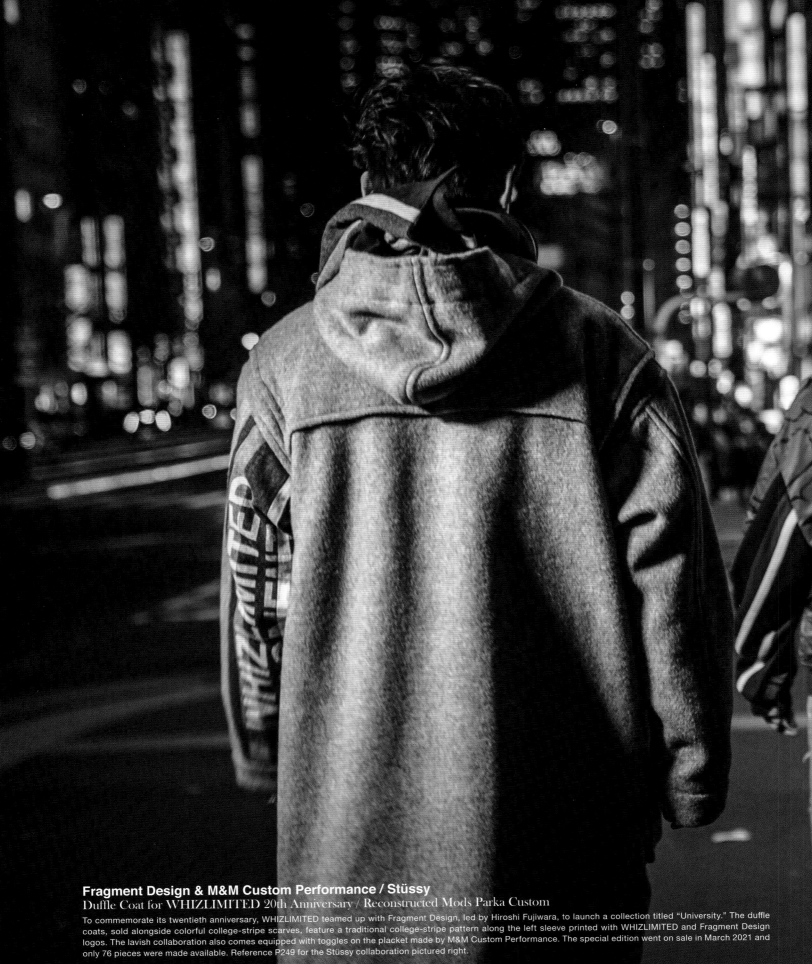

Fragment Design & M&M Custom Performance / Stüssy
Duffle Coat for WHIZLIMITED 20th Anniversary / Reconstructed Mods Parka Custom

To commemorate its twentieth anniversary, WHIZLIMITED teamed up with Fragment Design, led by Hiroshi Fujiwara, to launch a collection titled "University." The duffle coats, sold alongside colorful college-stripe scarves, feature a traditional college-stripe pattern along the left sleeve printed with WHIZLIMITED and Fragment Design logos. The lavish collaboration also comes equipped with toggles on the placket made by M&M Custom Performance. The special edition went on sale in March 2021 and only 76 pieces were made available. Reference P249 for the Stüssy collaboration pictured right.

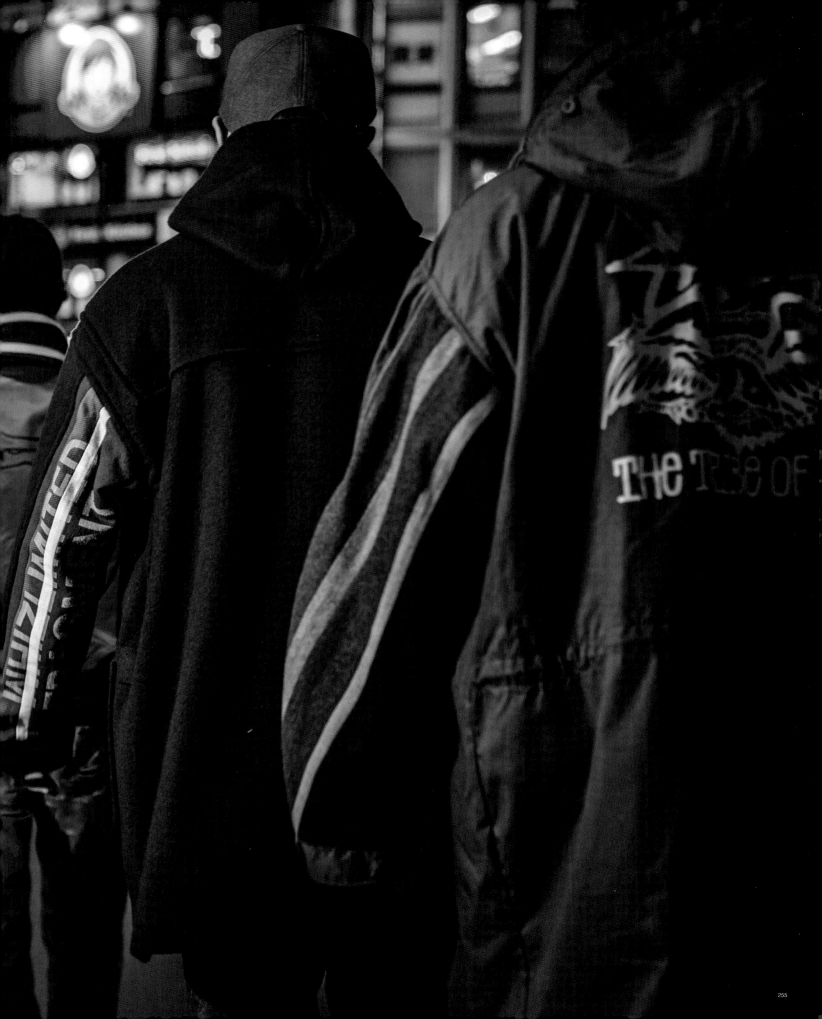